SEX

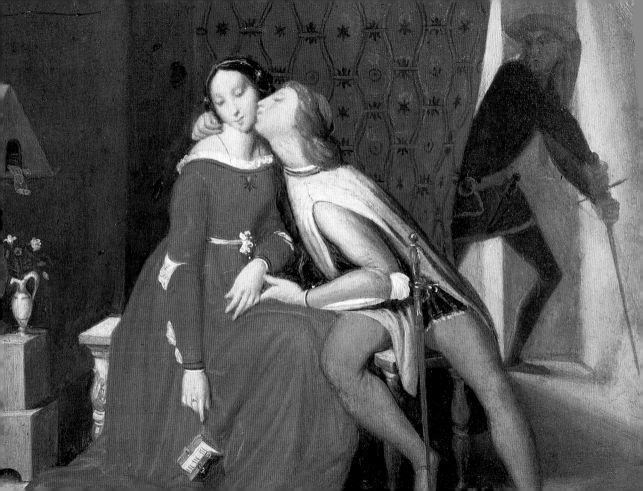

SEX

PORTRAITS OF PASSION

WATSON-GUPTILL
PUBLICATIONS
New York

First published in the United States in 1999
by Watson-Guptill Publications
a division of BPI Communications, Inc.
1515 Broadway, New York, NY 10036

This book was conceived, designed, and produced by
THE IVY PRESS LIMITED
2/3 St Andrews Place
Lewes, East Sussex, BN7 1UP

Editorial Director: SOPHIE COLLINS
Managing Editor: ANNE TOWNLEY
Project Editor: SORREL EVERTON
Editor: HILARY WESTON
Art Director: PETER BRIDGEWATER
Designer: CLARE BARBER
DTP Designer: CHRIS LANAWAY
Picture research: LIZ EDDISON
Additional research and collaboration: TONY WILLIAMS

Library of Congress Catalog Card Number: 99-60258

ISBN 0-8230-4784-9

Reproduction and printing in Hong Kong by Hong Kong Graphic and Printing Ltd.,
First printing, 1999

1 2 3 4 5 6 7 8 9/07 06 05 04 03 02 01 00 99

Page 2 illustration: *Paolo and Francesca, Surprised by Gianciotto (Detail),*
Jean-Auguste-Dominique Ingres
Pages 4–5 background illustration: *Young Lady Lying Naked on Bed,* Jerome Tisne

This book is typeset in Gill Sans and Bodoni

CONTENTS

I N T R O D

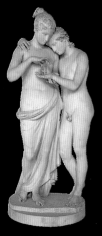

CANOVA
Amor and Psyche
1757–1822

Sex is something primeval. The space we give it in our words and thoughts shows it to be one of our main preoccupations. We see sexual images everywhere—a fact that tells us more about ourselves than about the world we inhabit. Naturally, then, sex is one of the most common subjects in art. It may be the main theme, it may form just a small part of the work, or it may exist only as a nebulous, unacknowledged overtone. It may be overt or concealed, explicit or oblique; it may even be unintentional, revealing more about the artist than was intended. Sex is to be found in the art of all societies. It is ubiquitous and eternal.

Nothing gives us a better insight into a society than the way in which the urges of sex and progress of love are treated in its art

U C T I O N

The quasireligious representations of very early art, the frank enjoyment of the East, the moralizing paintings of the Middle Ages, the jolly ribald romps in eighteenth-century pictures, and the romantic illustrations of the nineteenth century all reflect the philosophy of their times.

In some ways the more repressive societies provide us with some of the most interesting, and even stimulating, works. When it is not possible to admit openly what the picture is really about, it requires a deep understanding of what we now call "body language" and "semiotics" in order to communicate successfully such emotive matters as adultery, seduction, flirtation, cuckoldry, or shameful regret.

RUSHTON
*Back View of
Naked Woman
20th Century*

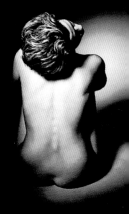

7

HOLLOSY
Husking Corn (Detail)
1885

For it is in minutiae that intensity of feeling is revealed. The nape of a neck, the angle of a leg, a glance, a stare—each detail can evoke new desires and old memories. And the scene of a couple slinking away from the party may seem innocent, but we know what they are up to; it reminds us of that fear of being caught in flagrante, that extra frisson that risk arouses. The range of emotions and complexities of a relationship can be greater when restraint or pretense are necessary. So many opportunities for comedy or tragedy, for triumph or for despair are lost if sex is no longer regarded as a pleasurable activity to be indulged in at will.

In more liberal times, sex is fun—not always frivolous, but not "serious" either; it is nothing to get pious about. Sex is

light-hearted, sometimes comical, a break from cares; a delight. Nothing could seem less mechanistic than this tender, bawdy, reckless period of time between the sheets. The private laughter of lovers stems from the undeniable fun of it all.

Although, ultimately, sex is an argument always leading to the same conclusion, it seems to be the widest and most varied subject in the world. Sexual images both reflect and influence our predilections and desires. Erotic art, far from being confined to set-piece depictions of the generative act, encompasses the widest range of our sexual encounters: our flirting and our follies, our love and our affections, our deceits and our disappointments— and our secrets.

HARRIS
Waiting for Enlightenment
20th Century

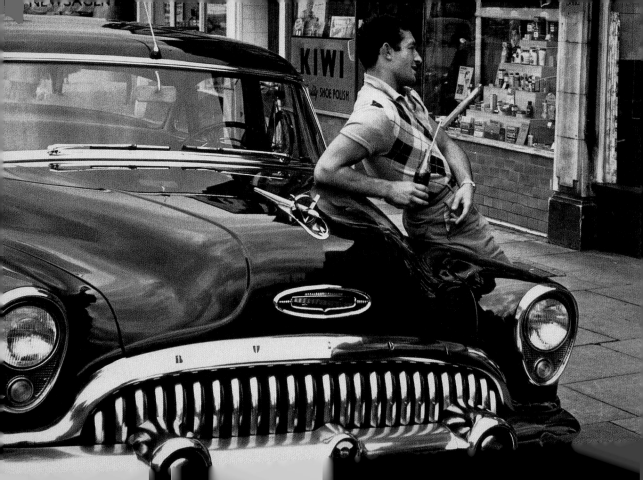

AT FIRST SIGHT

"I ne'er was struck before that hour
With love so sudden and so sweet."

JOHN CLARE (1793–1864) *FIRST LOVE*

AMERICAN
An American Buick (Detail)
1954

a glance

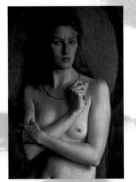

CORRY
Self-portrait (Detail)
1998

LOVE AT FIRST SIGHT: that old fairy tale. In our cynical age we smile at this unlikely part of the romantic ideal. And yet that sudden, unexpected meeting of glances can often lead to a momentous conclusion. So much can be conveyed by a look, both involuntarily and by design. We can choose to send a message by the practiced raising of an eyebrow, or our dilating pupils and reddening face may give us away, as desire manifests itself against our will.

For men, in particular, the most immediate sexual signals are visual, and women have always improved their effect by the use of fashion and makeup. This stimulation of desire is strongest when the sight is fresh. Even when we fall in love with someone we have known since childhood, desire takes us by surprise and we see them as new.

Even in more businesslike situations, that first sight can be of vital significance. The English author John Aubrey (1626–97) reports a case in which the selection of a bride was not attended by any surge of romantic ardor:

"My Lord's daughters were then both together abed. He carries Sir William into the chamber and takes the Sheete by the corner and suddenly whippes it off. They lay on their Backs, and their smocks up as high as their arme-pitts. This awakened them, and immediately they turned on their bellies. Quoth Roper, I have seen both sides, and so gave a patt on the buttock, sayeing, Thou art mine. Here was all the trouble of the wooeing."

a glance

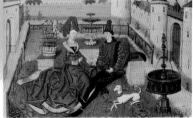

FRENCH
Illuminated manuscript (Detail)
15th Century

LIPPI

*A Man and a Woman
at a Casement*
15th Century

Hans Holbein (1497–1543), court painter to Henry VIII of England (1491–1547), was party to another passionless arrangement. In order to get Henry VIII to marry Anne of Cleves (1515–57), Thomas Cromwell (1485–1540) sent Holbein to paint a flattering portrait of her. Henry's real first sight of Anne was such a disheartening experience that he called her the Flanders Mare.

In our society, lovers may stare into each other's eyes for as long as they wish (no doubt seeking the telltale pupil dilation), but at other times and in other places such behavior would not be tolerated. Sometimes a covert appraisal would be necessary, even to the extent of seeming not to look at all. Sometimes the paying of polite and proper attentions would be sufficient cover for a tentative piece of

what we now call "nonverbal communication," betrayed perhaps by a becoming blush. Artists have seen and recorded all this. The glance revealing forbidden love; the affectionate gaze of domestic bliss; the gaping confusion of unexpected lust; and the long, lecherous stare of the voyeur.

We know what that look means, but we don't quite know how we know. We may be aware of "bedroom" eyes or "come-hither" eyes or of the "beady" eyes of the calculating and predatory, but it takes a scientist or an artist to be observant and dispassionate enough to see and understand the minute physiological changes that underlie these signals.

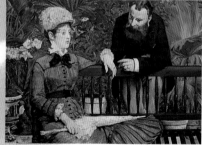

MANET
Dans la Serre
1879

BAUDRY

The Pearl and the Wave
19th Century

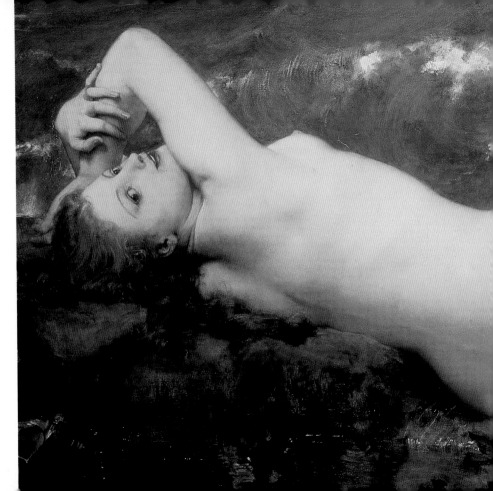

AN enticing image. The young woman lies on the sand and rock, looking alluringly over her shoulder with a licentious smile. She cannot possibly be comfortable, but she does not care. The breaking waves, symbolizing powerful natural forces, have a clear sexual connotation.

PAUL BAUDRY (1828–86)

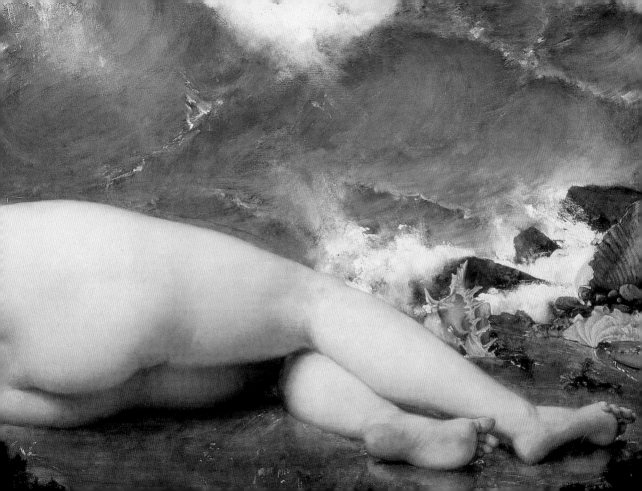

APTHORP

Poison Ivy Blowing a Kiss
1995

SINCE 1989 Apthorp has produced the drawings for the comic-book characters in *Batman*. In this scene Poison Ivy glances at Batman, blowing him a kiss in an attempt to ensnare him.

BRIAN APTHORP (b. 1955)

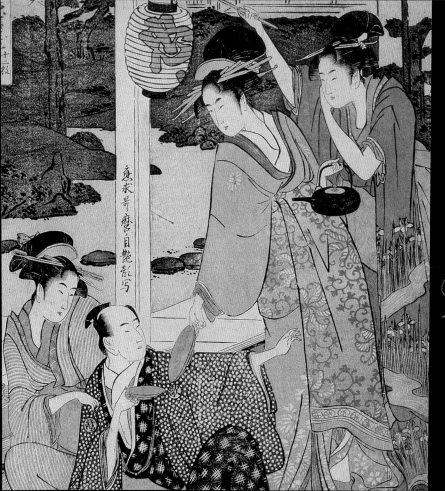

UTAMARO

*An Artist Surrounded by Geishas
at a Tea Party in the Yoshiwara (Detail)*
Late 18th Century

W HEN they arrived in
Europe in the nineteenth century,
traditional Japanese woodblock prints like
this had a great influence on French art.
A wooden block was carved so that the area
to be printed stands in relief. It was then
inked in various colors and an impression
taken. It produces a much broader effect
than that of wood engraving.

KITAGAWA UTAMARO (1753–1806)

19

CORRY
Self-portrait (Detail)
1998

THIS is a lascivious look; but more a pensive look of desire, than a sexual invitation. There are several visual clues to suggest this: she looks straight at us and her pupils are dilated, but she toys distractedly with her necklace and her arms are folded defensively over one breast.

KAMILLE CORRY (b. 1966)

ALMA-TADEMA
Antony and Cleopatra
1883

ANTONY, seen looking through the canopy at Cleopatra, is suddenly struck by her beauty. Cleopatra is aware of his gaze, but casually looks away. Rather disconcertingly, she seems to be looking at us, and with a somewhat flirtatious eye. The artist uses the dark canopy as a frame so that our attention is drawn to the brighter figures.

SIR LAWRENCE ALMA-TADEMA
(1836–1912)

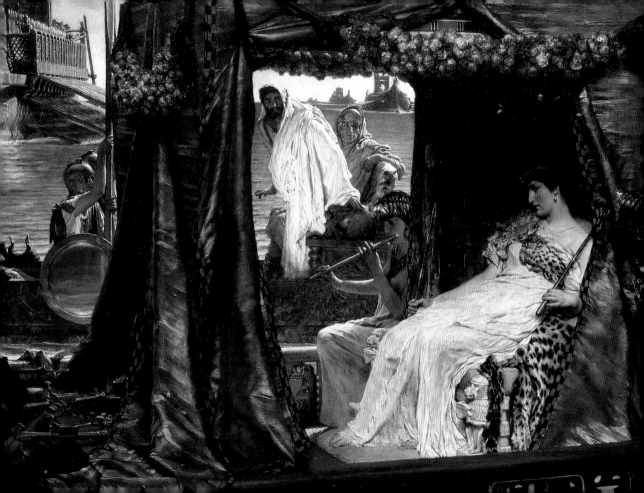

BOURNAIS
Untitled
20th Century

CAREFULLY controlled lighting is the key here. There is very little visual information, and yet we instantly interpret the image as a woman's face. We also read into this minimal view a stark, desperate vision of desire.

YANNIS BOURNAIS (CONTEMPORARY)

STEVENS
Untitled
20th Century

THIS image is similar in subject to the previous one, but entirely different in mood. While the shadows in Bournais' image suggest a demure secrecy, here the eyes are seen head-on and uncovered. There is an almost aggressive openness about the woman's lust.

BRIAN DAVIS STEVENS (CONTEMPORARY)

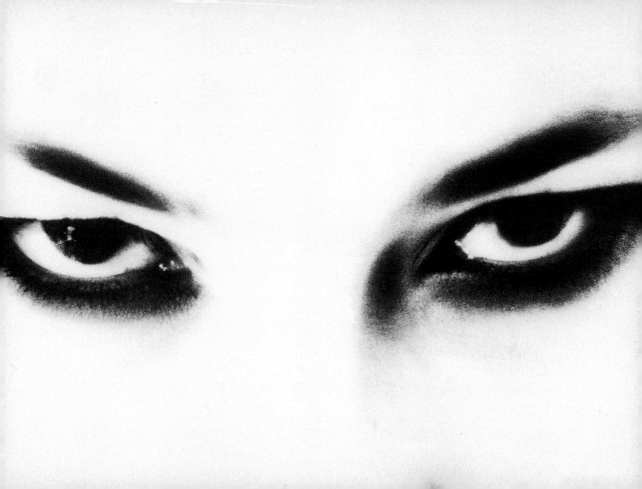

GRAVES
Adam (Detail)
1998

THE features contrast strongly in tone and treatment with the background and with the hair; they are all we see, and all we need to see. The distant, pensive expression hints at desire. His look is neither proprietorial nor wistfully envious; he does not yet know whether he can get what he wants.

C. DANIEL GRAVES
(b. 1949)

REYES
Raymond
1993

*T*HE body, not just the head, of this somewhat less overtly sexual man is visible. Indeed, this image, unlike the previous one, relies much more on the controlled, almost self-conscious pose, which gives his stare a good deal of its erotic power.

MIGUEL ANGEL REYES (b. 1964)

FOLLOWING PAGES
LYNCH
Nude
20th Century

*L*YNCH juxtaposes the forms of the rocks and the form of the woman. Although these shapes echo each other, there is a strong contrast between the cold, rough texture of the stone and her soft, warm skin. Her nudity accentuates the primitive atmosphere of the photograph.

KEVIN LYNCH (CONTEMPORARY)

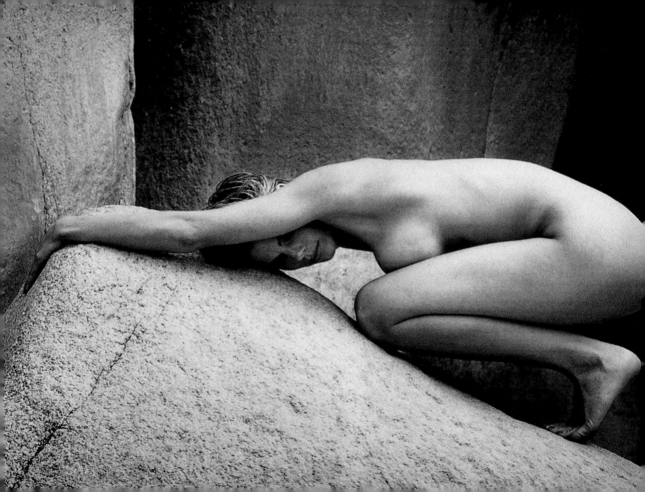

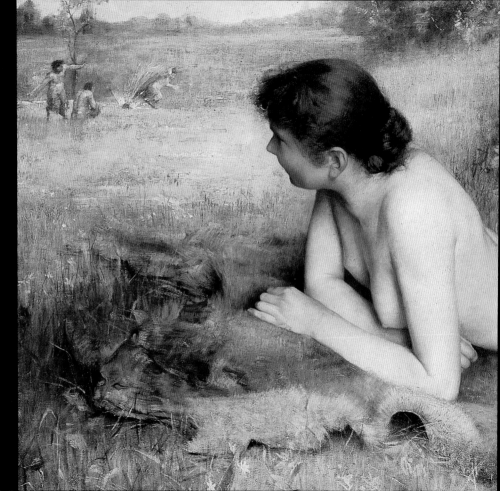

GLOCKNER
The Naiad (Detail)
Late 19th Century

THE woman, relaxing on the grass, is painted with great warmth and sensuality. She is a very worldly water nymph, and her obvious interest in the frolics of the naked men adds much to the sexual force of the picture.

EMIL GUSTAV ADOLF GLOCKNER
(1868–DEATH DATE UNKNOWN)

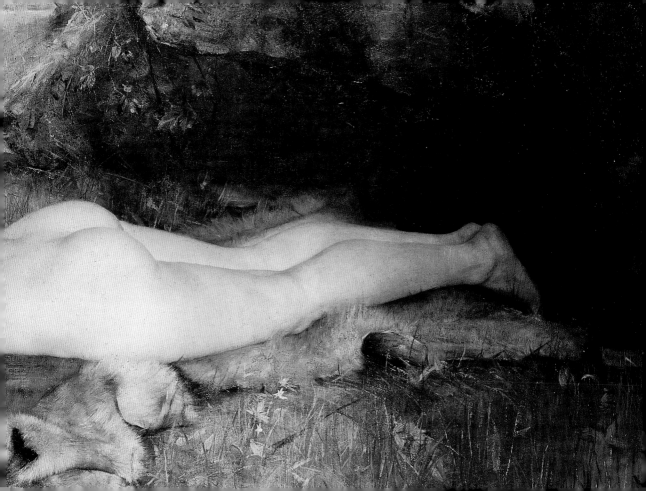

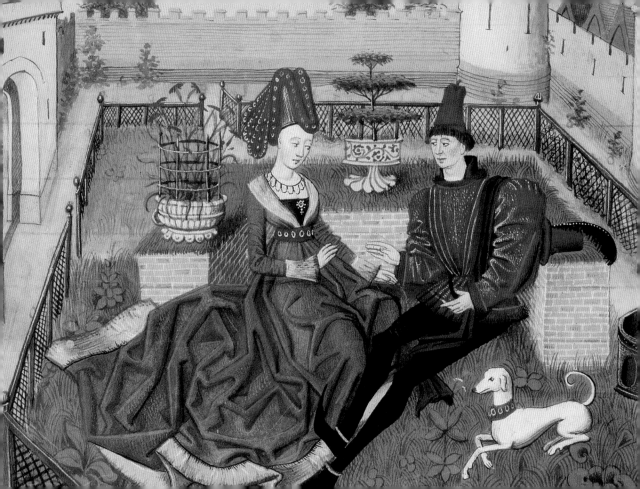

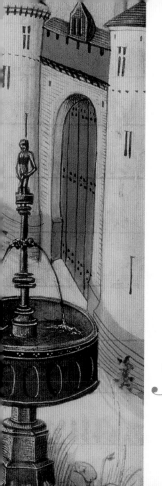

HESS
Her Garden
1990

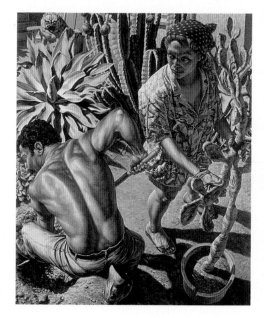

TN the middle of a mundane task, the woman is suddenly struck by the sight of the man's body. Her look is secret and lascivious, and she absent-mindedly fondles the potted succulent. The forms of the other plants echo the sexual imagery.

F. SCOTT HESS (b. 1955)

FRENCH
Illuminated manuscript (Detail)
15th Century

TN this illumination the formality of the composition reflects the formality of the courtship. Both figures look ill at ease, but they turn toward each other and their hands almost touch. The frisky dog, the open gate, and the figure on the fountain are all clues that romance is in the air.

> ❝
> And when she ceas'd,
> we sighing saw
> The floor lay pav'd with
> broken hearts
> ❞

Richard Lovelace (1618–58)
Gratiana Dancing and Singing

GERMAN

Illuminated manuscript (Detail)
1473

*L*OVE certainly seems blind in this case. And is the voyeur also a suitor for the lady? Medieval manuscripts were embellished by illuminations, which provide an excellent visual record of the times. Although most manuscripts were produced in monasteries, many contain pictures of a decidedly secular nature—whether it was warranted by the text or not.

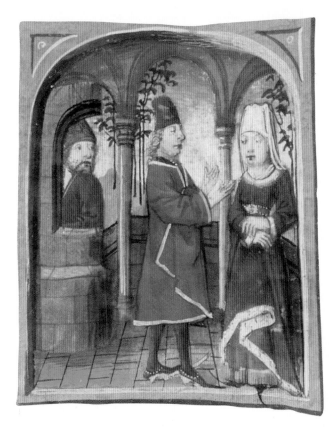

LIPPI
*A Man and a Woman
at a Casement*
15th Century

MUCH of Fra Filippo's work is deeply religious, but this picture reveals something of his character that led to his absconding with a nun, Lucrezia Buti. Eventually they were allowed to marry, and had two children. She became the model for some of his portraits of the Madonna.

FRA FILIPPO LIPPI (C. 1406–69)

33

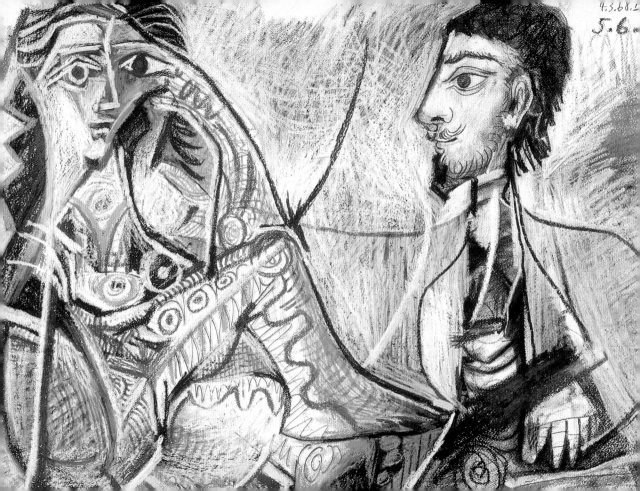
4.5.68.
5.6.

PICASSO
Nude Couple (Detail)
1968

A SUGGESTIVE, playful painting from late in Picasso's career. The couple are not obviously nude in reality, but their desires are made transparent by the artist's clever depiction of their body language.

PABLO PICASSO (1881–1973)

MOREAU
Galatea (Detail)
1880–81

*T*HIS painting is typical of Moreau in both style and subject. The cyclops Polyphemus gazes at the nymph Galatea, the object of his unrequited love. Galatea threw herself back into the sea when Polyphemus jealously crushed her chosen lover Acis with a rock.

GUSTAVE MOREAU (1826–98)

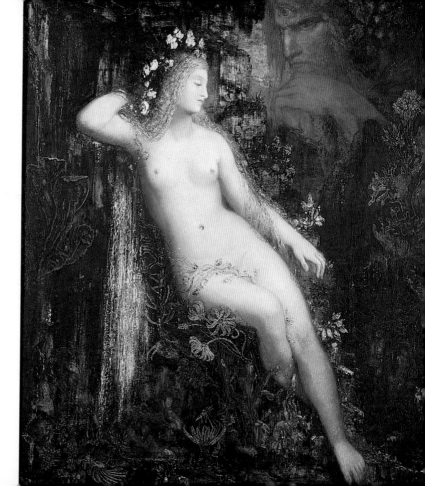

ITALIAN

Flirt (Detail)

1963

*T*HE peculiar
virtue of the
camera is that it can
reveal all by capturing
the most fleeting
moment. Yet here, the
same result is achieved
by a set-piece, which
could almost have
been posed for
the purpose.

MEET MY MAKER
THE MAD MOLECULE

"And I like your knowledge and I like your hair
and I like the way you've passed through your
marriageable days so beautifully unmarried.
And how you look with books and how nearly all
the men pass your beauty by. And leave your
magic all to me."

J.P. Donleavy (b. 1926)

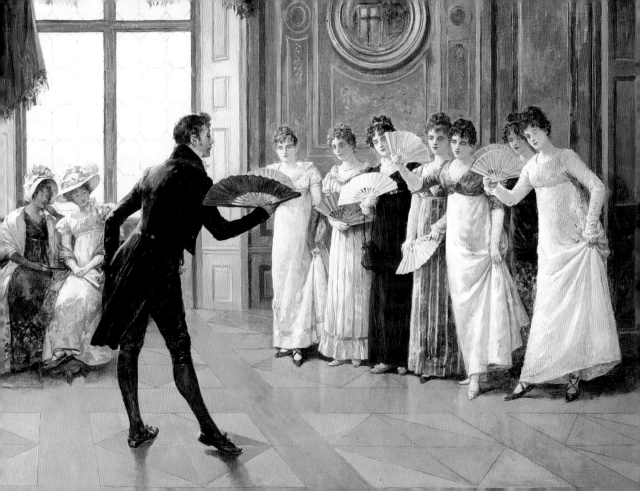

GLINDONI

Flirt à l'Éventail (Detail)
1908

THE young ladies enjoy a lesson in the correct use of the fan for purposes of flirtation. Some of the pupils eye the teacher appraisingly, but the mothers know better.

HENRI GILLARD GLINDONI (1852–1913)

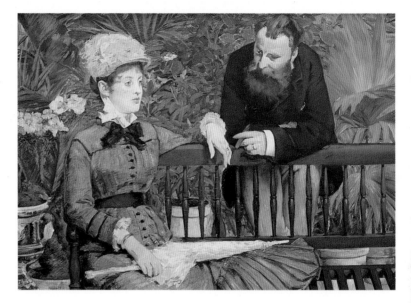

"
I looked up to see the very prettiest girl I ever set eyes on. 'Who on earth's that?' I asked Blaikie. 'That? Oh, one of the sisters,' he said listlessly. 'There are squads of them. I can't tell one from another.'
"

John Buchan (1875–1940)

MANET

Dans la Serre
1879

THIS painting of an encounter in a conservatory shows Manet's profound understanding of the effects of light. Although we may not be conscious of it, the lighting in such places is quite unusual; even the skin tones may be affected by reflections from the mass of greenery. Manet captures the atmosphere perfectly.

ÉDOUARD MANET (1832–83)

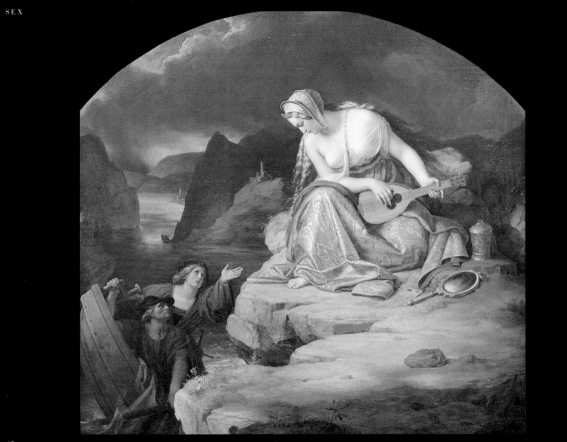

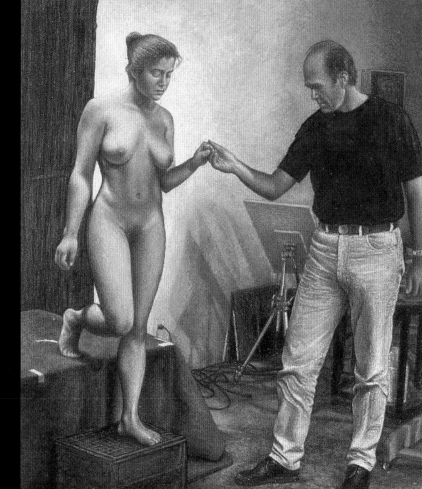

GEMÄLDE
The Lorelei (Detail)
1835

THE Lorelei is a dangerous rock in the Rhine, Germany, where a maiden drowned herself because of an inconstant lover, and became a siren. Here, her beauty and her music have entranced the boatmen, even as they sink into the water.

KARL BEGAS VON GEMÄLDE (1794–1854)

CHRISTENSEN
Chanson de Geste
1996

WHILE he painted, the artist was staring at the model's naked body with an intensity unknown in any other circumstance. Now, although he is sensitive to her vulnerability, and she assumes a quiet dignity, there is a strong sexual tension between them.

WES CHRISTENSEN (b. 1949)

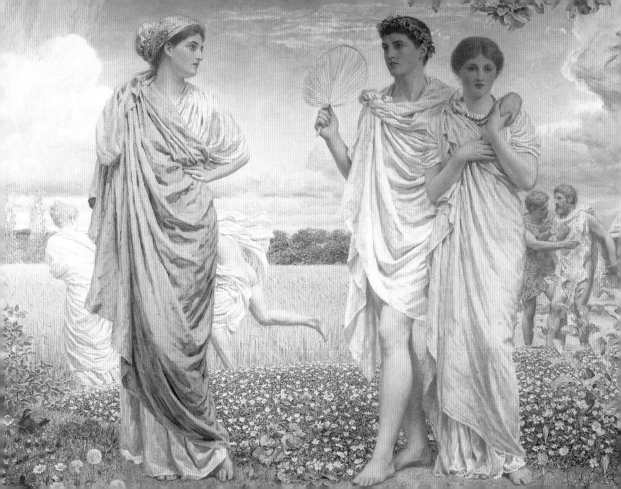

MOORE

*Loves of the Wind
and the Seasons (Detail)*
19th Century

IN this hint at forthcoming infidelity, the situation between the three figures in the foreground is evident enough; the behavior of those in the background is rather more intriguing.

ALBERT JOSEPH MOORE
(1841–93)

PALANKER

*Scylla and
Charybdis (Detail)*
1998

WE witness the sudden impact of a first glance, but the title suggests that it would be dangerous to come between this couple. To be between Scylla and Charybdis—who in Greek legend were two destructive monsters—means facing two equal threats, and, in attempting to avoid one, falling victim to the other.

ROBIN PALANKER (b. 1950)

RADIONOV
Down the River (Detail)
1997

THEIR boat may be passing through stormy waters, but their love persists, and they sit together in a companionable way. Or, perhaps, what they really see as they peer into the darkness are visions of the lusts of long ago.

GREGORY RADIONOV
(b. 1971)

GONZALÈS
Henri Guerard
Relaxing on the Beach
(Detail)
19th Century

T is a commonplace belief that there is a voyeur in each of us. Gonzalès makes us acutely aware of this by showing us the voyeur along with the object of his gaze, so that we are at once in and out of complicity with him.

EVA GONZALÈS (1849–83)

45

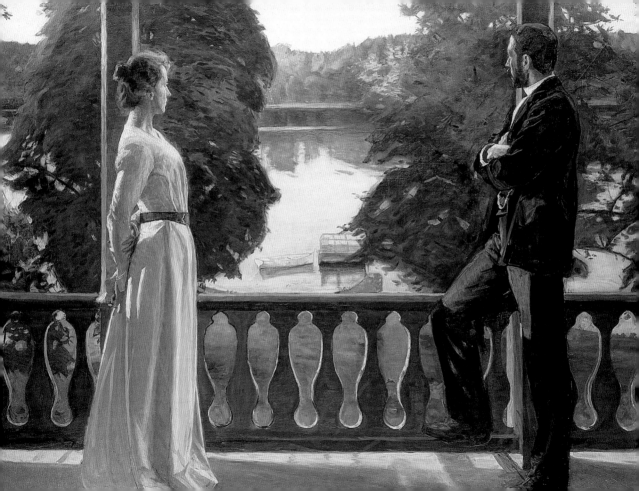

BERGH

Nordic Summer Evening
1899–1900

*H*ERE the body language is more pronounced. Although his arms are crossed defensively, their bodies are turned toward each other, and he points with his toe; she thrusts her hips at him. They will not look at each other, but neither do they see the beauty of the setting sun to which their heads are turned. Their true feelings are betrayed by their postures, and the atmosphere is filled with desire.

SVEN RICHARD BERGH
(1858–1919)

66
I saw that incomparable good conditioned Gentlewoman, Mrs. M. Wiseman, with whom at first sight I was in love.
99

John Aubrey (1626–97)

LEIGHTON

A Wet Sunday Morning
1896

A COMPOSITION that depends for its impact on who is looking at whom, and in what manner. The girl stares ahead, unseeing; the man adores her; the mature lady, sensibly, looks to her feet; but the sisters regard all with malicious delight.

EDMUND BLAIR LEIGHTON (1853–1922)

HARDY
A Meeting by the Stile (Detail)
Late 19th /Early 20th Century

HIS is a common device in art and literature: the chance encounter in the road. They do not realize what it will lead to—but we do: banter, misunderstanding, then love and marriage. Just such a meeting introduces Jane Eyre to Mr. Rochester in the novel *Jane Eyre* by Charlotte Brontë (1816–1855).

HEYWOOD HARDY (1842–1933)

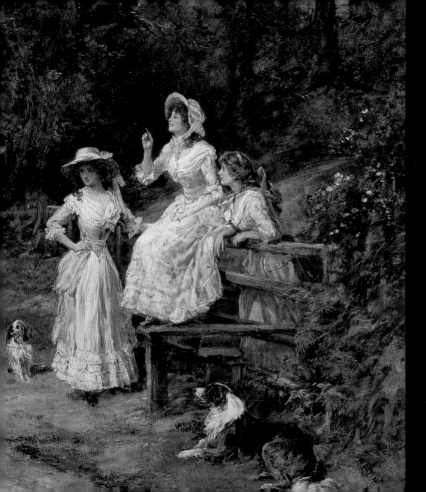

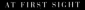

66

I took up my muff and walked on. The incident had occured and was gone for me: it was an incident of no moment, no romance, no interest in a sense; yet it marked with change one single hour of a monotonous life. . . . The new face, too, was like a new picture introduced to the gallery of memory, and it was dissimilar to all the others hanging there: firstly because it was masculine; and, secondly, because it was dark, strong, and stern.

99

Charlotte Brönte (1816–1855) *Jane Eyre*

49

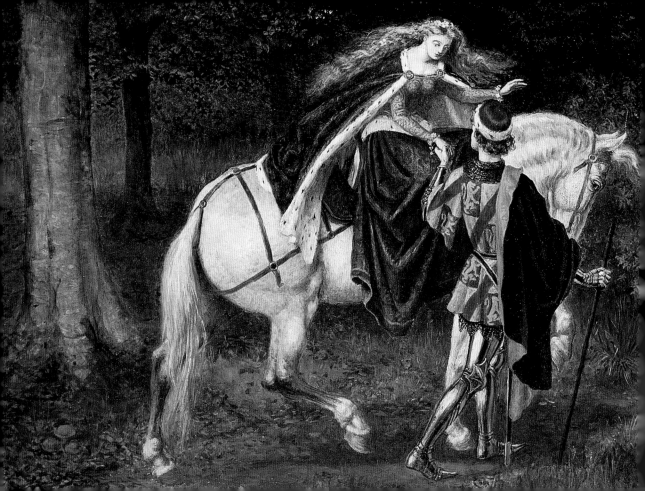

> **"**
> Love goes a-fishing with the rod Desire,
> Baiting his hook with Woman of delight.
> Attracted by the flesh, the men-fish bite.
> He hauls them in and cooks them in his fire.
> **"**

Bhartrhari (d. AD 651)

CRANE
La Belle Dame Sans Merci (Detail)
c. 1863

CRANE was a painter and book illustrator who was influenced by the romantic poets, such as John Keats (1795–1821), and by Pre-Raphaelites, including William Holman Hunt (1827–1910), who shared an idyllic view of the medieval world. This painting illustrates Keats' poem of the same title, which tells of the enchantment and downfall of a knight-at-arms. ("I sat her on my pacing steed and nothing else saw all day long.")

WALTER CRANE (1845–1915)

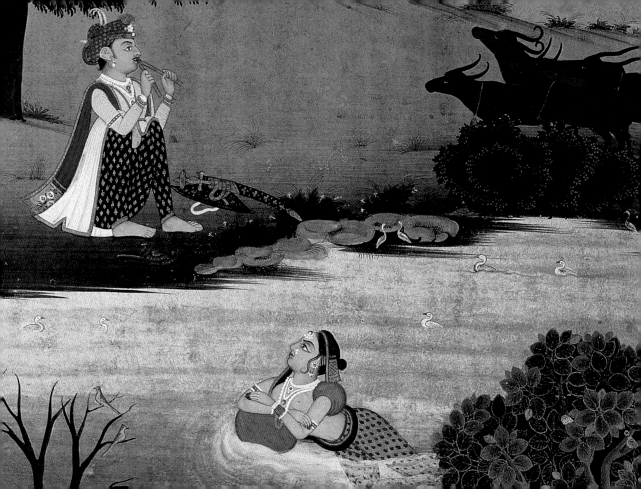

RAJPUT SCHOOL
Prince Playing a Flute (Detail)
18th Century

A PRINCE plays a flute on the bank of a river, the melody enticing his lover to swim across the river toward him. This could almost be a counterpart of the Siren of the Lorelei in Western folklore, but the roles are reversed; it is the man who lures the woman over the water, and she has eyes only for him.

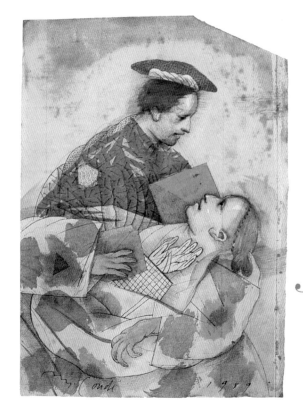

CONDÉ
Untitled
1989

A BIZARRE, but engaging, combination of modern and medieval elements. The two lovers gaze into each other's eyes in a pose that is just as familiar today as it must have been five hundred years ago.

MIGUEL CONDÉ (b. 1939)

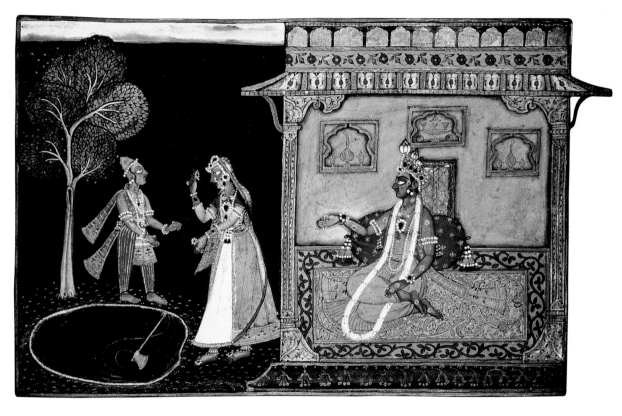

INDIAN

Untitled

c. 1685

*T*HE man on the left is a woodcutter. The woman is anxious to prevent him from felling the tree because she has a meeting under it with Krishna, who looks on. This is typical of Indian painting of the time: scale and perspective are adjusted to help make the point of the picture, rather than to attempt visual realism. To the same end we can view the interior at the same time as the outside.

THE AGONY AND ECSTASY
OF DIVINE DISCONTENT

"In the orchard and rose garden
I long to see your face.
In the taste of Sweetness
I long to kiss your lips.
In the shadows of passion
I long for your love.

Oh! Supreme Lover!
Let me leave aside my worries."

Love Poems of Rumi

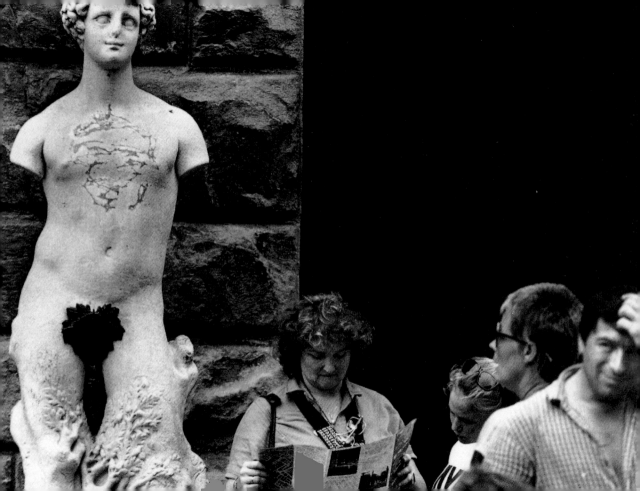

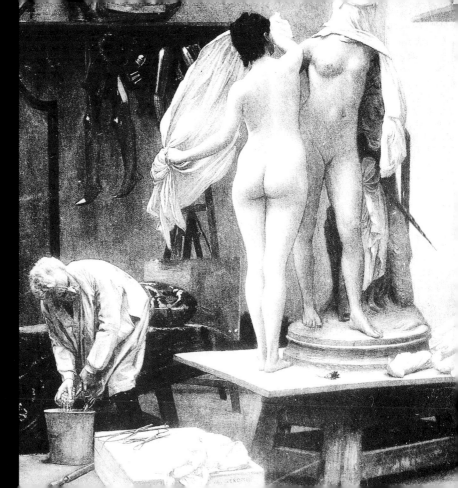

HUTCHINGS
Florence Tourists
1987

THE tongue-in-cheek covering of the genitals of this lifesize sculpture and its position above the tourists establish it, perversely, as an observer of and commentator on mankind.

ROGER HUTCHINGS (b. 1952)

GÉRÔME
The End of the Séance
c. 1870

THIS situation is intimate, yet also tense. The artist and model share a sense of achievement, of collaboration, as they tidy up. But the fact that the artist is still looking at her hints that, whatever his personal feelings, his work is always at the back of his mind.

JEAN-LÉON GÉRÔME (1824–1904)

SLONEM

Valentino I (Detail)
1995

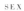

HIS is very broadly painted, with large areas of color and thick brushstrokes. It has almost a comic-book feel. The man is afforded much more detail and decoration than the woman, who observes him quietly from behind her fan.

HUNT SLONEM (b. 1951)

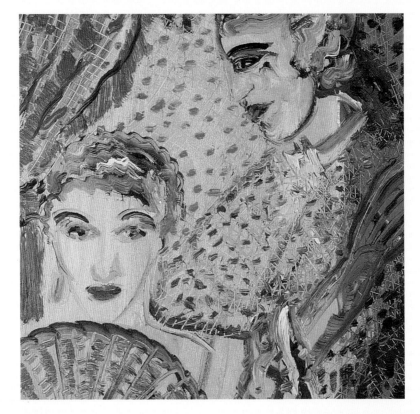

EVANS

Snake Charmer 2
1996

A MEDITATION on the game of love; the man performs in order to seduce the woman. Her identification with the snake generates a rather crude pun on the rules of snakes and ladders.

CYNTHIA EVANS (b. 1951)

WONG
Untitled
20th Century

*T*HIS photograph recalls the distant longing of an adolescent crush. The boy can only watch in fascination as the female figure treads the waves.

LANA WONG (CONTEMPORARY)

66

Watch his eye, too. Watch to see that when it is looking at you he is looking at you. Remember that by a slight shift of focus, the loving glance can turn into an absent stare over the left shoulder.

99

Stephen Potter (1900–69) *Anti-Woo*

61

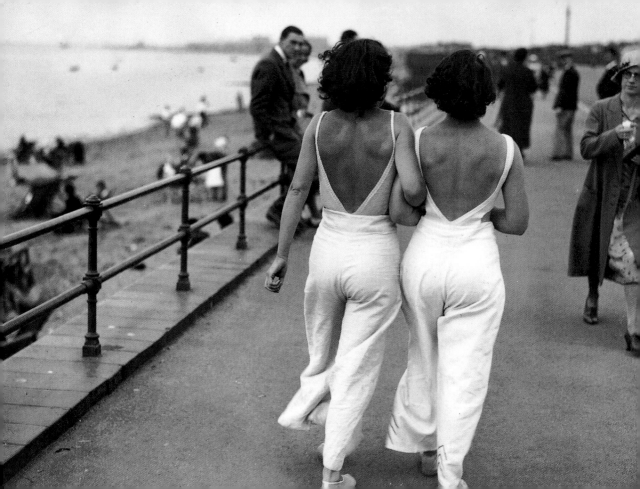

CHAPTER TWO

FLIRTING

"There is a sort of gallantry
due to the sex, which is best attained
by practising at home."

THE YOUNG MAN'S OWN BOOK 1838

HAMPTON
Matching Pair
1932

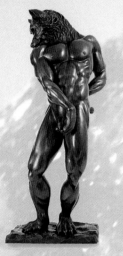

OD
Hybrid One
1996

ALL THE WORLD LOVES A LOVER——but not at the flirting stage. That odd behavior, so thrilling to the participants, and so often imagined to be invisible to others, can in fact be most irritating to the rest of us. We know how Mr. Pooter feels in George and Weedon Grossmith's *Diary of a Nobody* (published 1894): "I did not like the way she kept giggling and giving Lupin smacks and pinching him. Then her laugh was a sort of a scream that went right through my ears, all the more irritating because there was nothing to laugh at."

As times change, so do fashions in flirting. In prudish times they become more subtle, or at least less overtly sexual, but they are no less exciting for the participants. The lowered eyes, indicating modesty

flirtation

and submission, were probably just as alluring to a Victorian gentleman as a long intimate gaze followed by a brief knowing smile would have been to a young man in the "permissive sixties." And the sort of elegant verbal duels fought in the books of Jane Austen (1775–1817) are counterparts of the clumsier banter of today.

To a zoologist, flirting may be just another example of the courtship ritual of animals, simply a natural and necessary part of the process of selecting a mate. And, looked at from this point of view, it provides an interesting study of that nonverbal communication known as "body language." From the most obvious wink to the barely perceptible change of posture, we are doing it all the time. Even the middle-aged man holds in his stomach when an attractive woman

FISK
The Secret
1858

CRANACH
*The Legend of the
Nymph (Detail)*
1518

appears; he may have no hope of wooing her, but flirtatious behavior, however mild and however unconscious, is instinctive to us all.

Women have a very much larger repertoire for flirting than men. A man may adjust his posture, or smile like a shy little boy, or use a bold look, held slightly longer than normal; but from such comparative subtleties he jumps to the leer, the wink, and the crude crotch-displaying stance with his thumbs in his belt or his hands on his hips.

Women, on the other hand, use small and seemingly innocent gestures to communicate with great precision. This is not to say that women don't take pains to display their most appealing bodily

features, such as their breasts or buttocks: long dresses are cut to show the lines of the body underneath and can be just as revealing in their own way as the miniskirt of the 1960s and '70s. Nor are women always left unmoved by men's blatant posturings: trials have shown strong female responses to the sight of a pert male bottom.

In flirting, women are in control. They have the subtlety to steer the situation toward a truly sexual encounter, to make it seem a harmless and amusing pastime, or to use it to tease and humiliate. Men may think they know what they are doing, but as one of George Bernard Shaw's (1856–1950) characters exclaims to his colleague in *Man and Superman*: "Fool: it is you who are the pursued, the marked-down quarry, the destined prey."

RENOIR
Dance in the Country
1883

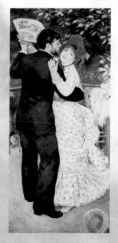

tease

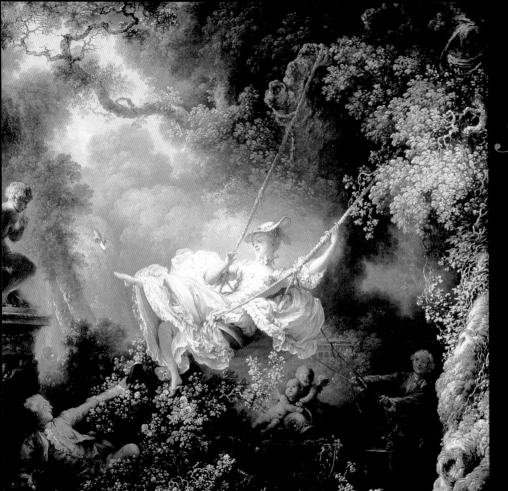

FRAGONARD
The Swing (Detail)
1767

THE woman's expression tells us that she knows exactly what she is doing; the man sees nothing beyond the view up her skirt; and perhaps the bishop is unaware of his part in such scandalous behavior. Fragonard painted this charming picture according to a strict set of instructions from his client.

JEAN-HONORÉ
FRAGONARD
(1732–1806)

HOGARTH
Before
c. 1730–31

THE young man makes a bold advance upon the woman's virtue; she raises her hand to ward him off, but with little resolve. While they are still at this flirting stage, they are happy, respectable, and secure. The young woman still has most of her symbolic apples—there is yet time to recover—but the danger of losing them is apparent.

**WILLIAM HOGARTH
(1697–1764)**

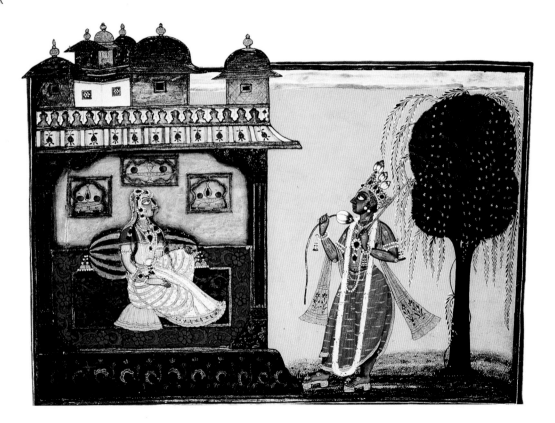

INDIAN

Krishna Visits His Sweetheart Radha
c. 1685

AN illustration to a poem by Bhanudatta. Of particular interest is the jumbled collection of roofs and towers, sitting atop a single room, at a much larger scale, in which the goddess waits to receive Krishna's attentions.

INDIAN

Ahmad Khan Bangash with a Lady
c. 1770

IT was quite popular at this time in India for important men to be pictured with their women. This example is painted in gouache, enriched with gold. Gouache is water-based color, which, unlike watercolor, is essentially opaque. It lacks the luminosity of watercolor, but is well suited to this sort of meticulous illustration.

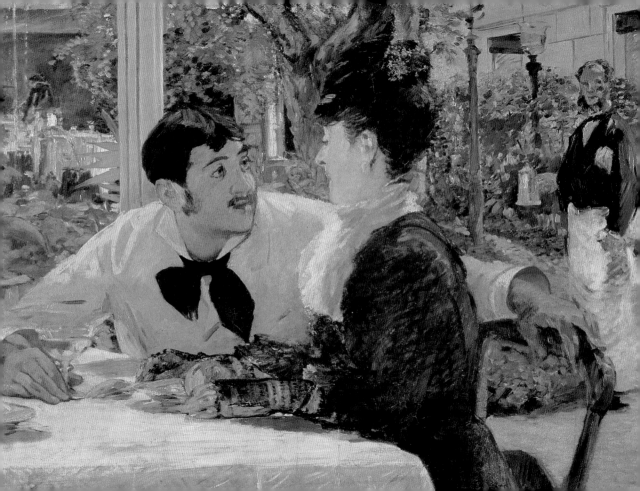

MANET

Chez Père Lathuille (Detail)
1879

A COUPLE at a table stare into each other's eyes as a waiter looks on. A painting from late in Manet's career, it shows the influence of the Impressionists. It is an outdoor scene, full of light, and less precise than his earlier work. Note, for example, the free treatment of the young man's hand, which creeps around the back of the woman's chair.

ÉDOUARD MANET (1832–83)

HENNESY

The Pride of Dijon (Detail)
1879

N OT only does the way in which they present their bodies to each other reveal the exact nature of their tête-à-tête, but the composition of the whole painting also depends upon their relative attitudes. The darker form of the man has a dynamic relationship with the strong curved form produced by the woman's body.

WILLIAM JOHN HENNESY (1839–1917)

FISK
The Secret
1858

*I*N this somewhat eerie composition, a secret meeting is discovered with delight. The woman, however, appears reluctant to get swept up in her suitor's approaches, perhaps put off by the calls of the search party. In the background the more innocent pleasures of the picnic go on unabated, emphasizing the illicit nature of the tryst.

WILLIAM HENRY FISK (1827–84)

FLÖTNER
The Perils of Love
c. 1530

*I*N a simple allegory, two lovers are flanked on the one side by the Devil and his promise of corruption and deceit, and on the other by Death with his hourglass, recalling the poem *To His Coy Mistress* by Andrew Marvell (1621–78). Love is transient and fickle.

PETER FLÖTNER (C. 1495–1546)

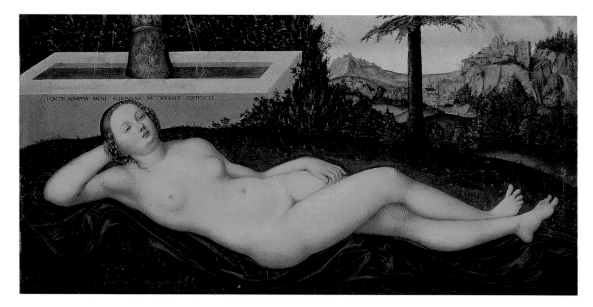

CRANACH

*The Legend of the
Nymph (Detail)*
1518

THE nymph looks at us as though we were disturbing her sleep, but still we feel that she is flirting with us—despite the inscription on the fountain warning us not to break the peace. Cranach was famous for his erotic nudes, his studio turning out multiple copies of his most popular paintings.

LUCAS CRANACH THE ELDER (1472–1553)

HESS

*The Open
Window (Detail)*
1996

THE woman manages to flirt boldly with the viewer, and at the same time to direct a much more covert piece of coquetry toward the secret admirers outside the window. A carefully posed glimpse of naked flesh is enough for them, but we require more sophisticated treatment.

F. Scott Hess (b. 1955)

PALANKER
Park Piece
1990

A PICTURE of a couple in a park at night. The strange setting suggests a clandestine meeting, with all the variety of emotions that entails. This is actually a pastel drawing, but it recalls the sort of image that is often produced by photography, and we interpret this picture as capturing an instant of movement.

ROBIN PALANKER (b. 1950)

66

She said, 'I bet
you'd have a bloody fit
if I said that I'm very
good in bed
and really fancy
doing it with you!'

99

Robin Skelton (1925–1998)
Her Leather Coat

RENOIR
Dance in the Country
(Detail) 1883

Y 1883 Renoir had
made a conscious
move away from the light, delicate
style of Impressionism, feeling that
he had exhausted its possibilities.
In this picture the new, bolder,
more definite style
is evident, particularly in the
solidity of the man's suit.

PIERRE-AUGUSTE RENOIR
(1841–1919)

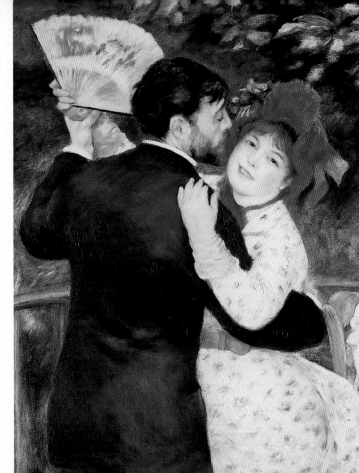

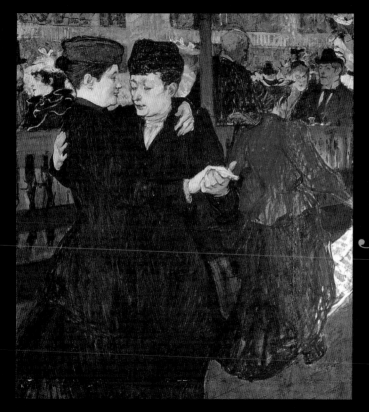

TOULOUSE-LAUTREC
The Two Waltzers (Detail)
1892

*T*HE influence of the flat patterning of Japanese woodblock prints is evident in the homogeneous areas of clothing in the two central figures; the effect is accentuated by the bright scarlet jacket of the woman on the right. The sensual atmosphere of the Moulin Rouge is conveyed by the picture's dense population of courting couples.

HENRI DE TOULOUSE-LAUTREC
(1864–1901)

GREEK

Dionysus

560–40 BC

*T*HIS is a detail from the interior of a bowl, found in Capua, Italy. Dionysus was the god of wine, and it is common to find Dionysiac images on Greek drinking vessels. In fact the libidinous antics of the followers of the cult of Dionysus provided a rich source of subject matter for erotic pottery and painting.

OD

Hybrid One

1996

*T*HIS bronze sculpture is a contemporary example of an erotic fantasy that has been explored since ancient times. The creature is half man and half beast: he combines an ideal of male physical beauty with the rapacious power and supposed sexual appetite of a wolf.

KIRA OD (b. 1960)

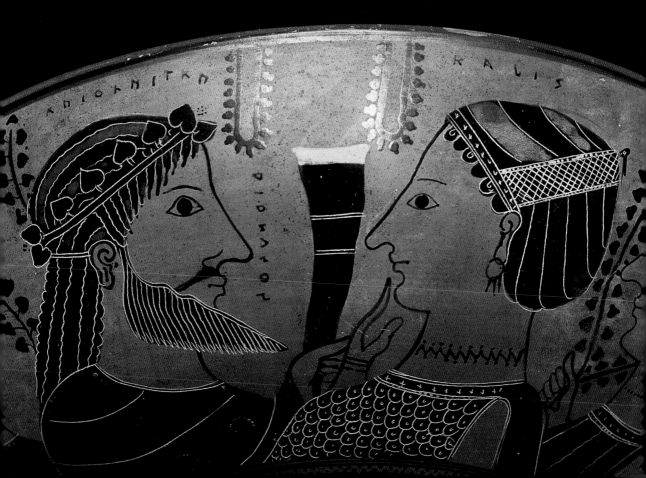

CAIN

Flirtation (Detail)
19th/20th Century

THE man flirts persistently with the woman, apparently unaware of her unpromising response. Hand on hip, he points with his knee and leans into her personal space. Her expression is bleak, and she leans away. This painting could be used as an illustration in a textbook on body language.

GEORGES JULES AUGUSTE CAIN (1856–1919)

Merely innocent flirtation,
Not quite adultery, but
adulteration.

George Gordon, Lord Byron
(1788–1824) *Don Juan*

ANDREOTTI

The Declaration
19th/20th Century

ANDREOTTI uses this interior scene to display his virtuosity. His treatment of the effects of light on the various textures and surfaces is much more important to him than social comment or the exploration of emotions.

FEDERIGO ANDREOTTI
(1847–1930)

AMERICAN
Gigolo and Vamps
20th Century

*I*N the 1920s the term "vamp" (an abbreviation of "vampire") was used to describe a woman who flirted in an excessive manner, unscrupulously using her sexual allure to gain her own ends. A gigolo is in some respects the male counterpart of a vamp, and the man pictured here is typical of the popular notion of a gigolo of the time: smooth, sleek, monocled, and displaying a wolfish grin.

AMERICAN
Rita Hayworth
20th Century

*A*TYPICALLY flirtatious film-still pose. Rita Hayworth (1918–87) was a "moviestar;" a Hollywood "Goddess." She was one of a number of women that the actor David Niven described as setting an unassailable standard of beauty and fun.

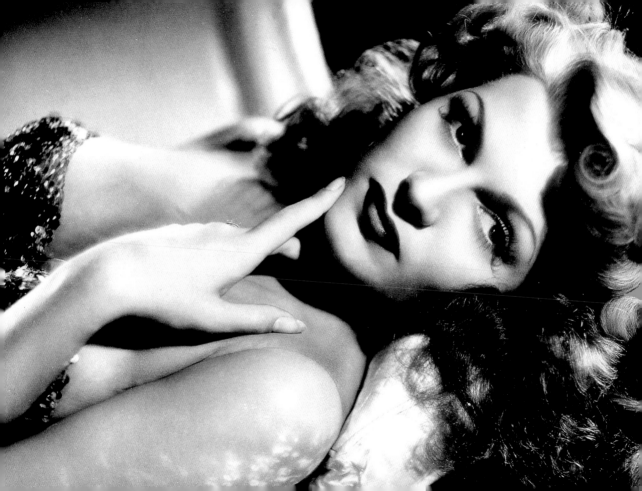

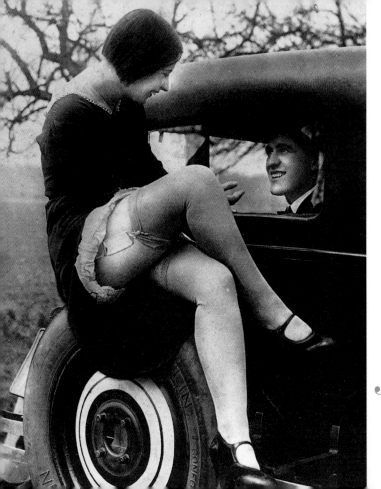

GERMAN

Prostitution (Detail)

1925

*A*N unambiguous offer to the man in the car. This photograph seems to anticipate the marketing techniques of the 1960s, where women were draped over cars in sexually alluring poses.

CAMPOS
My Wife and Me (Detail)
1996

THE woman displays herself, but the crocodile lurking in the background is her husband. This is an image that depends for its impact on Campos' ability to use acrylics to produce the sort of "realistic" effect normally associated with large-format photography.

PABLO CAMPOS (b. 1947)

CAMPOS
Leaping Kiss (Detail)
1996

*T*HE piercing desire
aroused by that
fleeting moment of
titillation may stir their
souls, but the absorbing joy
experienced by these lovers
will end all too soon; they
will come down to earth.

PABLO CAMPOS (b. 1947)

DE SILOS
Love Scene (Detail)
14th Century

N early piece of pre-Renaissance paneling from Penafiel Castle, Valladolid, in northern Spain. Despite the simplicity, the general tenor is made obvious by several clues, such as the man's sexually aggressive stance, the mooning eyes, and the phallic object in the woman's hand echoed by the surrounding plants.

CLAUSTRO DE SILOS
(14TH CENTURY)

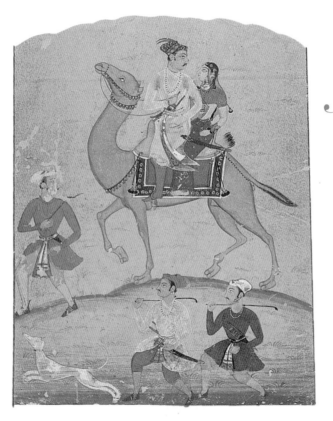

RAJPUT SCHOOL
Raga Maru (Detail)
1628

S the rider's inattention to where he is going testifies, flirting on the back of a camel is difficult—but not impossible.

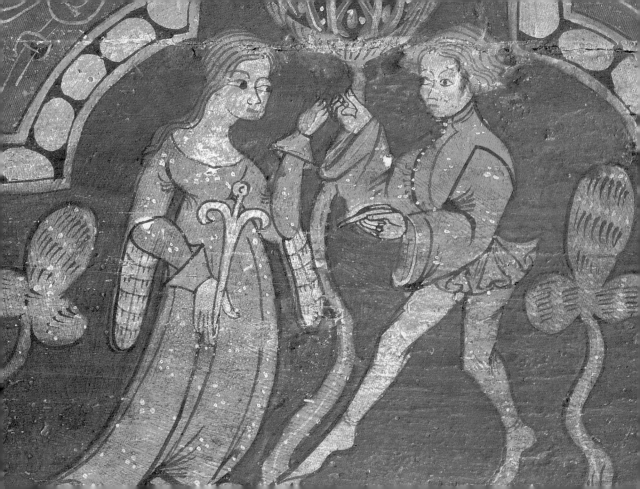

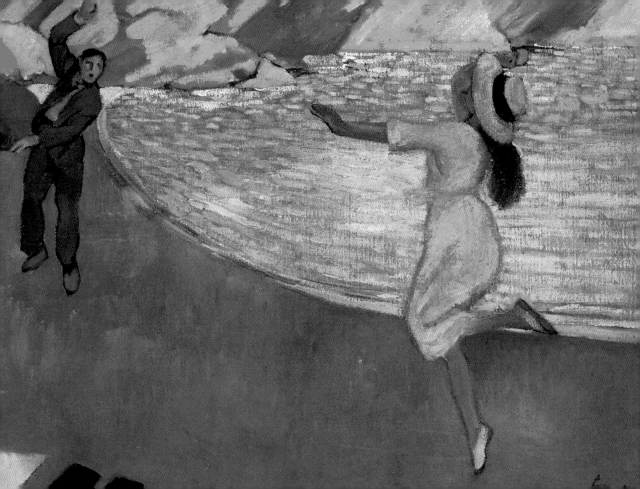

HERMANN-PAUL
The Lovers
c. 1900

THE movies have made the image of
two lovers rushing to meet each other
across a beach familiar to the point of
becoming a cliché. This example predates
any cinematic tradition and must once have
had a freshness long since taken from it.

HERMANN-PAUL (HERMANN RENÉ GEORGES
PAUL) (1864–1940)

GERMAN
The Courtship of Shepherds
18th Century

THE romantic suggestion of innocent
pastoral happiness, complemented
by the naive style of this image, is
probably even more appealing now than
it was in the eighteenth century—and
even more unlikely.

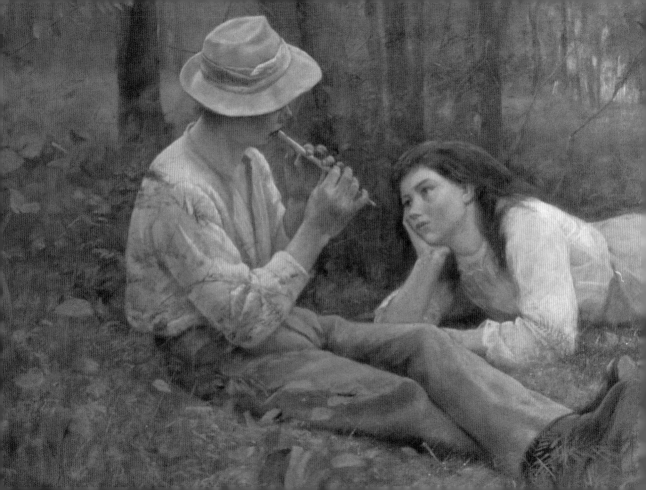

66

'Come, little cottage girl, you seem
To want my cup of tea;
And will you take a little cream?
Now tell the truth to me.'
She had a rustic woodland grin
Her cheek was soft as silk,
And she replied, 'Sir, please put in
A little drop of milk.'

99

Barry Pain (1864–1928)
The Poets at Tea

McCUBBIN
The Flute Player (Detail)
19th/20th Century

A CLASSIC scene. In a
seductively intimate location, the
flute player captivates the girl by employing the
flirting technique of charming through music.
FREDERICK MCCUBBIN (1855–1917)

PERSIAN
Two Lovers (Detail)
c. 1590

THE style of this picture accords with contemporary Persian literature, which is rich in stories that explore the caprices and wantonness of human behavior in a sympathetic and often humorous way. In these stories strict fathers are outwitted, wayward wives escape detection by subterfuge, and parted lovers achieve their ends in the most unlikely circumstances.

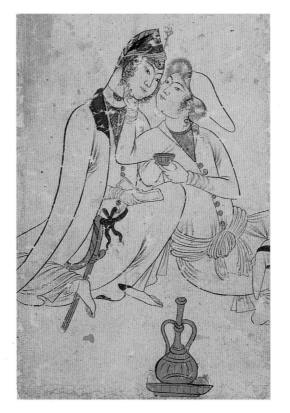

QASIM
Portrait of Shah Abbas I with one of his Attendants (Detail)
1627

FLIRTING with Shah Abbas the Great (ruled 1587–1629) must have been an unnerving undertaking. He was an absolute ruler, an astute trader, and a formidable soldier who re-established the Persian empire by his conquests over the Uzbeks, the Turks, and the Great Mogul.

MUHAMMAD QASIM
(17th CENTURY)

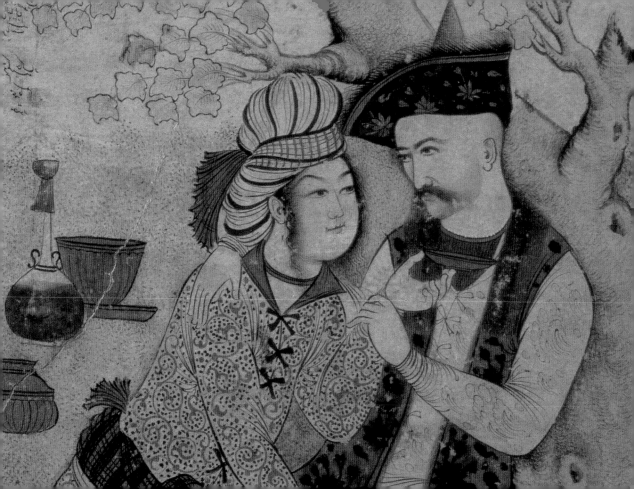

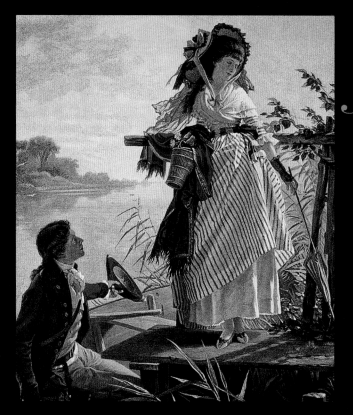

VON RAMBERG

Invitation to a Boat-Ride (Detail)

1866

*T*HE critical moment is depicted here; so often, apparently innocent social transactions can mask a sexual subtext. The invitation is to much more than just a boat-ride.

ARTHUR VON RAMBERG (1819–75)

STONE

Mated (Detail)

19th Century

*T*HE title of the picture seems to suggest a note of triumph. Perhaps there are unseen observers—the parents, who, as so often in the past, are anxious to secure a match that will be socially beneficial to both families.

FRANK STONE (1800–59)

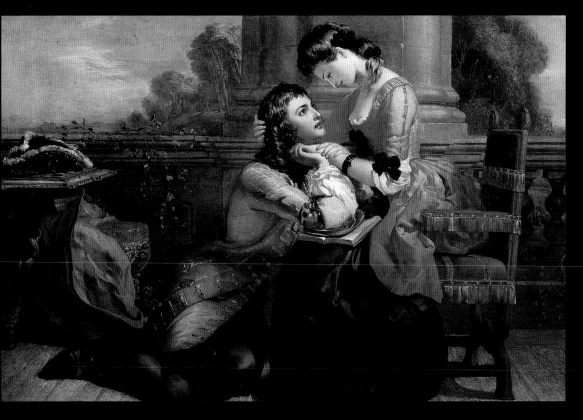

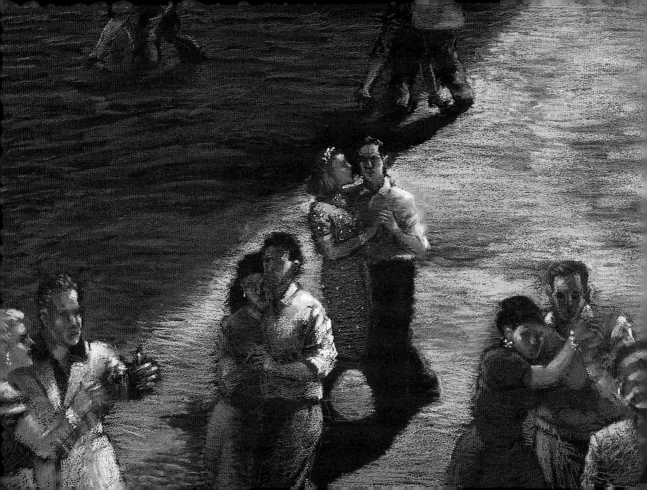

LOPEZ

Tango in the Key of Yellow

1997

*T*HE tango supplies many possibilities for sexual maneuvering; and not only with one's dancing partner. Here, the lighting and the viewpoint give the onlooker the privilege to observe the scene in a voyeuristic way. It is executed in pastel, which is an ideal medium for the unusual, and intense, use of color.

RICHARD LOPEZ (b. 1943)

LOPEZ

Ojo-a-Ojo

1997

*A*S in the previous picture, Lopez explores the erotic aspects of dance. Here, however, the medium is charcoal, and it is used in a much freer and yet more economical way to suggest the rhythmic movements of the participants.

RICHARD LOPEZ (b. 1943)

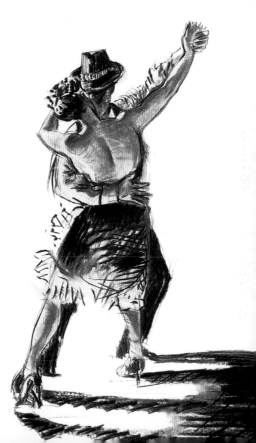

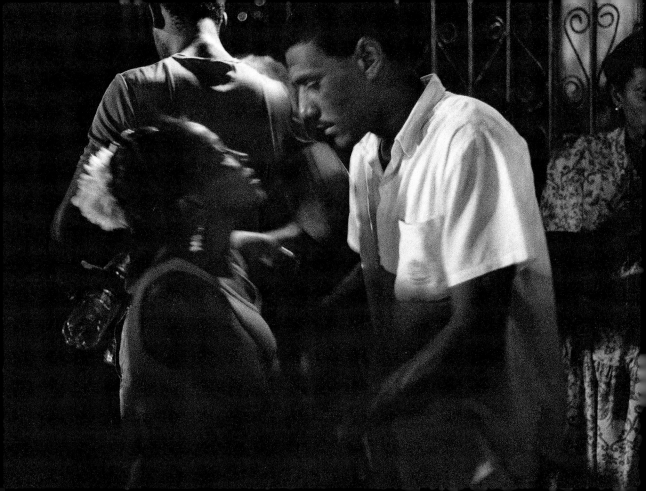

HE low light level and the slight blurring caused by movement help to give this shot a strong impression of spontaneity. There is an unspoken communication between the couple; they are alone in a crowd. The plastic drink bottle seems somewhat incongruous, and yet it provides a kind of confirmation that the scene is not posed.

OF LOVE AND
OTHER DEMONS

She saw him for the first time inside a bullfighting corral erected at a fair, wrangling a fierce bull with his bare hands, almost naked, and unprotected. Days later she saw him again, dancing the cumbé at a carnival that she attended wearing a mask. Judas was in the center of a circle of onlookers, dancing with any woman who would pay him . . . Bernarda asked him how much he cost. Judas replied as he danced: "Half a real." Bernarda took off her mask. "What I'm asking is how much you cost for the rest of your life."

Gabriel García Márquez (b. 1928)

ALMA-TADEMA
Pleading (Detail)
19th Century

THE strong horizontal lines formed by the marble slabs, the man's prone body, and the sea concentrate attention toward the left of the picture, where the woman's clearly defensive posture forms a vertical barrier, buttressed by her outstretched arm. The result is an excellent evocation of the conflict and tension of an embarrassing situation.

SIR LAWRENCE ALMA-TADEMA
(1836–1912)

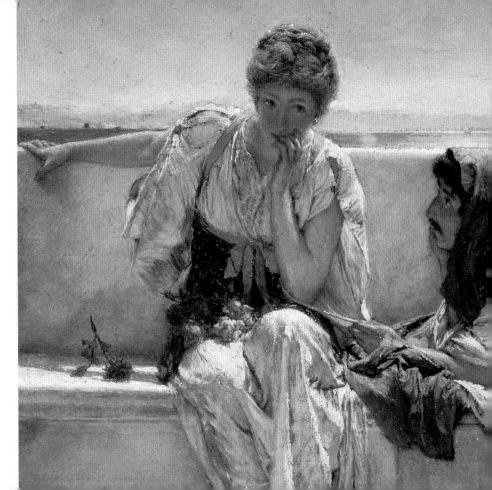

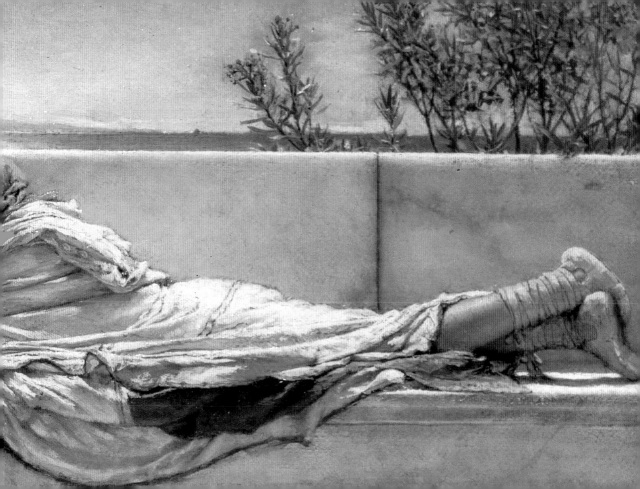

IT STARTED
WITH A KISS

"Lord, I wonder what fool it was
that first invented kissing!"

JONATHAN SWIFT (1667–1745) *POLITE CONVERSATION*

AMERICAN
Kiss (Detail)
20th Century

kissing

HAYEZ
The Kiss (Detail)
19th Century

"KISSING!" SAID THE LADY, with great discomposure of countenance, and more redness in her cheeks than anger in her eyes; "Do you call that no crime? Kissing, Joseph, is as a prologue to a play. Can I believe a young fellow of your age and complexion will be content with kissing?" This is how Henry Fielding's (1707–54) Lady Booby warns the eponymous hero, Joseph Andrews, that he is playing a dangerous game. A kiss is just the start.

And yet a kiss can also be innocent, even chaste. Quite apart from kisses used as a salutation or a sign of respect, and having absolutely no erotic connotation to them at all, there is still a huge variety of modes of osculation. A kiss remains a symbol of both romantic love and unfettered lust.

In young love, that first kiss will have an impact that will, alas, never quite be experienced again. It may be a clumsy, nose-bumping business, but the feel and taste and smell of it may well be remembered forever—remembered with regret when familiarity has dulled those fresh sensations. Or it may be remembered with longing when age permits conventional intimacies—old men carelessly kissed by girls who erroneously think them rendered safe by age.

 A demure peck on the cheek is sometimes all that is permissible in public, but that fleeting brush of lips can still raise the blood pressure and provoke distracted thoughts of other things. A secret kiss in private, though, is much more rewarding physically, and it can be

PALANKER
Predator I
1994

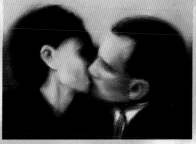

SAMUEL
Untitled (Detail)
20th Century

desire

performed at short notice and while fully clothed—and how much more thrilling it will be if it is an illicit kiss, perhaps even a kiss in the dark.

Then there is the stolen kiss: an impudent advance or a sudden revelation. It is approached with a delicious trepidation and the uncertainty of its outcome gives it piquancy.

Best of all there is serious kissing, open-mouthed and employing the tongue. This can be so arousing and cause such a concentration of feeling that in many ways it may be a more intimate act than that of sexual intercourse itself. This is a kiss that Lady Booby knows too well; so very different from that thoughtless caress bestowed as a duty when desire has ebbed, the Judas-kiss of betrayal.

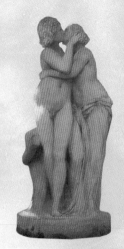

A farewell kiss is a moment of sweet sadness for lovers. It expresses both regret and hope, as Emily Dickinson (1830–86) said, "Parting is all we know of heaven, and all we need of hell." The parting kiss is certainly erotic, but love and affection predominate.

Because a kiss can be so varied and so versatile, it has always been a useful device in art. It can portray all sorts of nuances of a relationship between the participants: filial affection, light-hearted teasing, betrayal, seduction, or transports of lust. There are even examples of where it has been used as a metaphor for copulation. The work of painters, illustrators, sculptors, and photographers over the years would certainly have been much more difficult if there were no such gesture as the kiss.

SIEMIRADZKI
Following the Example of the Gods (Detail)
19th Century

. . . *xxx*

SLONEM
Kiss (Detail)
1996

*T*HIS is a Hollywood screen kiss, based on images of Rudolph Valentino (1895–1926). (Note the immaculate suit and oiled hair.) Valentino died suddenly at the height of his fame, and was mourned extravagantly by his adoring fans.

HUNT SLONEM (b. 1951)

"

O Love, O fire!
once he drew
With one long kiss my
whole soul thro'
My lips, as sunlight
drinketh dew.

"

Alfred, Lord Tennyson (1809–92) *Fatima*

BALDRY
The Kiss
19th Century

CHIAROSCURO is the use of contrasting areas of light and shade. This composition relies on chiaroscuro for much of its impact. The pale softness of the woman contrasts with the darker masculine forces.

G. BALDRY (19TH CENTURY)

115

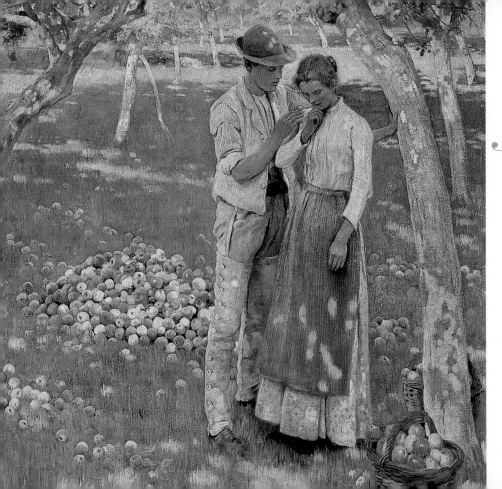

ERICHSEN
The Orchard (Detail)
19th Century

THE orchard setting recalls the Garden of Eden, suggesting that the impending kiss will involve a loss of innocence. The man's advances are at last coming to fruition, and trouble lies ahead. This painting can be particularly admired for the depiction of sunlight penetrating the tree canopy.

NELLY ERICHSEN
(ACTIVE 1882–97)

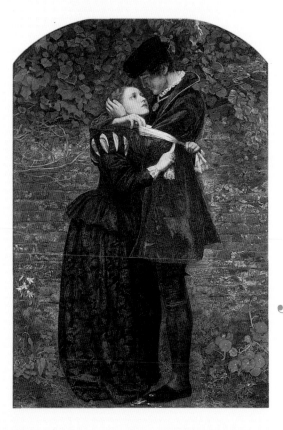

And our spirits rush'd together at
the touching of the lips

Alfred, Lord Tennyson (1809–92)
Locksley Hall

MILLAIS

The Huguenot

1852

*M*ILLAIS was a leading figure of the Pre-Raphaelite
Brotherhood, a group of artists who wished
to return to what they believed to be the simplicity and
honesty of art before the time of Raphael. John Ruskin
(1819–1900) defended the movement from the violent attacks
of Charles Dickens (1812–1870) and other critics; and Millais
repaid the debt by marrying Ruskin's ex-wife.

SIR JOHN EVERETT MILLAIS (1829–96)

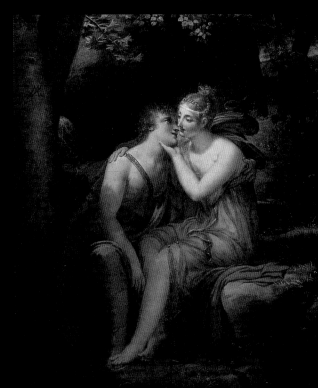

ANSIAUX
Angélique et Médor (Detail)
1828

THIS picture illustrates a scene from the epic poem, *Orlando Furioso* (1516) by Ludovico Ariosto (1474–1533). The poem took ten years to complete.

ANTOINE-JEAN-JOSEPH ANSIAUX (1764–1840)

SIEMIRADZKI
Following the Example of the Gods (Detail)
19th Century

THE tale of Cupid and Psyche in Greek mythology represents a model of constancy. Cupid, sent by jealous Aphrodite to curse Psyche, falls in love with her instead. After a tiff, he flounces off, and Psyche has to suffer great tribulations at the hands of Aphrodite; but she remains firm in her love and eventually the couple are reunited. She is rewarded with immortality.

HENRYK SIEMIRADZKI (1843–1902)

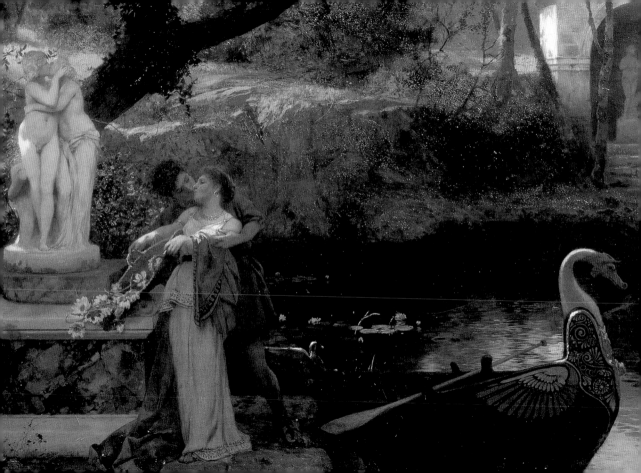

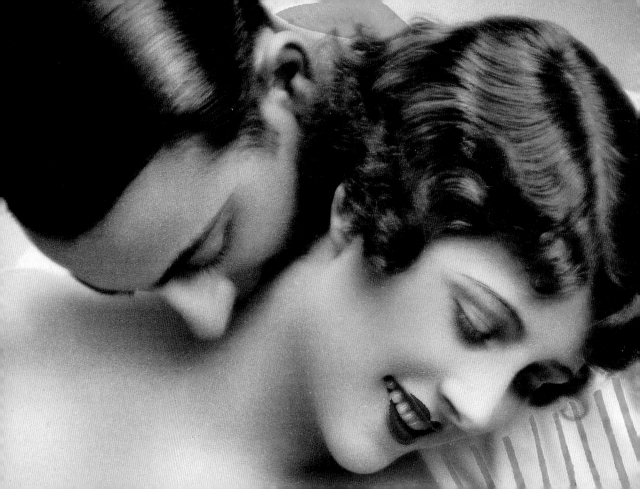

FRENCH
The Kiss (Detail)
c. 1920

AT the beginning of this century, picture postcards were very popular. Brevity was essential, and the picture itself became part of the communication, either explicitly or by implication. The wide range of subjects included some, like this, that were often considered rather immodest.

FRENCH
A Few Kisses (Detail)
c. 1920

AS in this case, some postcards were actual photographic prints, and, at a time before a cheap and accurate process of color photography had been perfected, many of them were hand-tinted with dyes.

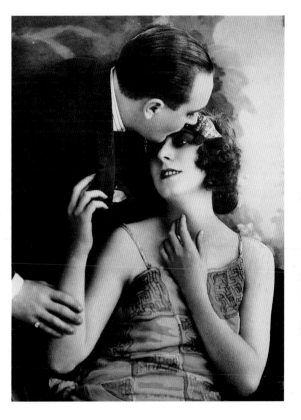

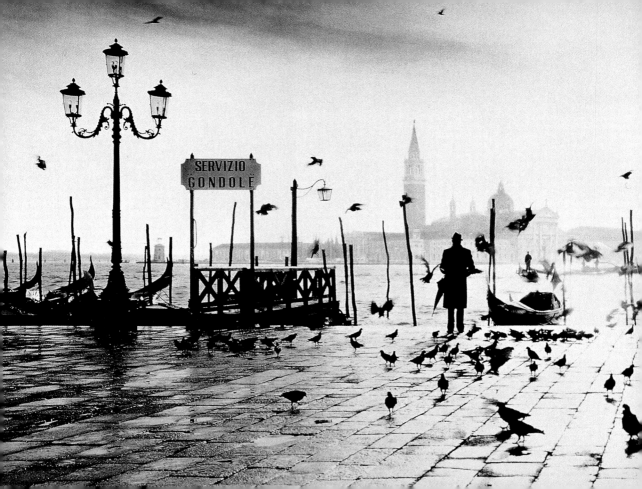

SERVIZIO
GONDOLE

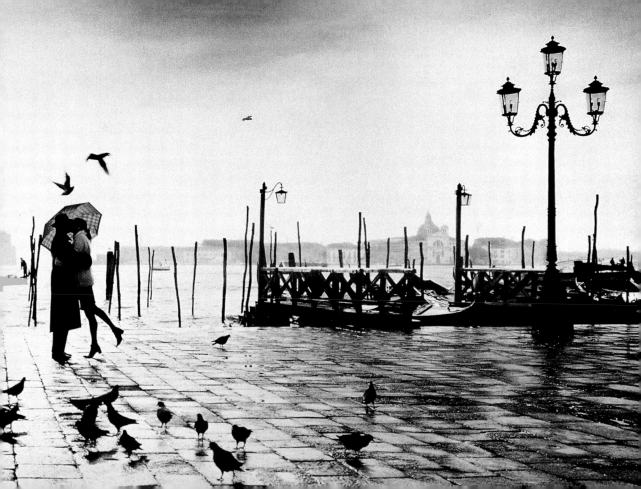

PREVIOUS PAGES

BROWN

*Couple Kissing on
Wet Piazzeta*
20th Century

*T*HE intimacy of
the kiss transforms
the most public place
into a private one. Here
the couple is isolated in
the vast flat square; yet
strangely, private
moments such as these
are integral to the life of
public places—without
the lovers the scene
would be desolate.

JOHN BROWN
(CONTEMPORARY)

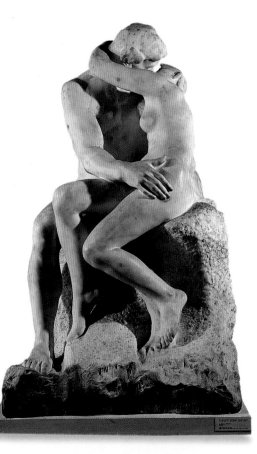

RODIN

The Kiss
1899

*T*HE *Kiss* was originally conceived
as part of Rodin's huge commission
to produce a bronze entrance to the
Musée des Arts Décoratifs. This work,
The Gates of Hell (1880–1917) inspired
by *Inferno* by Dante (1265–1321), was
never finished, but served as the genesis
for the majority of Rodin's naturalistic,
Impressionist sculptures.

AUGUSTE RODIN (1840–1917)

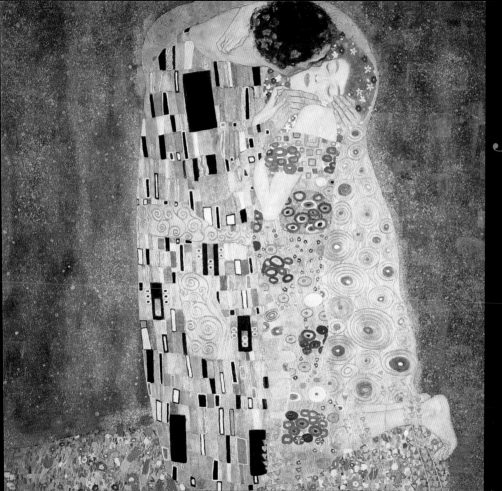

KLIMT
The Kiss (Detail)
1908

LIMT'S most famous picture is a mass of gold and ornamentation. The saccharine image of two lovers clinging to one another on a bed of flowers is offset by the juxtaposition of the cliff-edge, over which they may fall.

GUSTAV KLIMT (1862–1918)

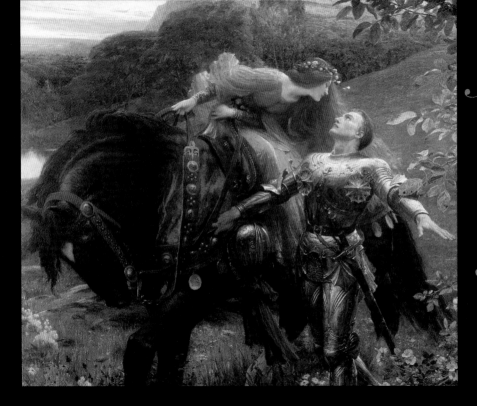

DICKSEE

La Belle Dame Sans Merci
1902

*A*s she leans down to kiss the knight, la belle dame already has him "in thrall."

SIR FRANK DICKSEE (1853–1928)

ZATZKA

The Rose Bower
19th/20th Century

*I*n a luxurious fairy-tale setting, two lovers lie comfortably, he nibbling her cheek. Both he and the figure watching from among the roses seem impossibly young to have an active interest in such matters.

HANS ZATZKA (1859–1945)

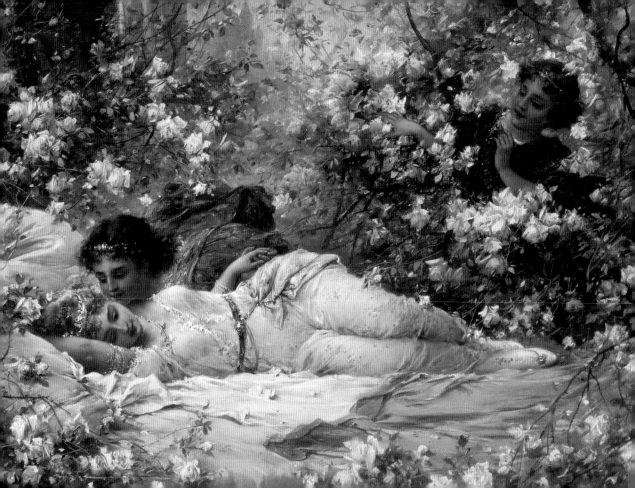

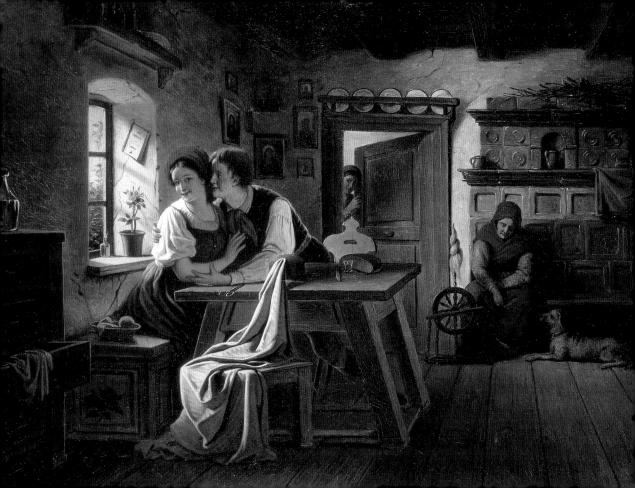

KURTWEIL
Lovers in the Kitchen
19th Century

*A*S the old woman dozes the young man takes his chance to snatch a kiss. But, in a detail reminiscent of earlier Dutch genre paintings, their dalliance is observed. This painting gives us a useful visual record of the interior of a country dwelling of the time.

JOHANN KURTWEIL (ACTIVE MID-19TH CENTURY)

STEINLEN
The Kiss
1895

*T*HE use of charcoal and pastel helps to express the dreariness of the interior. Life appears to be hard and joyless, and the woman seems to respond to the man's embrace with resignation rather than ardor.

THÉOPHILE-ALEXANDRE STEINLEN (1859–1923)

HAYEZ
The Kiss (Detail)
19th Century

EVEN in moments of passion we are subject to the laws of physics. This tender kiss is conducted in a stance that looks distinctly awkward for the woman, but she is happy to suffer for her love.

FRANCESCO HAYEZ
(1791–1882)

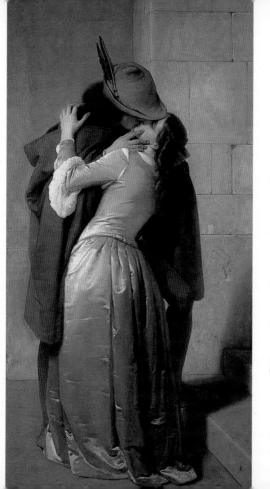

66
A long, long kiss, a kiss of
youth, and love,
And beauty, all concentrating
like rays
Into one focus, kindled
from above;
Such kisses belong to
early days.
99

George Gordon, Lord Byron
(1788–1824) *Don Juan*

FORTESCUE-BRICKDALE
The Pale Complexion of True Love
1899

THE formal composition complements the humor of this delightfully sardonic picture. He sinks to kiss the hem of her gown; she is unmoved by this act of abasement, and even the pigeons turn their backs.

ELEANOR FORTESCUE-BRICKDALE (1871–1945)

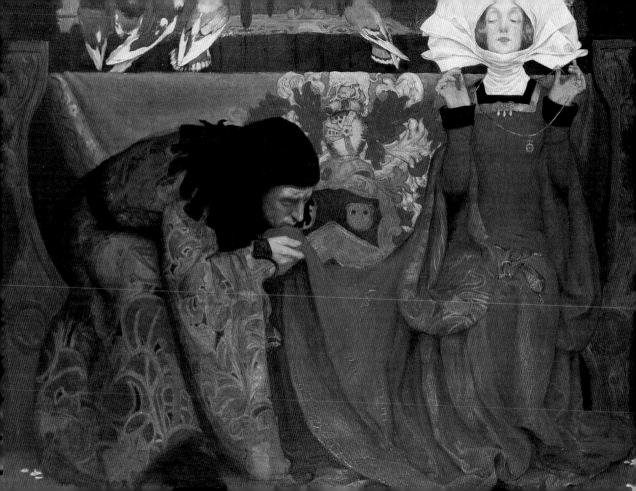

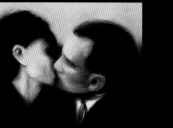
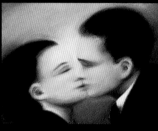
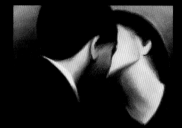

PALANKER
Predator 1–6
1994

PALANKER'S *Predator* series, seen in order, resembles a sequence of stills from a movie. In fact, each image is based on a different screen kiss, so that only the physical act itself, and not the lovers, endures throughout the series.

ROBIN PALANKER (b. 1950)

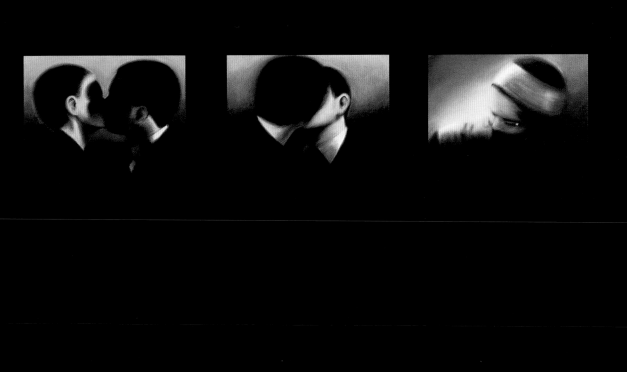

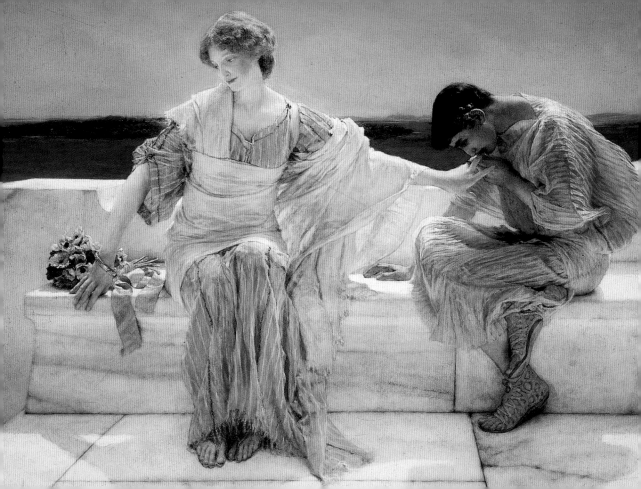

ALMA-TADEMA
Ask Me No More (Detail)
1906

*T*HIS is just the sort of classical
fantasy in an architectural
setting that led *Punch* to describe
Alma-Tadema as a "marbellous
artist." His work was extremely
popular, however, and he was so
successful that he was able to
buy a magnificent house in the
fashionable London area of
St. John's Wood, rebuilding it in
the style of a Roman villa.

SIR LAWRENCE ALMA-TADEMA
(1836–1912)

AS I WALKED
OUT ONE EVENING

I'll love you dear, I'll love you
Till China and Africa meet
And the river jumps over the mountain
And the salmon sing in the street,
I'll love you till the ocean
Is folded and hung up to dry
And the seven stars go squawking
Like geese about the sky

W.H. Auden (1940)

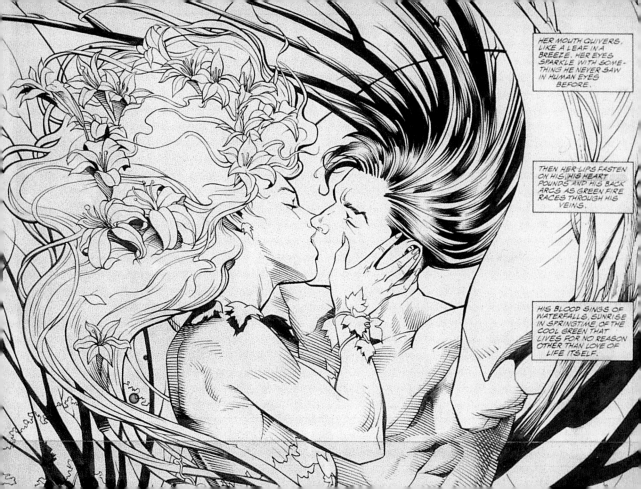

HER MOUTH QUIVERS, LIKE A LEAF IN A BREEZE. HER EYES SPARKLE WITH SOMETHING HE NEVER SAW IN HUMAN EYES BEFORE.

THEN HER LIPS FASTEN ON HIS. HIS HEART POUNDS AND HIS BACK ARCS AS GREEN FIRE RACES THROUGH HIS VEINS.

HIS BLOOD SINGS OF WATERFALLS, SUNRISE IN SPRINGTIME, OF THE COOL GREEN THAT LIVES FOR NO REASON OTHER THAN LOVE OF LIFE ITSELF.

APTHORP

Ivy/Bruce Wayne Kiss (Detail)
1995

*P*OISON Ivy delivers a lethal kiss to Batman's alter ego. Only a second kiss can save him. Apthorp depicts man losing himself in the pleasures of a fantastical *femme fatale*.

BRIAN APTHORP (b. 1955)

TOULOUSE-LAUTREC

Queen of Joy
1892

*I*T was largely through the work of Toulouse-Lautrec that poster design came to be recognized as a serious art form. His simple, elegant designs concentrated on the human form at the expense of detail, and were influenced by the flat patterns of Japanese Ukiyo-e.

HENRI DE TOULOUSE-LAUTREC (1864–1901)

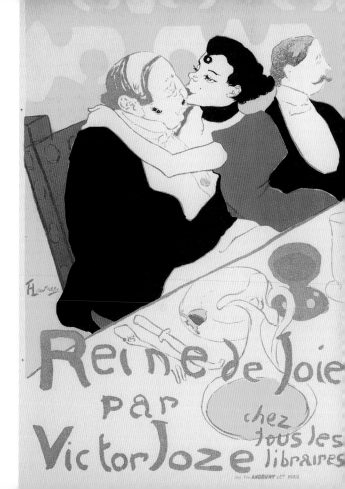

NAVA
Screen Kiss II
1994

ONE of a series of pictures by Nava on the theme of the screen kiss. It moves us from the cinema to the studio. But although we can see the cameras and the careful manipulation of the mood, the actual kiss retains its visual force.

JOHN NAVA (b. 1947)

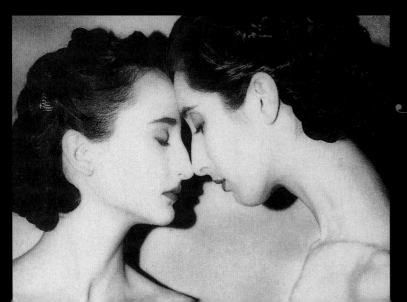

SAMUEL
Untitled (Detail)
20th Century

*T*HE intense lighting creates strong, crisp shadows, and the exposure time for the shot is calculated to heighten the contrast between the skin tone of the figures and the blackness of their hair. The screen in the foreground serves to emphasize, rather than disguise, their nakedness.

DEBORAH SAMUEL (b. 1956)

CHILDERS
The Kiss
20th Century

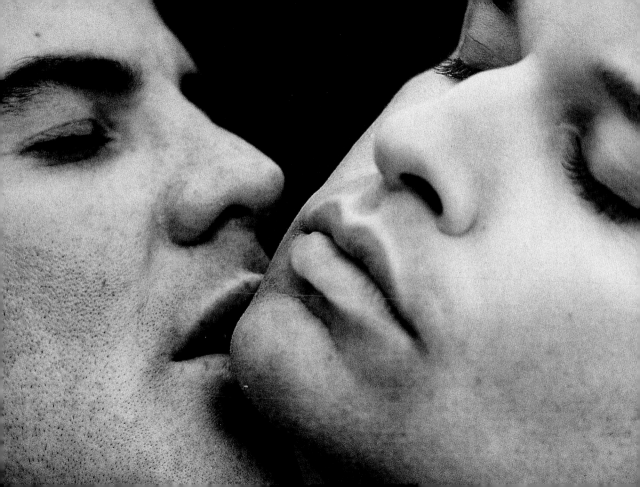

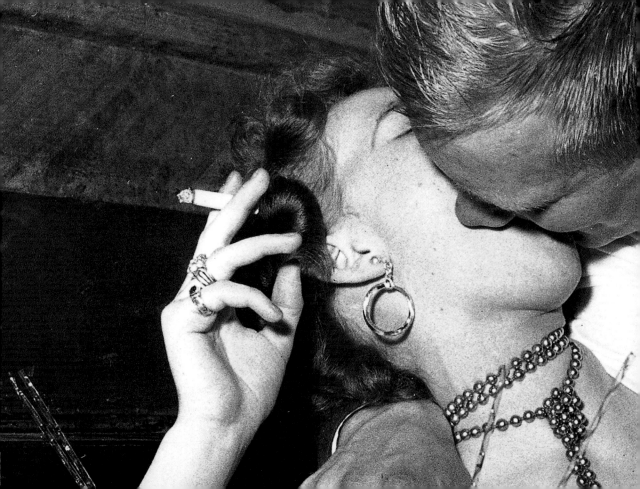

> 66
>
> 'I saw you take his kiss!' 'Tis true.'
> 'O modesty!' 'Twas strictly kept:
> He thought me asleep: at least, I knew
> He thought I thought he thought I slept.'
>
> 99

Coventry Patmore (1823–96)
The Angel in the House

FIRTH
Courting Couple
1956

To sober eyes a drunken kiss seems clumsy and unsubtle, but to those involved it is a whirlwind of passion. The participants do it with unrestrained enthusiasm; yet, with alcohol's peculiar logic, the woman hangs onto her cigarette as though it were a precious item to be preserved from harm.

JOHN FIRTH (CONTEMPORARY)

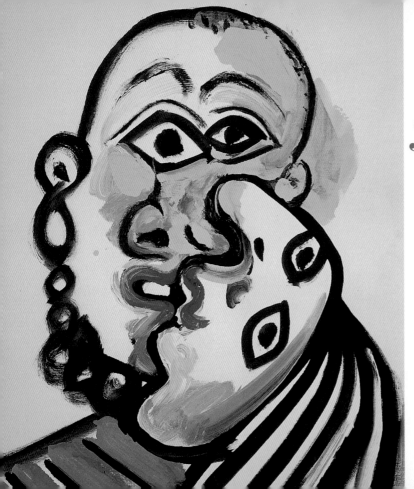

PICASSO

Kiss

1969

*P*ICASSO achieves a striking effect by the sparing use of a limited palette. The muted blue and beige make way for the thick, strong black strokes and the emphatic shock of the red lips, the visual center of the picture.

PABLO PICASSO (1881–1973)

LINGNER
Amorous Workers
1929

*A*N image
of solid
respectability: two
reliable, straightforward
people sit, united and
protective of each
other. He gives her an
affectionate but
considered peck on
the cheek; she looks
defiantly toward us.

MAX LINGNER
(1888–1959)

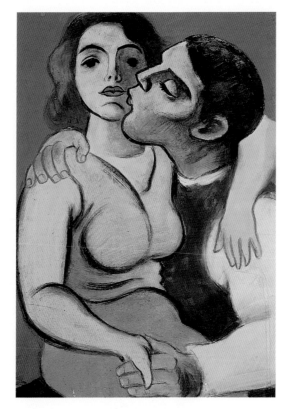

66
I abhor the slimy kiss,
(Which to me most loathsome is).
Those lips please me which
are placed
Close, but not too strictly laced:
Yielding I would have them; yet
Not a wimbling tongue admit:
What would poking-sticks
make there,
When the ruff is set elsewhere?
99

Robert Herrick (1591–1674)
Kisses Loathsome

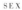

> Kiss me, Kate.

William Shakespeare
(1564–1616)

WATERHOUSE
*La Belle Dame
Sans Merci (Detail)*
1893

HE poem of the same
name by John Keats
(1795–1821) again provides the
subject matter. La belle dame
has taken the knight to "her elfin
grot," and he is about to bestow
"kisses four." This time the
enchantress is much more
sensual and the handling of the
paint more sensuous.

JOHN WILLIAM WATERHOUSE
(1849–1917)

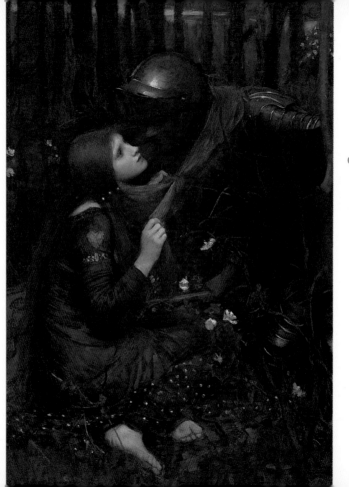

DYCE
*Francesca da
Rimini*
exhibited 1837

FRANCESCA
da Rimini was put
to death with her
lover, Paolo, in
Ravenna in 1289.
He was the younger
brother of her
unattractive husband.
Here, Dyce shows the
lovers just before
discovery—the hand
of the spy creeps
over the wall.

WILLIAM DYCE
(1806–64)

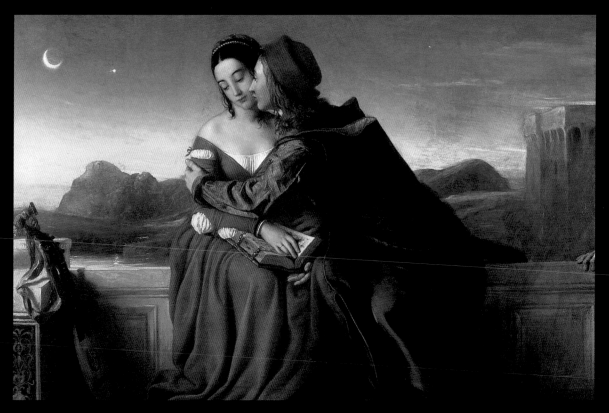

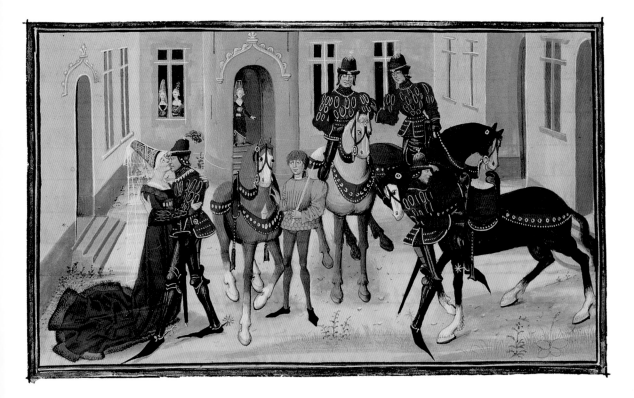

FRENCH

Illuminated manuscript
15th Century

A S the men prepare to ride out, leaving the women behind, one couple enjoys a last-minute farewell kiss. The men's military uniforms are no less gorgeous than the women's dresses.

FRENCH

A Heart of Love (Detail)
14th Century

O NE of the most famous examples of the tragic love affair, the tale of Lancelot and Guinevere, was introduced into Arthurian romance by the French poet, Chrétien de Troyes (fl. 1170–90). Here, we see the first kiss between the queen and the errant knight.

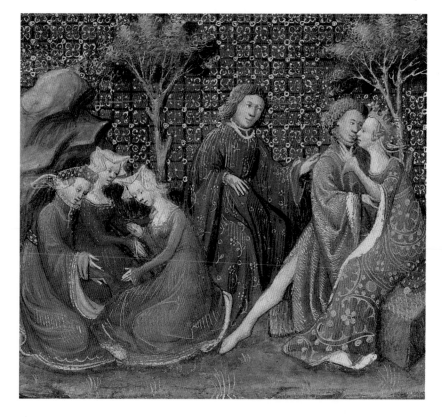

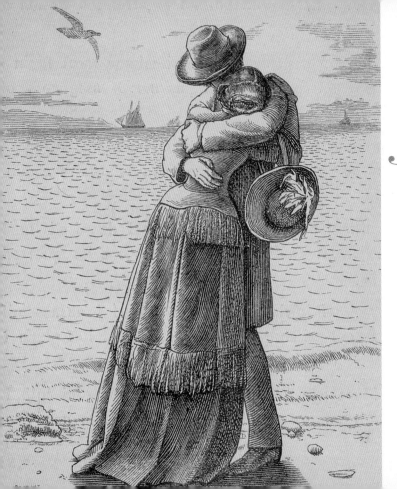

AFTER

MILLAIS

Locksley Hall

1857

*T*HIS is a wood engraving, used as an illustration for the famous edition of the poems by Alfred, Lord Tennyson (1809–92) published by Edward Moxon in 1857. William Holman Hunt (1827–1910) and Dante Gabriel Rossetti (1828–82) also contributed to this book, which had a strong influence on the development of English literature.

ENGRAVED BY JOHN THOMPSON
AFTER SIR JOHN EVERETT MILLAIS (1829–96)

FRENCH
Prelude (Detail)
19th Century

*T*HE charming woodland
setting and the formality
of the clothes contrast provocatively
with the urgent clutching hand and the
importunate knee; and the woman
responds on tiptoe. A reminder that
the gentry were just as much prey to
forbidden libidinous urges as were
the rude peasantry.

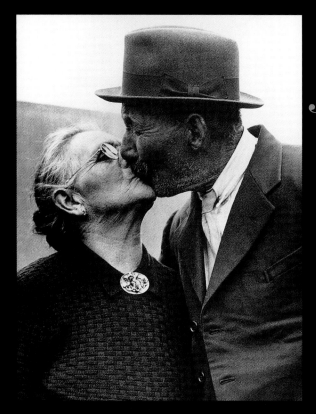

JOHNSON
Golden Wedding
1939

THE title crystallizes the romance of an otherwise straightforward image. Instances of enduring love—rare as they may be—are welcome to us because they confirm the possibility of realizing an ideal.

J. R. V. JOHNSON OF OXFORD (20TH CENTURY)

ARON
Elderly Couple (Detail)
20th Century

A TENDER, passionate kiss, delivered in public as a signal to the world at large, and the staking of a sexual claim. The woman is as pleased as any to receive affection from the man she loves.

BILL ARON (CONTEMPORARY)

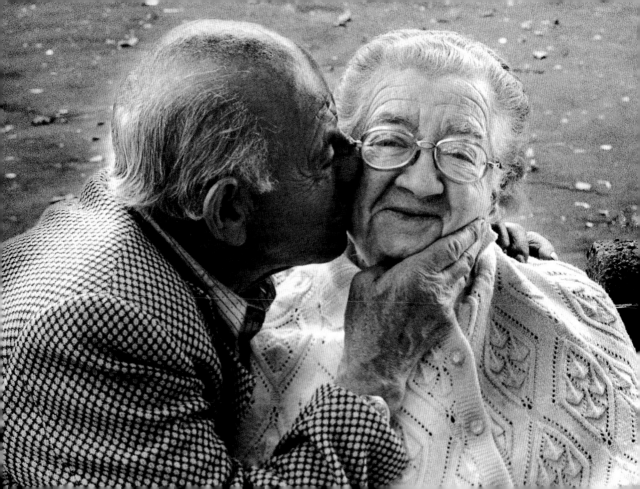

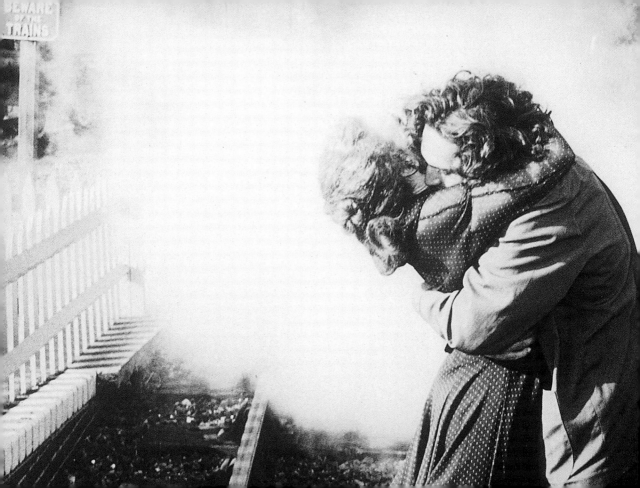

CHAPTER FOUR

A PASSIONATE EMBRACE

"With arms, legs, lips close
clinging to embrace,
She clips me to her breast,
and sucks me to her face."

JOHN WILMOT, EARL OF ROCHESTER (1647–80)
THE IMPERFECT ENJOYMENT

HOGG
Untitled
20th Century

lust

PICASSO
Couple
1969

AN EMBRACE IS OFTEN a demonstration of affection or, increasingly often nowadays, a polite salute between casual friends on meeting or parting. Even the English will now engage in this sort of social grappling without undue embarrassment. In his book *Manwatching* (published in 1979), Desmond Morris notes that these kinds of hugs usually involve arms around shoulders and around the back of the other person. When the hands slip down to the buttocks, this is a sign of passion. Passionate embraces will often be quite long-lasting and the participants will press their bodies close together from thigh to chest.

Such embraces are not permitted in public in more modest societies, and certainly not in prudish ones, where the penalties may

be very severe. Even where public displays of passion are not actually proscribed they are very often considered to be licentious, or at least indelicate and disturbing to the sensitivities of unwilling witnesses. Photographers and illustrators have sometimes exploited this and provided an extra frisson by depicting lustful embraces in a public setting.

Out of the public eye, of course, the passionate embrace gets closer and closer to foreplay and to the actual act of intercourse. It may not always, however, be simply part of that inevitable progression: sometimes it is seen as an end in itself. A rather unsatisfactory end, one may suppose, but nevertheless an exciting and rewarding activity in its own right. In the 1950s the problem pages of popular

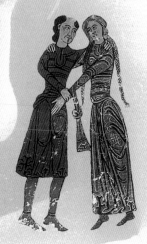

SPANISH
Bible illustration (Detail)
1162

intense

newspapers were full of advice (usually to adolescent girls) on "How Far to Go." This was concerned with the phenomenon of "petting" among teenagers.

The term "teenagers" itself had been adopted to describe a generation of young North American and British people who had, for the first time, leisure, money, and freedom enough to indulge themselves in a way that infuriated many of their elders. Naturally, one of the things they wanted to do with their freedom was enjoy sex. "Petting" was sexual activity beyond kissing, but short of actual penetration. The more intense embraces were termed "heavy petting," and teenagers were warned that this could quickly arouse men to the point where they lost control. The assumption was still that the male

ROUILLARD
Untitled
1994

was the proactive sexual participant, and that the female was making "concessions" to an importunate intruder.

Physical lovemaking, short of actual copulation, has provided an excellent source of subject matter in both literature and the visual arts. "Bodice Rippers" are a form of romantic novel that exploit the universal interest in sex, but do not embarrass the target readership. The ultimate act is simply hinted at by reference to passionate embraces, often described in some detail but with perfect propriety.

The visual equivalent of the bodice-ripper tactic has always been common. Passionate embraces are, not surprisingly, very much more common in Western art than are frank depictions of coitus.

CHAGALL
Couple on the Shore
1955

romantic

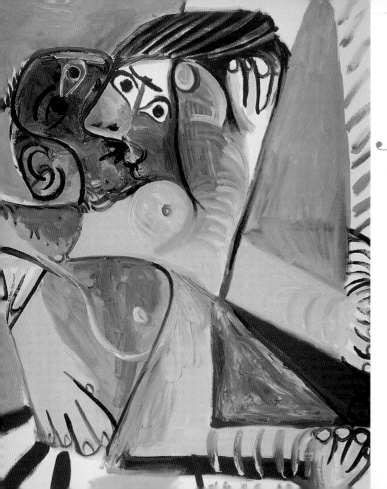

PICASSO
Couple
1969

*T*HIS painting fits the popular conception of "a Picasso:" the flattened perspective of the faces, the curious jumble of assorted body parts, and the apparently childish style. And yet the artist is able to convey strong sexual feelings without the need for anything approaching photographic realism.

PABLO PICASSO (1881–1973)

CHAGALL
Moonlight (Detail)
1926

*T*HIS picture is perhaps less fantastical than Chagall's other works. Indeed the subject—lovers embracing at the gate at the end of the night—seems relatively conventional. But the details, like the ladder and the couple lying on a distant roof, create a dreamlike quality.

MARC CHAGALL (1887–1985)

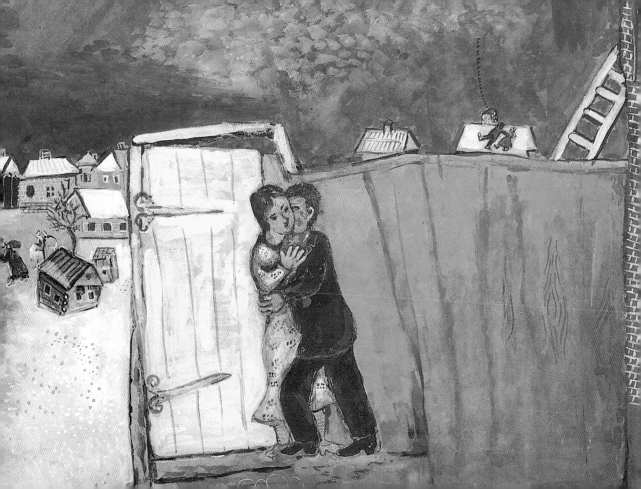

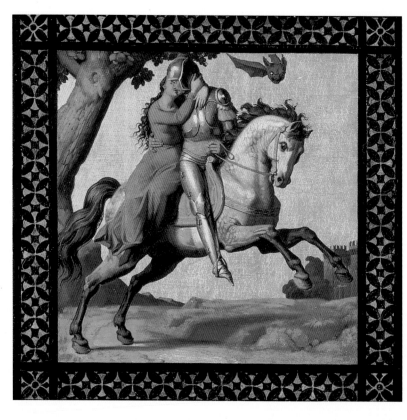

ORSEL
Good and Evil: Libido (Detail)
1832

A PAINTING, showing the sin of lust. Its title is interesting in that it predates the introduction of the word "libido" into English. Sigmund Freud (1856–1939) used it in about 1913 as a technical term in psychology.

ANDRÉ JACQUES-VICTOR ORSEL (1795–1850)

FRAGONARD
The Bolt
c. 1777

T HE conspicuously symbolic bolt, is pushed over to the right in this image; but the waiting bed occupies most of the canvas and will clearly be the scene of the real "action" forthwith.

JEAN-HONORÉ FRAGONARD (1732–1806)

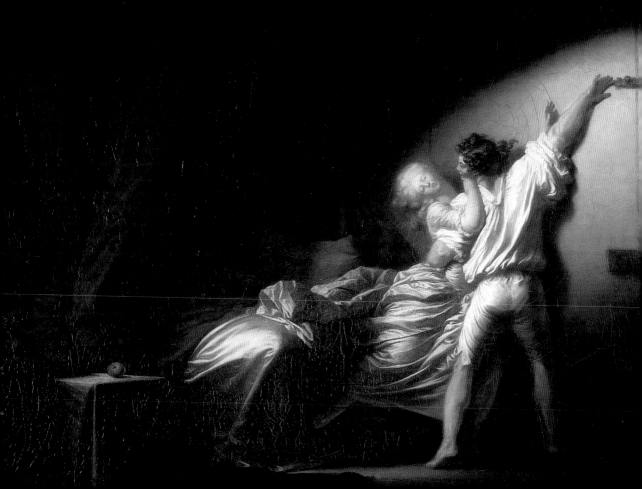

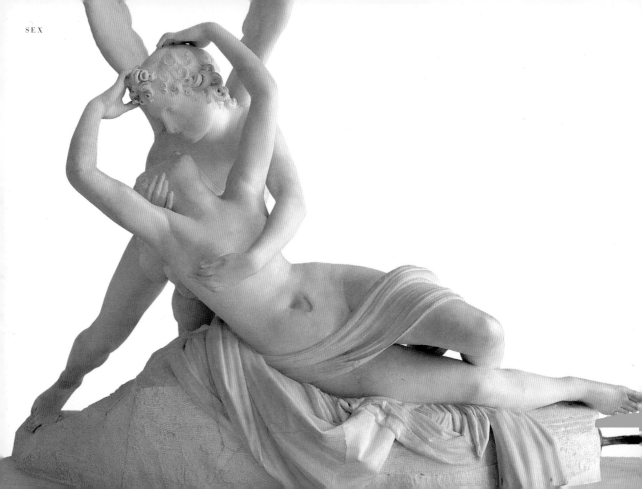

CANOVA

Cupid and Psyche

1787–93

*C*ANOVA was one of the leading members of the Neoclassical movement. He was extremely successful in his own time but, unlike many popular artists, he always insisted on the importance of handling the materials himself. This work shows his great technical virtuosity.

ANTONIO CANOVA
(1757–1822)

ON THE HAPPY
CORYDON AND PHYLLIS

The nymph seemed almost dying,
dissolved in amorous heat;
She kissed and told him sighing,
My dear your love is great:
And something else, but what
I dare not name.

Sir Charles Sedley (1639–1701)

PALANKER

What You Will #1
1994

A MAN and woman kiss on a rotating platform. Palanker used only couples who were in the first ardent throes of love as models; couples who were more used to each other could not produce the required degree of lasciviousness.

ROBIN PALANKER (b. 1950)

AMERICAN

Valentino and Ayres
1921

*R*UDOLPH Valentino and Agnes Ayres in *The Sheik*. Ayres, an aristocratic Englishwoman, soon succumbs to Valentino's exotic charms. *The Sheik* was made in the same year as *The Four Horsemen of the Apocalypse*, the film that established Valentino as a star.

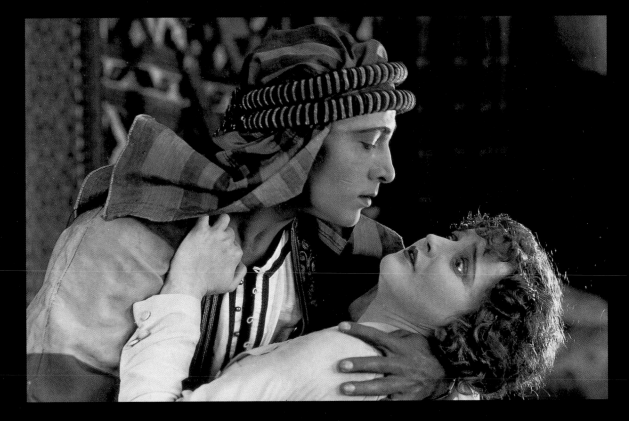

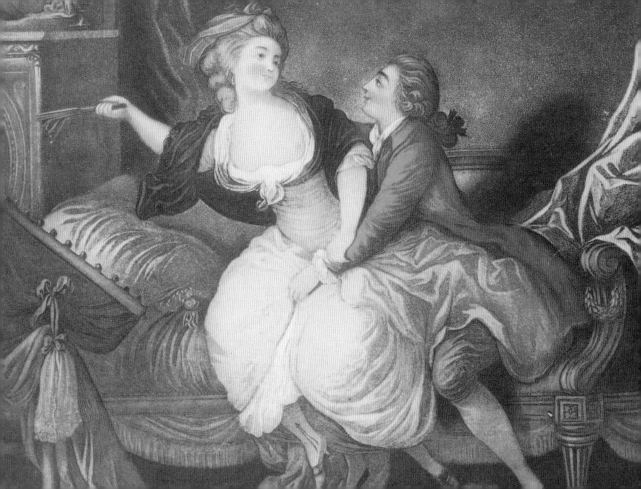

AFTER

HUET
The Broken Fan (Detail)
c. 1780

THE lady has just hit the gentleman with her fan. And, although she clutches at his wayward hand, he is by no means discouraged. This is a copper engraving by Louis Bonnet of a piece by Jean-Baptiste Huet.

COPPER ENGRAVING BY LOUIS BONNET (1743–1793),
AFTER JEAN-BAPTISTE HUET (1745–1811)

SPANISH
Two Lovers in a Courtyard (Detail)
19th Century

THIS is a lithograph, a method of printing invented by Alois Senefelder (1771–1834) in 1798. The design is drawn with greasy crayon onto the surface of a stone, water applied, and the stone inked. The ink is only accepted by the greasy areas.

SCHOOL OF FRANCISCO JOSÉ DE GOYA Y LUCIENTES
(1746–1828)

GÉRICAULT
Couple Embracing by a Reclining Woman
19th Century

THE dark-haired woman watches as the couple maneuver into an intimate embrace. It is unclear whether she is only temporarily detached, a willing but unasked participant, or a bored third party. At any rate, the lovers seem uninhibited by her presence. A broad-minded scene for the early nineteenth century.

THÉODORE GÉRICAULT (1791–1824)

SLONEM
The Kiss
1996

ANOTHER image of the great Rudolph Valentino (1895–1926), here standing majestically straight as his prey collapses into him. The picture is called *The Kiss*, in an allusion to what must surely follow. Valentino represents the first real sexual idol of the cinema, the beginning of a continuing Hollywood mythical tradition.

HUNT SLONEM (b. 1951)

66

I, who loved you so completely,
You who pressed me closely to you,
hard against your party frock.

99

Sir John Betjeman (1906–84)

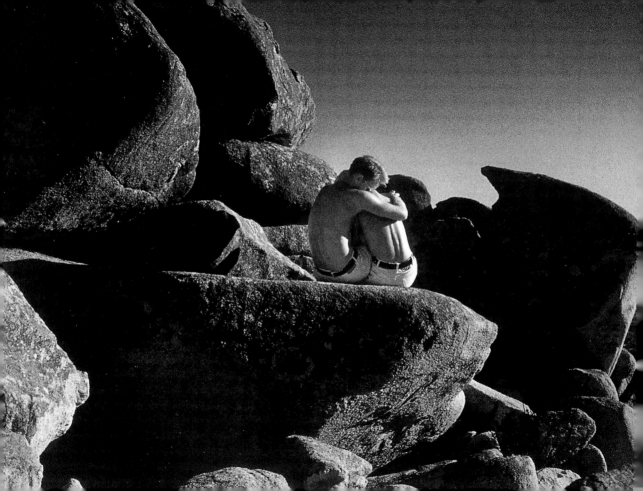

HIRSCHBERG
Untitled
20th Century

*T*HIS couple seems incongruous with the surroundings: insubstantial products of the twentieth century alone in a primordial landscape; soft, vulnerable flesh against the gritty hardness of the rocks. Their relationship is one of mutual protection against the ravages of the world.

TANIA HIRSCHBERG
(CONTEMPORARY)

MAY
Couple Kissing
20th Century

*T*HE point to which our eyes are drawn in this photograph is well off-center, adding to the general sense of movement and helping the evocation of the dizziness of a passionate kiss. He cups the back of her head in his hand, a clear signal of desire, which indicates that he wishes to continue—and that he wants to progress further.

STEFAN MAY (b. 1962)

INDIAN

Krishna and Radha
Embracing in a Grove (Detail)
c. 1785

W HAT is remarkable
about the Pahari
school is that it treats religious
subjects in a fairly secular manner—
this is not so much iconography as
straightforward illustration. No
attempt is made to portray Krishna
and Radha as magnificent figures.

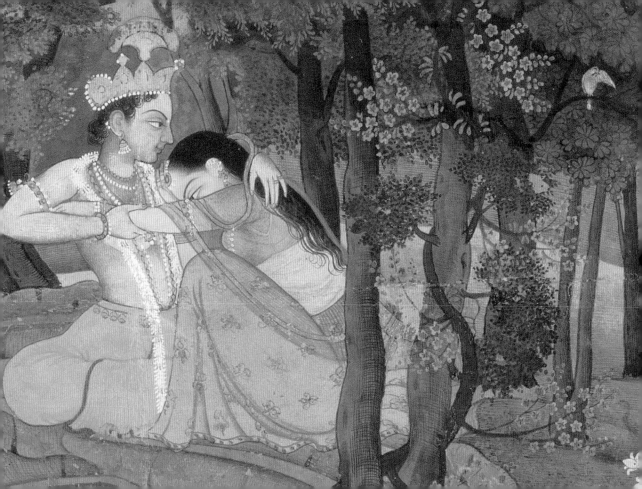

GERMAN

"Thou shalt not commit adultery" (Detail)

15th Century

VIVID image used to reinforce the injunctions of the seventh Commandment. The motivation to commit adultery is attributed to the Devil rather than the lovers themselves. Although they have eyes only for each other and think their passion real, in fact the demon, unseen by either of them, is pushing them together.

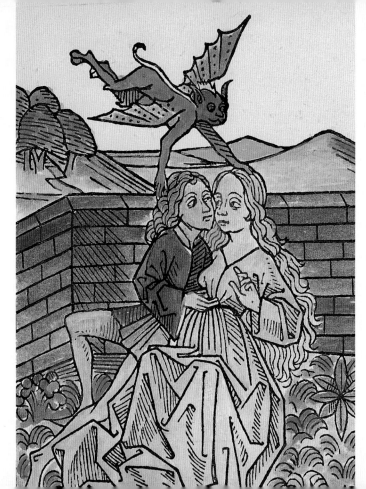

GERMAN
The Joy of Love
14th Century

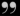S the man lies back in his sweetheart's caressing arms, the falcon plays at least two symbolic roles: it identifies the man as a successful (sexual) hunter; and represents his control over the woman. This is an illustration to a piece by the famous German poet and minstrel, Walter von der Vogelweide (1170–1230).

66

No word they spake, nor earthly thing they felt,
But like two senseless stocks in long embracement dwelt.

99

Edmund Spenser (c. 1552–99)
The Faerie Queen

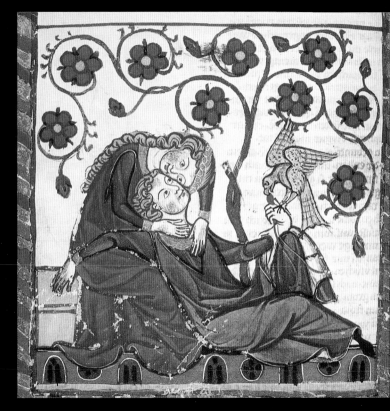

APTHORP

*Batman and Swooning
Poison Ivy (Detail)* 1996 (left)
Final Embrace (Detail) 1995 (right)

BATMAN'S forceful embrace is intended only to protect Poison Ivy; her submissive response is more overtly sexual. Apthorp raises interesting questions about the connection between conflict, sex, and gender roles.

BRIAN APTHORP (b. 1955)

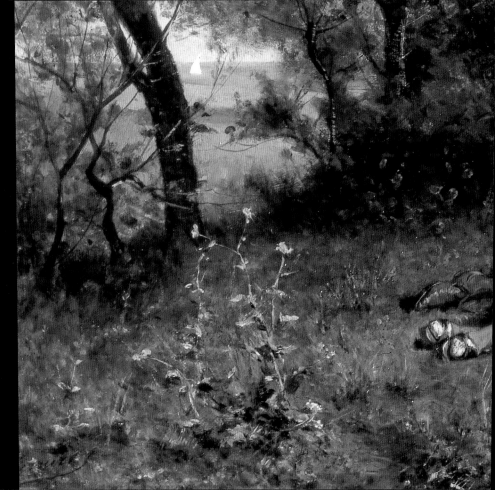

SERRURE
The Picnic
19th Century

THE picnic is well advanced: the food, and the guitar, have long since been put aside. Now, the lovers revel only in each other. The air is heavy with expectation.

AUGUSTE SERRURE
(1825–1903)

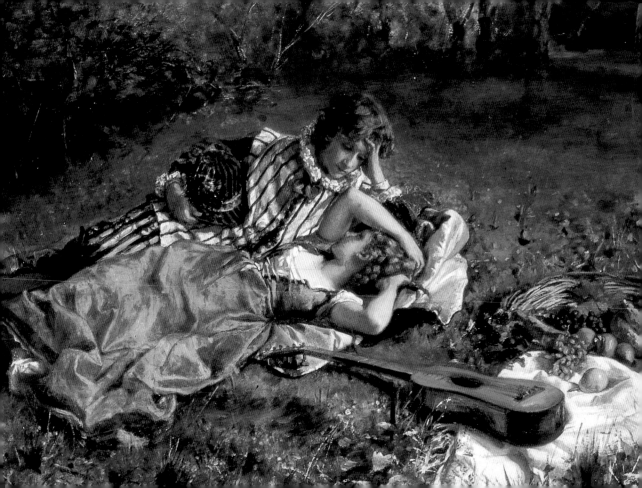

FRENCH
Kissing (Detail)
1925

*T*HIS formally dressed couple seem incongruous with the rustic background. They are, in fact, in the studio, and the romantic setting is merely a painted backdrop. Although she stares lovingly into her partner's eyes, the woman is obviously finding her revealing pose difficult to maintain.

FRENCH
The Kiss (Detail)
c. 1920

*H*ER strap slips as the passion mounts, but they keep on smiling. The unnaturally smooth complexion of the man may be due to retouching of the negative. This was a very common practice at the time, and required a good deal of skill.

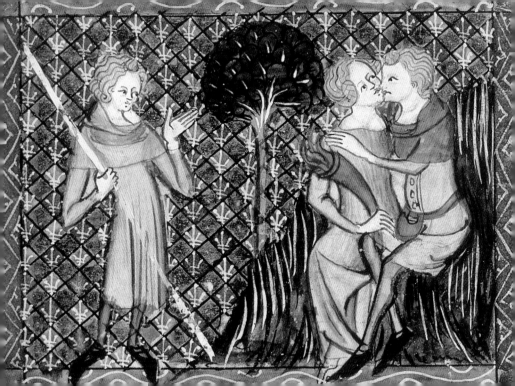

> 66
> 'No, no; for my virginity,
> When I lose that,' says Rose, 'I'll die;'
> 'Behind the elms, last night,' cried Dick,
> 'Rose, were you not extremely sick?'
> 99

Matthew Prior (1664–1721)
A True Maid

FRENCH

Illuminated manuscript (Detail)
14th Century

I N this illustration to the romance in verse *Roman de la Rose* (thirteenth century), two lovers are discovered in a secret tryst in the woods by a gamekeeper. The style is typically medieval, with a decorative and highly stylized background.

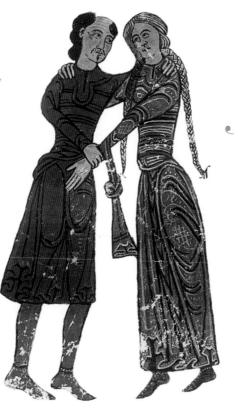

SPANISH

Bible illustration (Detail)
1162

A N illustration to Deuteronomy, Chapter 25, Verse 11: "If two men are having a fight and the wife of one tries to help her husband by grabbing hold of the other man's genitals, show her no mercy; cut off her hand." Yet here the situation seems to be far from hostile.

LTHOUGH this seems to be a carefully considered photograph, with a very well-arranged pose, it is, nevertheless, extremely evocative: the viewer can sense the feel of smooth skin and the smell of hair and warm flesh.

TANIA HIRSCHBERG
(CONTEMPORARY)

NAVA
*Study for
Screen Kiss II*
1994

ERE we get a close-up in the grand tradition of the screen kiss. The moment of hesitation fades into the first tentative brushing of lips. We can almost hear the orchestra's stirring accompaniment.

JOHN NAVA (b. 1947)

66
We discovered in each other
and ourselves worlds, galaxies,
a universe.
99

Anne Rivers Siddons (b. 1936)

BIANCHI
Untitled 17
20th Century

NAKED figures huddle together in a close embrace, while a laughing man lies alone in a pose of surrender that seems to invite sexual contact. The placing of the figures and their attitudes echo the sculptural forms of the architecture.

TOM BIANCHI (b. 1949)

BIANCHI
Untitled 6
20th Century

THE two lovers clasp each other as though engaged in ballroom dancing, but there is a much more insistent sexual power in their embrace than in even the most abandoned of dance steps.

TOM BIANCHI (b. 1949)

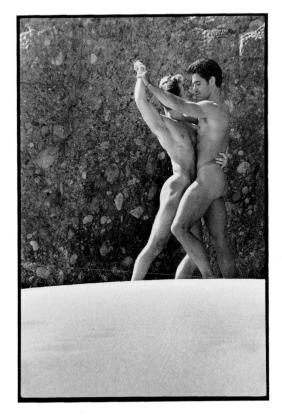

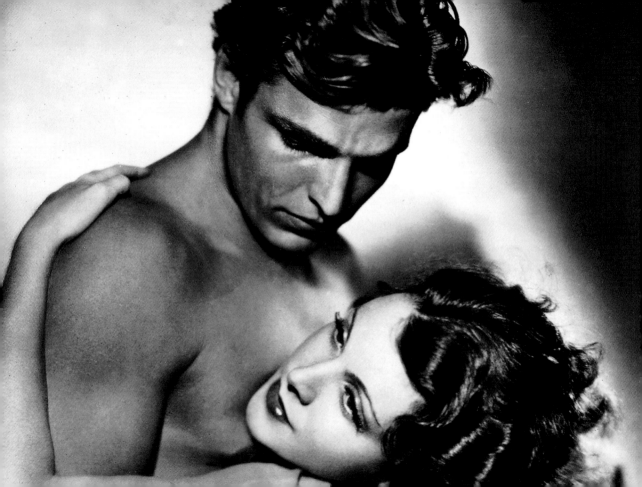

THIS photograph shows the classic early Hollywood conception of Tarzan. The King of the Jungle is a tanned muscular man into whose arms Jane can melt—but he is clean shaven and his hair is carefully dressed; a sanitized primitive man for respectable consumption.

THE KISS

"I was a child beneath her touch,—a man
When breast to breast we clung, even I and she—
A spirit when her spirit looked through me—
A god when all our life-breath met to fan
Our life-blood, till love's emulous ardors ran,
Fire within fire, desire in deity."

Dante Gabriel Rossetti (1828–82)

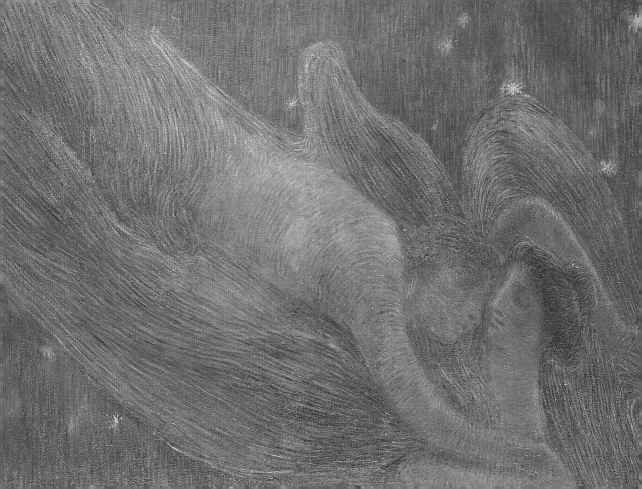

PREVIATI
Triptych of the Day
19th Century

A PECULIAR title for this painting, given the backdrop of stars and the ethereal hues of the embracing figures. Possibly the blond figure descending to join his stationary companion represents the sun "waking" the sleeping earth.

GAETANO PREVIATI (1852–1920)

MÖLLER
The Embrace
1928

S OME of the graphic design and illustration of the 1920s showed an increasingly exaggerated stylization. This is a fairly extreme example, but it does demonstrate how far an image can be distorted and still be interpreted by the viewer without the least difficulty.

MÖLLER (20TH CENTURY)

ROUILLARD
Untitled
1994

THE identification of the embracing couple with the tree is a clear symbol of the strength of love. An angel and a devil, love's advisers, flutter among the branches, while an odd assortment of homunculi fight each other below—all in contrast to the peace of nature.

ANDRÉ ROUILLARD (b. 1931)

CHAGALL
Couple on the Shore
1955

CHAGALL'S vision of the two lovers lying on a beach at sunset acquires a nightmarish quality from the strong blues and reds and the ominous, vague shapes in the sky. But the lovers themselves are unconcerned.

MARC CHAGALL (1887–1985)

66

Oh lift me from the grass!
I die! I faint! I fail!
Let thy love in kisses rain
On my lips and eyelids pale.
My cheek is cold and white, alas!
My heart beats loud and fast:—
Oh! press it to thine own again,
Where it will break at last.

99

Percy Bysshe Shelley (1792–1822)
The Indian Serenade

MILLER

Passionate Reunion
1934

*H*ISTORY and mythology abound with instances of lovers separated by disapproval, chance, or war. The joy and passion of the reunion confirm the truth of the proverb, "absence makes the heart grow fonder."

DOUGLAS MILLER (CONTEMPORARY)

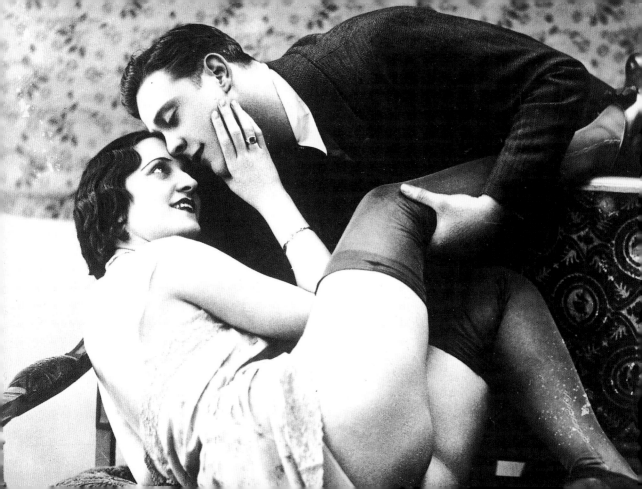

CHAPTER FIVE

UNDRESSING

Lord Illingworth: "The Book of Life begins with a man and a woman in a garden."

Mrs. Allonby: "It ends with Revelations."

OSCAR WILDE (1854–1900)
A WOMAN OF NO IMPORTANCE

FRENCH
Lovers on a Sofa
c. 1925

revealing

bare all

WHAT A TANTALIZING TORMENT it is to watch one's lover undressing at last. A dry mouth, a quick pulse, a light head, the terrible distraction of anticipation: our whole mind and body concentrated on this vision, the slowly emerging promise of delight. Alternatively, there may be a frantic clawing of cloth, buttons flying, seams sundering in a wild struggle to get each other into bed.

In *Fear of Flying* (published 1974) Erica Jong's character was always seeking the "zipless fuck," and who can blame her? Undressing can be a fraught and dangerous business. The act of undressing may be a clumsy interruption in the natural progression of the pursuit of love, or it may be part of the whole exciting experience.

FRENCH
Postcard (Detail)
c. 1898

The manner of undressing is often of crucial importance—what less arousing sight can there be than that of a man dressed only in socks and shirt and tie? Many women seem able to manage it much more gracefully, but, as so often in art, what seems so natural requires forethought and planning. Women's underwear is rarely selected for its serviceability; a whole industry is devoted to producing enticing lingerie that will only ever be seen in intimate situations. The ultimate in artful divestment is the striptease, the essence of which is to heighten desire by erotic movements and by delaying fulfillment until the last possible moment. The dance of Salome has provided many painters with an excellent excuse to appeal to the libido while referring to the Bible. Happily, such an elegant and sensuous tempo

CRESILAS
Diomedes
c. 430 BC

strip

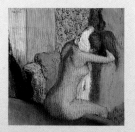

DEGAS
After the Bath
c.1870

is not always required. There is something very appealing about the cheerful swains who fling off their clothes in the scandalous prints of the Georgian period.

When the disrobing is complete there is the nude. Sex is a matter of universal preoccupation, even in prudish times, and it is not surprising that the nude has always been one of the most common subjects throughout the history of art. But imagine how tedious it would be if complete nudity were to become the accepted norm. Custom would certainly stale the infinite variety of such sights. We would lose all the pleasures of anticipation and speculation, and we would lose that intensified sexual reaction that occurs when all is at last revealed.

Artists know very well that those little glimpses of forbidden flesh can be even more titillating than simple nakedness. A classical nude may be aesthetically sublime, and is never devoid of sexual interest, but for erotic power it cannot compare with that apparently unconscious flash of thigh or nipple. These are human gestures that appeal to the voyeur in us. We can imagine these things actually happening to us in familiar situations.

There are a great many examples of artists using this seductive power of women in a state of dishabille, a small example of which is shown here, but rather more unusual is the peep through the open breeches of the man in the second of William Hogarth's two sequential paintings, *Before* (p.69) *and After* (pp.370–71).

PARK
Untitled
20th Century

203

DELACROIX
Woman with White Stockings
19th Century

HERE seems to be a hint of fetishism here, and although she is reclining the woman is not at all in repose—things will soon move on. Delacroix was a very quick worker, once declaring that if you could not manage to draw a man falling from a window in the time it took him to reach the ground from the fifth floor, you would never be able to produce monumental work.

EUGÈNE DELACROIX (1798–1863)

DAVID
The Love of Paris and Helen (Detail)
18th/19th Century

THIS is a classical subject—it was this piece of adultery that led to the Trojan war. Paris abandoned his wife, Oenone, and carried off Helen, wife of Menelaus. Although, in this picture, Paris is already undressed he keeps his "Phrygian cap," because that is how he is always portrayed in Neoclassical art.

JACQUES-LOUIS DAVID (1748–1825)

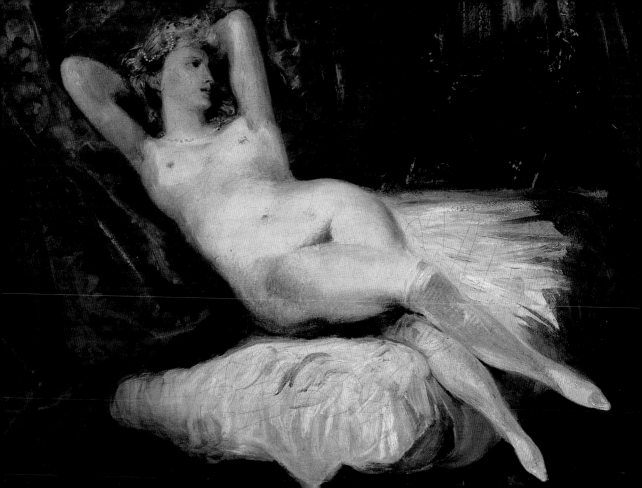

HUGREL
Bacchante (Detail)
19th Century

BACCHANTAE were the female companions of the wine god Bacchus, and by association were rowdy, enthusiastic, often licentious, and usually drunk. This classical connection allows Hugrel the depiction of an uninhibited, sexually inviting nude. The thyrsus in her hands, a wand entwined with ivy and headed with a large pinecone, is a strong phallic symbol.

PIERRE HONORÉ HUGREL
(1827–DEATH DATE UNKNOWN)

> **"**
> Full nakedness! All joyes
> are due to thee,
> As souls unbodied, bodies
> uncloth'd must be.
> **"**

John Donne (1572–1631) *Elegie*

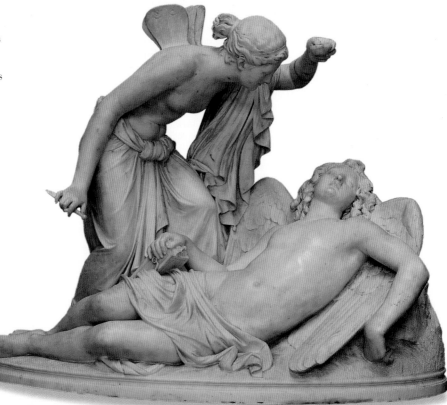

BEGAS

Cupid and Psyche
1857

CUPID fell in love with Psyche but, because he wished to keep his identity secret, he visited her only during darkness and told her never to look at him. However, she was unable to resist temptation, and when she beheld his naked beauty she was so overcome that she let fall a drop of hot oil from her lamp; this awoke him and he abandoned her.

REINHOLD BEGAS (1831–1911)

ALSINA

Nude
19th Century

A GOOD many female signals of sexual invitation are apparent here: the open stance, raised knee and intertwining legs, cocked head and submissive offering of the breasts. The hand hovering near the woman's own genitals is also a subtle, yet effective, erotic device.

RAMON MARTÍ ALSINA (1826–94)

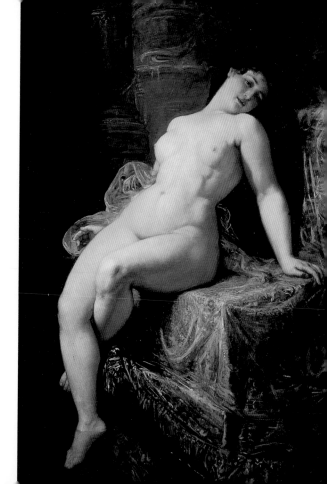

NISLE
Lucie
c.1850

THIS is an illustration to the memoirs of Giovanni Jacopo Casanova de Seingalt (1725–98). These memoirs give a lively and cynical account of Casanova's extensive adventuring throughout Europe. They were first published in twelve volumes in 1828–38. However, the full original text, in all its pornographic detail, was not published until 1960–61.

JULIUS NISLE (ACTIVE MID-19TH CENTURY)

BÉCAT
Les Bijoux Indiscrets
1939

THIS is an illustration to the work (published 1748) of Denis Diderot (1713–84). Although the setting is fairly accurate for the eighteenth century, the woman looks as though she belongs to Bécat's own time. Her underclothes are distinctly of the 1930s—in reality, a woman of the earlier period would have worn none.

PAUL-EMILE BÉCAT (ACTIVE MID-20TH CENTURY)

LEIGNIEL

Untitled (Detail)
20th Century

*A*LTHOUGH little of the body can be seen in this photograph, we have a feeling that the woman is undressing—and that she is not undressing in order to retire for a night's sleep. The image is full of a quiet sensuality.

ANNE LEIGNIEL (CONTEMPORARY)

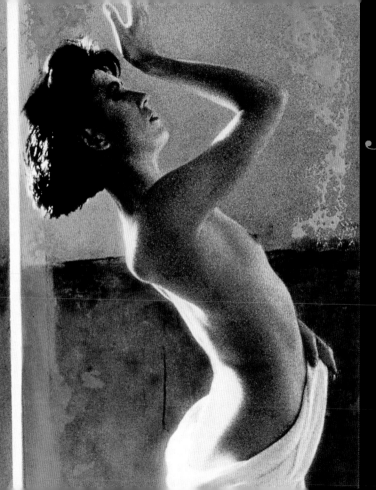

VENINGER

Triptych 3
1987

THE woman's body curves back in a lithe, feline gesture. We have the feeling that the last remnant of covering is about to fall from her, and that she will then turn her attention to us—vigorous and demanding.

ADRIENNE VENINGER (b. 1958)

66

Away with silks, away with lawn,
I'll have no scenes, or curtains drawn:
Give me my mistress as she is,
Dressed in her nak'd simplicities:
For as my heart, e'en so mine eye
Is won with flesh, not drapery.

99

Robert Herrick (1591–1674)
Clothes Do but Cheat and Cozen Us

213

PENOT
Ravishing Beauty
19th Century

A SURPRISINGLY erotic image for Late Victorian times. The woman's shawl is held provocatively low and her head is held back to make an unambiguous display of her breasts and neck. Her pale complexion is a reminder that perceptions of beauty change with the times; today, a tanned skin would be considered more attractive.

ALBERT JOSEPH PENOT (ACTIVE LATE 19TH CENTURY)

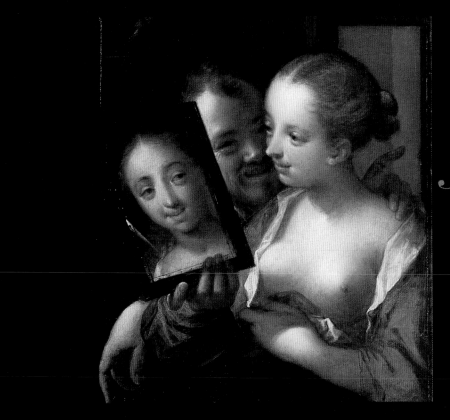

AACHEN
Flirting Couple with Mirror
c. 1596

*T*HERE is no hard, driving passion here, just happy, unaffected sexuality. The cheerful frolics of this pair are typical of the work of Aachen. The painting is in oil on copper, a technique that can provide an added luminosity if the paint is applied in thin glazes onto the reflective surface of the metal.

HANS VON AACHEN
(1552–1615)

215

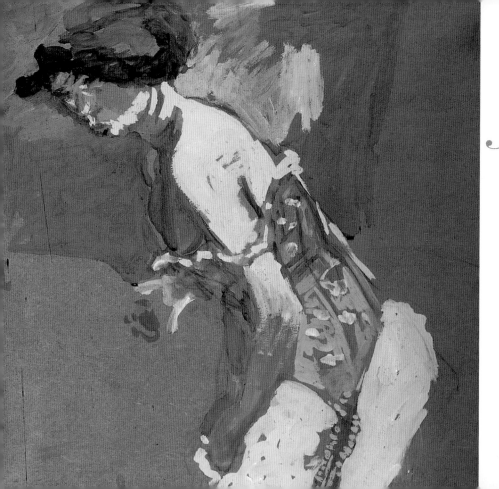

VUILLARD
The Pink Corset
1910

THIS apparently casually painted picture demonstrates Vuillard's mastery of light and color. Undressing was a considerable undertaking at the time this was painted, and the woman goes about the task with an air of preoccupation—perhaps she is not quite happy with the situation.

ÉDOUARD VUILLARD
(1868–1940)

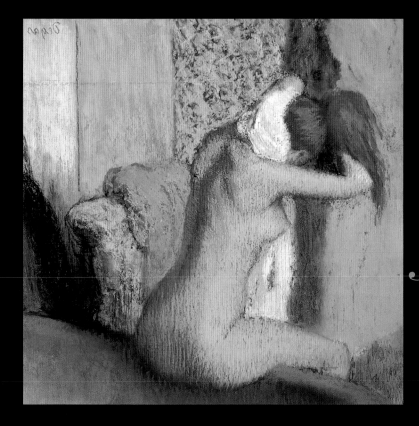

DEGAS

After the Bath

c. 1870

THE woman sits drying her hair; she is so absorbed in her task that she has lost awareness of her nakedness. This makes voyeurs of the viewers, and provides an additional sexual fillip to the picture. Women at their toilet was a favorite subject for Degas, and he is able to make the activity seem prosaic but at the same time arousing.

EDGAR DEGAS (1834–1917)

217

FRENCH
Postcard
c. 1898

THIS is a remarkably well-conceived shot for an erotic postcard. The white lace of the bed and the pale flesh of the woman are emphasized by the delicate touches of hand-coloring.

BÉCAT
Les Bijoux Indiscrets (Detail)
1939

AN illustration to the work of Denis Diderot (1713–84), a prolific French philosopher, author, and critic. Although some of his serious work was considered seditious, his lighter work, such as *Les Bijoux Indiscrets*, often deals in a satirical way with the follies of society.

PAUL-EMILE BÉCAT (ACTIVE MID-20TH CENTURY)

GAILLARD
Untitled (Detail)
20th Century

*T*N this carefully cropped photograph, Gaillard displays the beauty of a young female body, seen purely as a series of sculptural forms; but at the same time it is an image filled with a strong erotic appeal.

DIDIER GAILLARD (b. 1953)

PRAXITELES
Aphrodite of Cnidus
Mid-4th Century BC

*T*HIS is a Roman copy of the most famous work by the Greek sculptor, Praxiteles. The original, which has been destroyed, was a work of extraordinary significance because it was the first ever life-sized nude statue in Greek art. It was very much admired at the time it was made—Pliny described it as the finest statue in the world.

PRAXITELES (ACTIVE MID-4TH CENTURY BC)

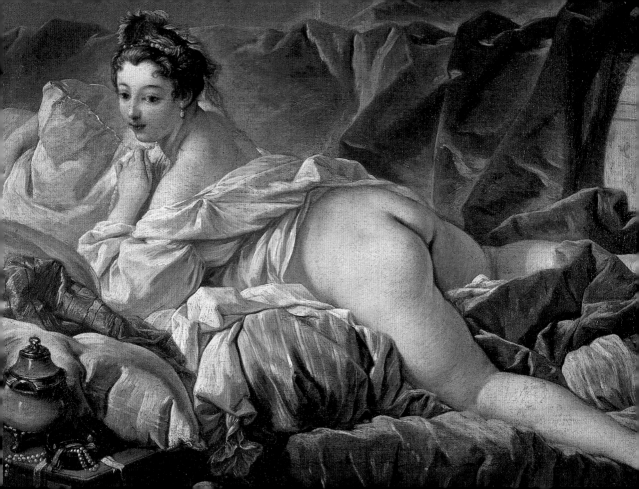

BOUCHER
The Odalisque
1745

66

Every part of me was open and
exposed to the licentious courses of
her hands, which, like a lambent fire,
ran over my whole body, and thaw'd
all coldness as they went.

99

John Cleland (1709–89) *Fanny Hill*

*A*N odalisque was a female
slave or concubine in the
Turkish Sultan's seraglio. This particular
odalisque has a distinctly European look
about her, and her pose is almost exactly
that which Boucher used, some years later
in 1751, for his strongly erotic portrait of
Mademoiselle O'Murphy, one of the
mistresses of Louis XV.

FRANÇOIS BOUCHER (1703–70)

223

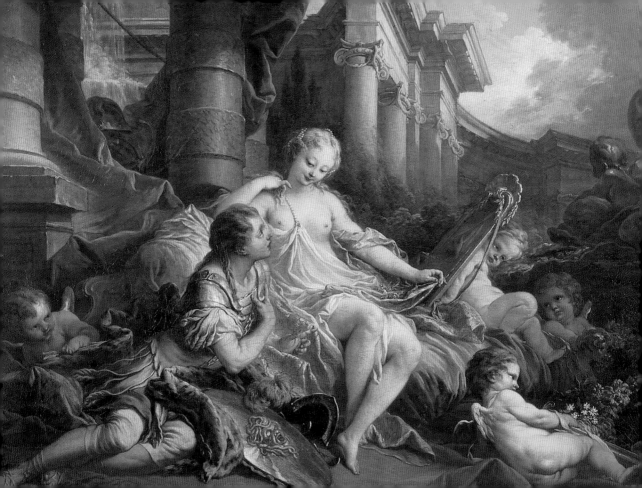

BOUCHER
Rinaldo and Armida
1734

RINALDO was a paladin in the court of Charlemagne (742–814), and a great hero of medieval romance, appearing in *Jerusalem Delivered* by Torquato Tasso (1544–95). In this Italian epic poem (published 1581), he is seduced by a beautiful sorceress, Armida, and wastes his time in licentious pleasures.

FRANÇOIS BOUCHER (1703–70)

TINTORETTO
Portrait of a Woman Revealing Her Breasts
fl. 1545–94

TINTORETTO'S work often consisted of religious paintings with complicated perspectives, or very fine portraits, particularly of old men. The subject of this painting may not be typical, but it still demonstrates his exquisite draftsmanship.

JACOPO ROBUSTI (KNOWN AS TINTORETTO) (1518–94)

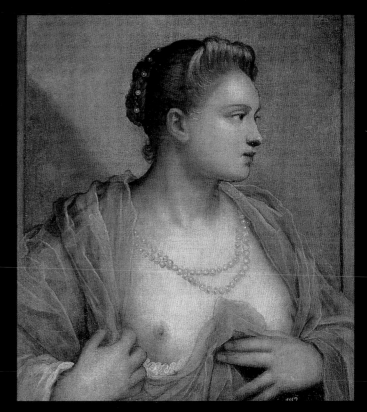

BOUCHER

The Raised Skirt

1742

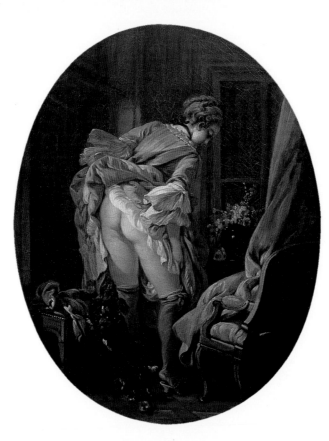

*T*HE little black dog looks on with interest as the lady uncovers her secrets; and we too are allowed to see her hidden beauty, and to feel the additional, clandestine pleasures of the voyeur.

FRANÇOIS BOUCHER
(1703–70)

226

FRENCH

Distraction (Detail)
19th Century

*T*HIS is not the sort of distraction from one's work that is often encountered. The lady might merely have been intent on adjusting her stockings and have been surprised by the effect her actions had on the gentleman, but her arm around his shoulder tells us that she knew precisely what she was doing.

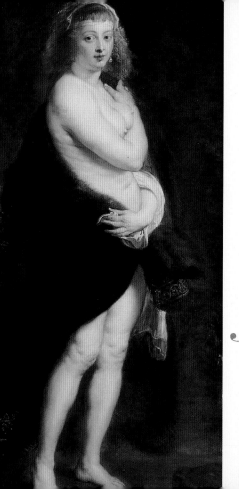

The girl takes off her dress.
Headlights reveal her glamour.
Her coral reeks of musk.

Christopher Logue (b. 1926)

RUBENS
Hélène Fourment in a Fur Wrap
c. 1630

IN this sensual portrait, the sexual tension between the painter and the model is immediately apparent. In fact, he married her: the daughter of a rich silk merchant, she was sixteen years old when she became his second wife in 1630. His later portrait of her, *Hélène Fourment with Two of Her Children*, painted in about 1637, shows a quieter but pleasantly uxorious feeling for her.

PETER PAUL RUBENS (1577–1640)

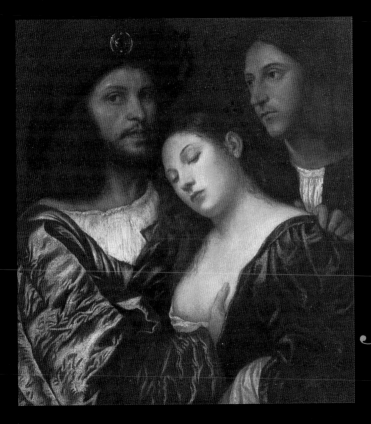

ITALIAN
Seduction
16th Century

*T*HIS seduction seems to be a
rather efficient and serious
business. But who is the man on the
right? A fellow seducer perhaps, or a
trainee? Or maybe even a willing,
soon-to-be-cuckolded husband?

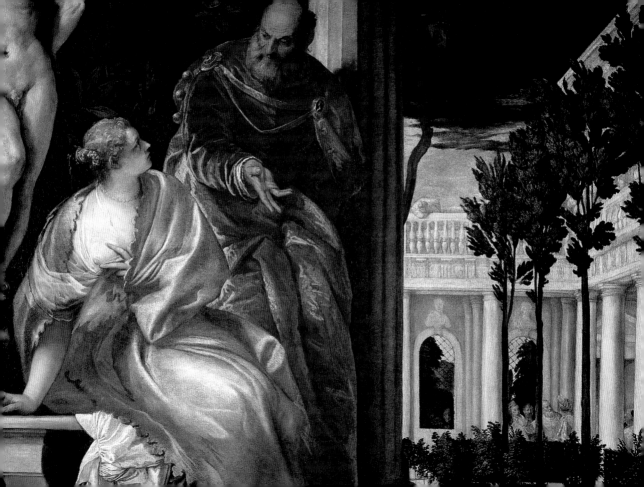

VERONESE
*Bathsheba
Bathing (Detail)*
c. 1575

AS he was walking on his roof one evening, King David looked out and saw Bathsheba bathing. He was so struck by her beauty that he sent for her, and seduced her. When she became pregnant with his child, he arranged for her husband, Uriah the Hitite, to be killed in battle so that he could marry Bathsheba himself. The rich clothing, the marble columns, and the biblical subject are all typical of Veronese.

PAOLO CALIARI (KNOWN AS VERONESE) (1528–88)

GUERCINO
Woman Undressing
c. 1620

A FREE, bold drawing, made to look easy by one of the best draftsmen of the seventeenth century. With just a few simple lines, Giovanni Francesco Barbieri, also known as "Guercino" ("Squinting One") captures the movement and haste of undressing.

GIOVANNI FRANCESCO BARBIERI (KNOWN AS "GUERCINO") (1591–1666)

231

CHRISTENSEN

The Cast Room

1998

WITHOUT their clothes the models mirror the artefacts around them in a Baroque pose of twisting, chasing, pulling, and clutching.

WES CHRISTENSEN (b. 1949)

CONDÉ

Untitled 19

1987

THE woman turns away, and the man seems equally shy as he hides behind his fan. Although their desire leads them on, still he tempers his lascivious touch with the end of his sleeve.

MIGUEL CONDÉ (b. 1939)

GAILLARD
Untitled
20th Century

*H*ERE, there is much less sense of the naked human body as a piece of abstract sculpture than in Gaillard's photograph on page 220. This is a much more conventionally sexy shot, complete with half-removed black stocking; yet it lacks the seductive power of the other image.

DIDIER GAILLARD (b. 1953)

DOUGLAS
Artist Advances Towards Middle Age
1998

*T*HE presentation of the female nude opposite is in sharp contrast to the unguarded honesty of this male figure. But, as he stands with a shaft of light illuminating his eyes and the midline of his body, there is a feeling that perhaps this pose, in its own way, is just as self-consciously sensual as the other.

STEPHEN DOUGLAS (b. 1949)

CHRISTENSEN
Rhetorical Device
1990

THE man and the woman seem intent on impressing each other: he is apparently unmoved by her naked beauty, and she adopts a pose that suggests deep interest in his intellectual musing. The pomegranate and the gun, however, are symbols that hint at the true character of their thoughts.

WES CHRISTENSEN (b. 1949)

RADIONOV
Dreaming
1997

THIS is another painting in which all the man's attention seems to be directed toward his reading, but this time, in spite of his pile of erudite books, we cannot be misled—the fiery nature of his dreams is revealed to us all.

GREGORY RADIONOV (b. 1971)

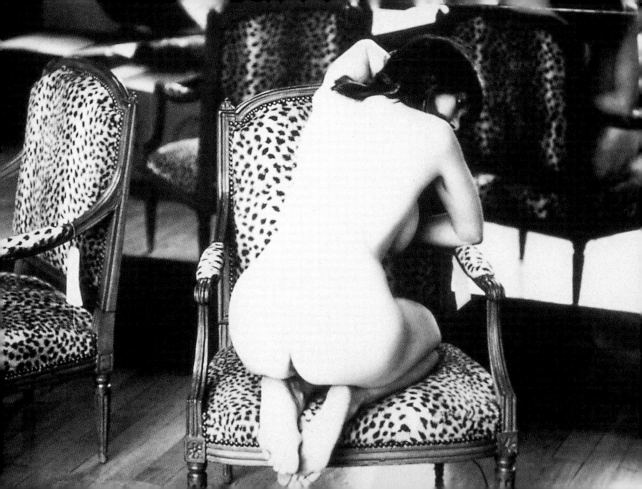

KITCHEN

Mors in Lutetia 2 (Detail)
1997

THIS is a self-portrait, taken in a Paris apartment. The naked female form fits beautifully into the composition, and there is no feeling of incongruity as she kneels in the familiar room.

E. F. KITCHEN (b. 1951)

THE GRADUATE

"I'll get undressed now," she said, running one of her fingers around the edge of the hat. "Is that all right?"

"Sure," Benjamin said. "Fine. Do you—do you—"

"What?"

"I mean do you want me to just stand here?" he said.

"I don't know what you want me to do."

"Why don't you watch," she said.

"Oh. Sure. Thank you."

Charles Webb (b. 1939)

EX

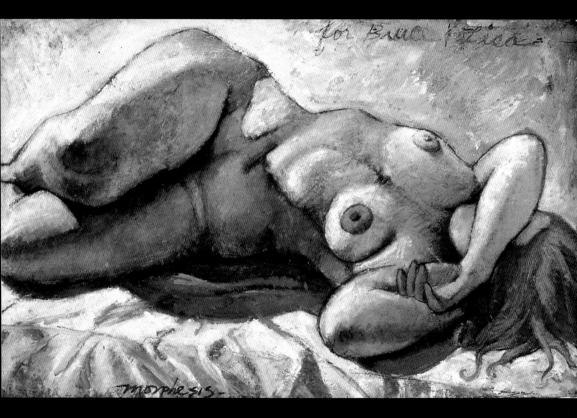

for Bruce Felicia

morphesis

MORPHESIS
Reclining Figure
1991

*I*N this modern painting, the familiar subject of the nude is used as a vehicle to explore more esoteric matters of interest to the painter: the quality of light and the perception of color.

JIM MORPHESIS (b. 1948)

KLIMT
Danae
1907–8

*D*ANAE, daughter of the king of Argos, was locked in a tower by her father because it had been prophesied that she would give birth to a son who would kill his grandfather. But Zeus visited her in a shower of gold and impregnated her—the issue of this union was Perseus. Here Klimt indulges himself at the height of his golden period.

GUSTAV KLIMT (1862–1918)

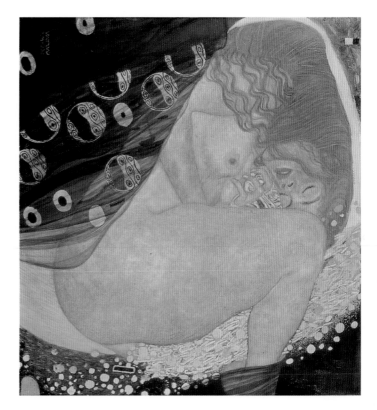

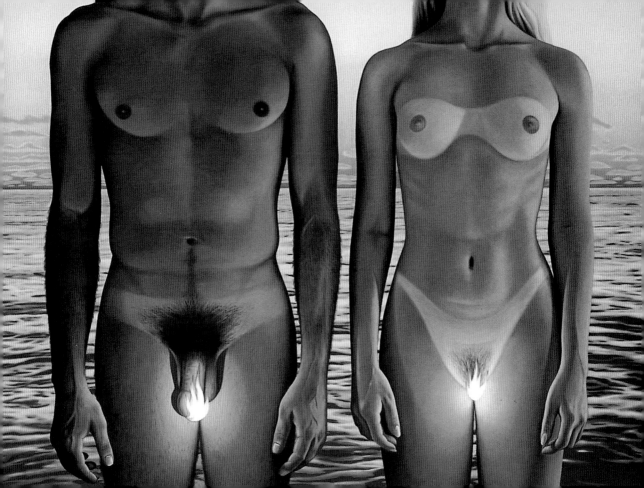

CAMPOS

*Acquired Incendiary Device
Syndrome—AIDS*
1996

*T*HIS couple are so aroused by lust that their genitals are ablaze—they are literally inflamed with passion. But the title suggests that having unprotected sex may indeed be playing with fire.

<small>PABLO CAMPOS (b. 1947)</small>

JANOSOVA

Shedding
1980

*A*S she undresses this woman sits in a very self-assured pose, and her easy power is symbolized by the ax at her side. This is no shy, submissive creature; she is a confident woman who gets exactly what she wants.

<small>ANITA JANOSOVA (b. 1951)</small>

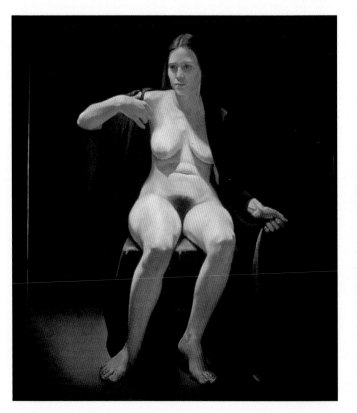

WOMAN sits in a romantic landscape, naked under her simple wrap. She is apparently absorbed in her own profound thoughts, and yet there is a feeling that she is well aware of her image and the effect she wishes to produce.

JOYCE TENNESON (b. 1945)

66

Ayesha swiftly threw off her uzy wrapping, and loosened the golden snake from her kirtle.

99

H. Rider Haggard (1856–1925)

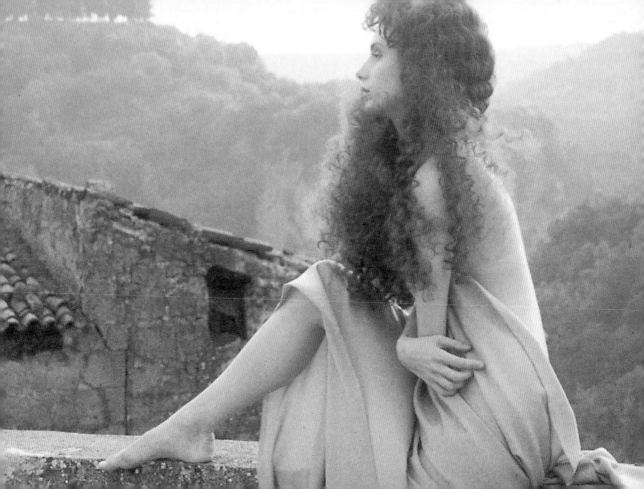

DAUMICH
Windfall
1924

HE woman lies in a provocative pose with the windfall apple nestling between her naked breasts; the knowing smile on her face is for the benefit of the man, who is revealed only by his clutching hands in the branches of the tree. This picture refers to the folly of Adam and Eve, and makes a visual comparison between the ripe fruit and her firm breasts and rosy cheeks.

MAX DAUMICH (ACTIVE EARLY 20TH CENTURY)

KUSTODIEV
The Beauty
Early 20th Century

HE young woman's expression is inviting; but her slightly defensive posture reveals an air of self-consciousness. Kustodiev's title suggests that for him her hesitancy is part of her allure.

BORIS MIHAJLOVIC KUSTODIEV (1878–1927)

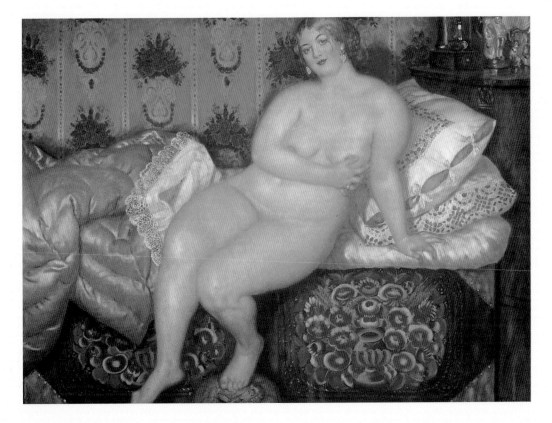

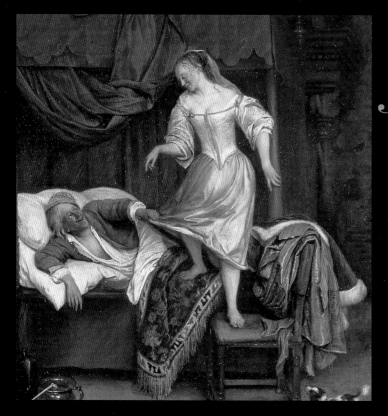

STEEN
Bedroom Scene (Detail)
17th Century

THIS good-humored scene is typical of the work of Steen, who depicted social and domestic life with sympathy and genial wit. His father was a brewer, and he himself worked for some years as a tavern-keeper, which no doubt helped to give him a compassionate understanding of the foibles and the virtues of ordinary people.

JAN HAVICKSZ STEEN (1626–79)

66

'Boy,' he said, 'I did the only thing you could do in them days when you'd seen a lady in her petticoats.'
'And what was that?'
'I married her,' he said.

99

H. E. Bates (1905–74) *My Uncle Silas*

FRENCH
Wedding Night
c. 1900

NDRESSING in 1900 was no trivial undertaking. The man seen here is faced with various unfamiliar articles of clothing and many strange fastenings. However, he sets about his task with commendable fortitude, and no doubt the obstacles will only increase the eager anticipation they both enjoy.

TENNESON
Untitled
20th Century

*T*HE delicate color adds much to both the aesthetic and the erotic attraction of this sensitive image. The diaphanous covering, partially concealing the breasts, makes this picture far more arousing than a conventional nude shot. We have the feeling that this is a real person—warm, human, and appealing.

JOYCE TENNESON (b. 1945)

PARK
Untitled
20th Century

A BEAUTIFULLY composed and controlled photograph. The simple shapes and textures, and the single area of bright colour in the cloth, work together to produce an almost abstract design. There is, however, still a feeling of movement, life, and sensuality.

CLARE PARK (CONTEMPORARY)

ETRUSCAN

Helen and Menelaus
c. 4th Century BC

THIS image on a bronze mirror shows Helen with her husband, Menelaus, King of Sparta. In Greek legend, she was the surpassingly beautiful daughter of Zeus and Leda. Her elopement with Paris led to the Trojan War, which lasted for ten years. Eventually, she was reconciled with Menelaus—and they certainly seem pleased with each other in this picture.

CRESILAS
Diomedes
c. 430 BC

*T*HIS is a Roman copy of a sculpture
by the Greek Cresilas. It represents
the hero Diomedes, who took part in
the Trojan War and, with Ulysses, carried
off the palladium (a statue of the goddess
Pallas Athena) from Troy. Unfortunately,
while he was engaged in these glorious
activities, his wife, Aegialea, distinguished
herself in a rather less honorable manner
by living in adultery with Hyppolytus.

CRESILAS (fl. 440–430 BC)

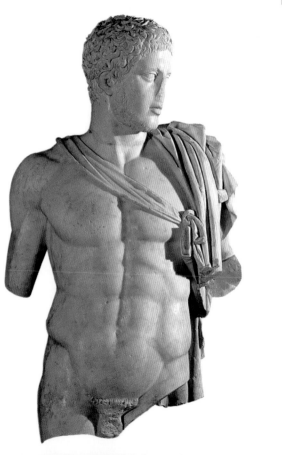

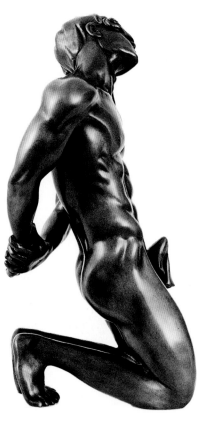

OD

*Sacramental Presentation
of Pure Desire*
1991

IN this wryly titled sculpture,
Od identifies "pure desire"
not with a concept or abstract
emotion, but with a physical
manifestation—the man's urgent
erection. A cloth constitutes the
only clothing, but it conceals
nothing as the man offers
his rampant penis to the
unidentified object of his desire.

KIRA OD (b. 1960)

BIANCHI

Untitled 6 (Detail)
20th Century

THE naked man poses
in a sexual display that
emphasizes the muscular
development of his body.
The fact that he has been
photographed in the
open air, in a wild, natural
environment, adds an extra
erotic dimension to
the image.

TOM BIANCHI (b. 1949)

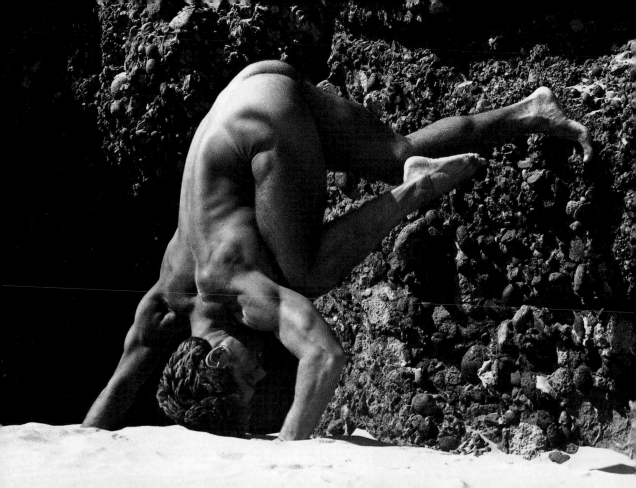

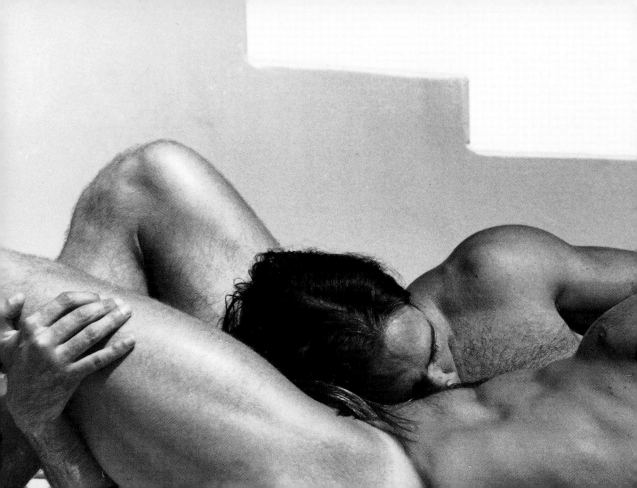

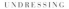

> **"**
> His love was passion's essence:—as a tree
> On fire by lightning, with ethereal flame.
> Kindled he was, and blasted.
> **"**

Byron (1788–1824) *Childe Harold's Pilgrimage*

BIANCHI
Untitled 11
20th Century

T HE fine flesh tones are accentuated by the contrast with the plain background. There is a feeling of warm, living beings, as the two figures lie together enjoying the contact between their naked bodies. They are almost in repose, but the sexual tension is still there.

TOM BIANCHI (b. 1949)

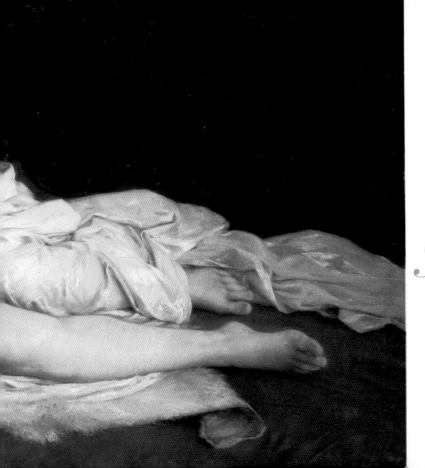

COLLIN

Sleep

1873

IN the prudish times when this picture was painted, the depiction of nudes was made more acceptable by omitting women's pubic hair. This practice was so common that it was even suggested at one time that the shock and revulsion of discovering hair on his wife's body led to Ruskin's inability to consummate his marriage. But the suggestion seems highly unlikely in view of Ruskin's wide knowledge of the art of franker times.

LOUIS JOSEPH RAPHAEL COLLIN (1850–1916)

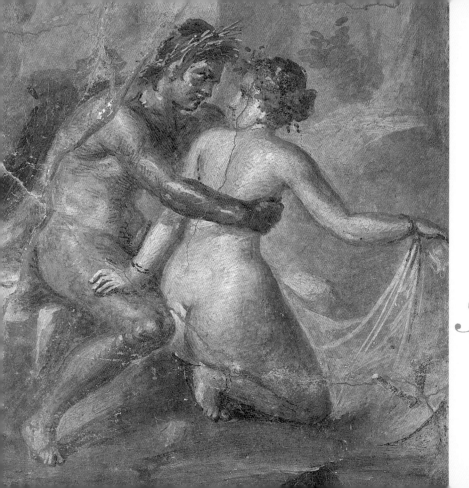

ROMAN
Erotic Scene
1st Century

THIS wall painting shows foreplay between a satyr and a maenad, two of a whole host of Greco-Roman mythological beings with erotic connotations. Pompeian erotic art, however, was by no means limited to religious and iconic images: it was commonplace to have frank pictures and statues everywhere, even in the street.

BOUCHER
Pastoral Music
c. 1743

THE music of the swain has captured the heart of this delicate young woman, and she leans toward him in an unmistakable attitude of desire. The pastoral setting heightens the impact of her naked flesh, which is painted with Boucher's customary sensuality.

FRANÇOIS BOUCHER (1703–70)

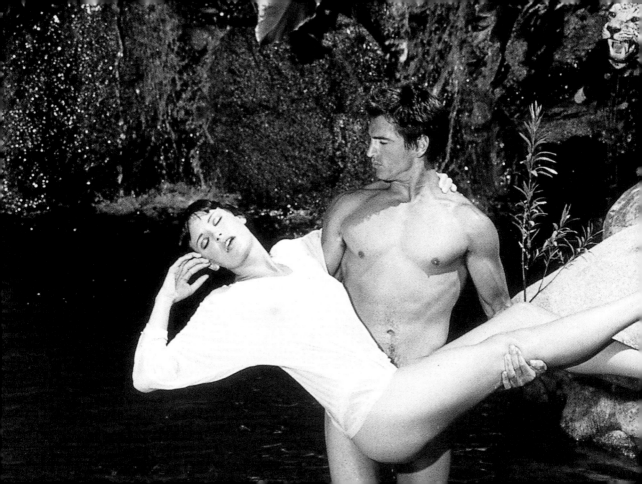

CHAPTER SIX
FOREPLAY

"Licence my roving hands,
and let them go,
Before, behind, between, above, below."

JOHN DONNE (1572–1631) *ELEGIE*

CHILDERS
Untitled (Detail)
1998

arousal

BLAKE
Satan Watching
Adam and Eve
(c.1807)

"OK, SHEILA, BRACE YOURSELF!"—this is how the stereotypical Australian male is popularly supposed to conduct foreplay. And indeed the idea that techniques of sexual arousal might be the object of study in a wholesome Christian society would have been considered disgraceful at one time. Such lubricious tricks were the province of gigolos, rués, and strumpets.

The more sophisticated Victorian man knew that such things were widely practiced in Eastern countries: travelers and writers such as Sir Richard Burton (1821–90) had published translations of works like *The Perfumed Garden* and the *Kama Sutra*, but respectable women were supposed to be spared the knowledge of such horrors. In fact, on his death in 1890, Burton's wife destroyed not only his newly finished

revision of *The Perfumed Garden*, but also most of his original notes. Chaste women in North America and Britain were supposed to be innocent and submissive; they were not required to enjoy sex, and they were certainly not supposed to take an active interest in the business.

With the changes brought about by two world wars—the rise of feminism, the dismantling of the rigid social structure, and the decline of the traditional moral order—attitudes toward sex became much more liberal. Inevitably, there was an increasing demand, not least from women, that sex should be a bit more fun. Foreplay went gradually from being taboo and improper to being a required and integral element of intercourse. Scientific studies in sexuality became popular. Although the value of such publications as Dr. Alfred C. Kinsey's report

RODIN
Eternal Spring
1884

on sexual behavior in the human male (published 1948), and later in the human female (published 1953), is now in doubt, they reflect a change in tone, and were very influential at the time.

The importance of foreplay was now proclaimed by advice columns and by humorless books on how to go about it. (One can imagine turning aside from the object of desire to consult Chapter 6: "Well, the areolae are tumescent alright, but surely by now there should be a deep flush spreading down . . .")

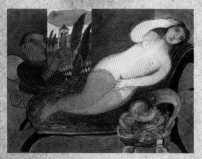

CIENFUEGOS
Woman and Man with the Flowered Robe
20th Century

The whole clinical process contrasts strongly with the attitudes revealed in Oriental art and literature. Here, particularly in the case of *The Perfumed Garden*, the subject is treated in a pleasantly human

manner. Instruction and advice there may be, but it is presented with humor and poetry. The same light touch is evident in contemporary paintings. They are explicit, but at the same time they are executed with care and love; and what is more, the people portrayed in them are obviously enjoying themselves—they are behaving in a way that is natural to them.

It is still true that each generation suspects that really they are the generation to have discovered the joy of sex. But in spite of all the searching for g-spots and the consumption of Viagra, most of what we know about sexual arousal has been known for centuries, and many of the things we do have been depicted, or even more intriguingly, hinted at, in painting, sculpture, and photography.

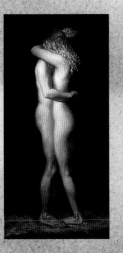

ERLEBACHER
Embrace
1995

FUSELI
Gunther and Brunhild (Detail)
(1807)

BY placing the smaller Brunhild in perspective behind Gunther's physical bulk, the contrast between dominatrix and dominated is reinforced. In the German legend, Gunther falls short of Brunhild's stringent expectations—and suffers the consequences.

HENRY FUSELI (1741–1825)

ZICHY
Couple Engaged in Foreplay
1901

THESE lovers, wrapped up in each other, are oblivious to the outside world. Of that world, the artist draws only the bed, which serves as the arena for their activities, and even that is far more sketchily portrayed than the lovers themselves.

MIHALY VON ZICHY (1827–1906)

SHUNSHO
Lovers with Folded Screen (Detail)
c. 1785

IT is easy to see frank prints such as this and conclude that 18th-century Japan was a liberal place. In fact, as the ruling samurai class declined, it imposed tighter and tighter censorship controls as part of an attempt to maintain the moral and political status quo. Some artists, including the great Utamaro himself, were imprisoned.

YUSHIDO SHUNSHO (1726–92)

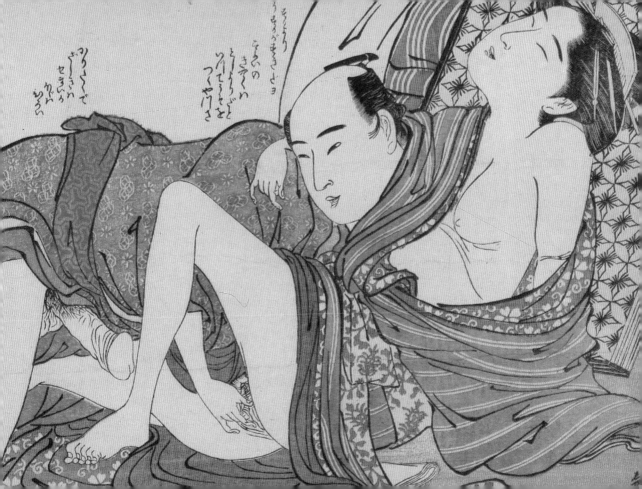

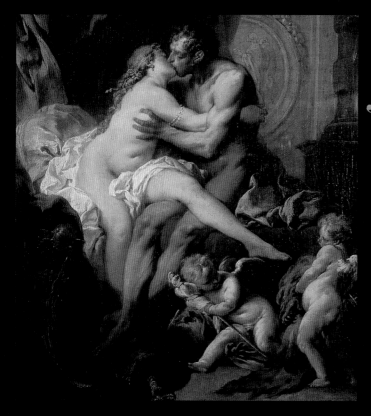

BOUCHER
Hercules and Omphale
18th Century

HERCULES was required to become the servant of Omphale for three years. During this time he lived submissively, spinning wool and wearing women's clothing, while Omphale wore Hercules's own garb, the skin of a lion. There is, however, nothing effeminate about the task he is called upon to perform in this picture—and, while it is carried out, the cherubs hold onto the distaff and the lion skin.

FRANÇOIS BOUCHER (1703–70)

66

She smiled and said, 'Hola, Comrade,' and Robert Jordan said, 'Salud,' and was careful not to stare and not to look away.

99

Ernest Hemingway (1899–1961)
For Whom the Bell Tolls

GÉRARD
Cupid and Psyche
1798

IN his version of the Greek myth, Gérard manages to convey the virtue as well as the beauty of Psyche, who was a model of constancy. After Cupid fled, she had to endure many hardships and humiliations, but her love never faltered and, eventually, they were reunited.

FRANÇOIS PASCAL SIMON GÉRARD
(1770–1837)

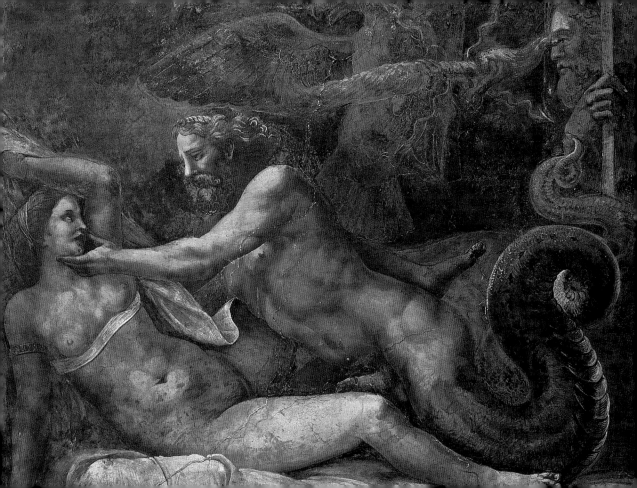

BAYROS
Erotic Scene
1912

AN elaborately dressed woman beats her lover's naked bottom with peacock feathers. This engraving is influenced by the English illustrator Aubrey Beardsley (1872–1898).

FRANZ VON BAYROS (1866–1924)

AFTER
GIULIO
Jupiter and Olympias
1526–35

GIULIO fled to Mantua in 1524 to escape persecution for a series of pornographic prints he had produced. This fresco, which shows something of that eroticism, is from the great Palazzo del Tè that he designed in the city.

FRESCO BY RINALDO MANTOVANO
AFTER A DRAWING BY GIULIO ROMANO
(1492–1546)

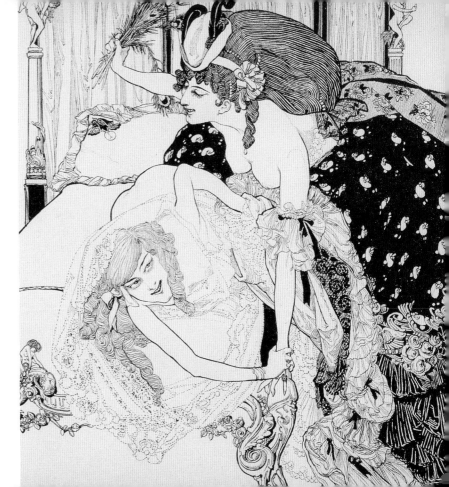

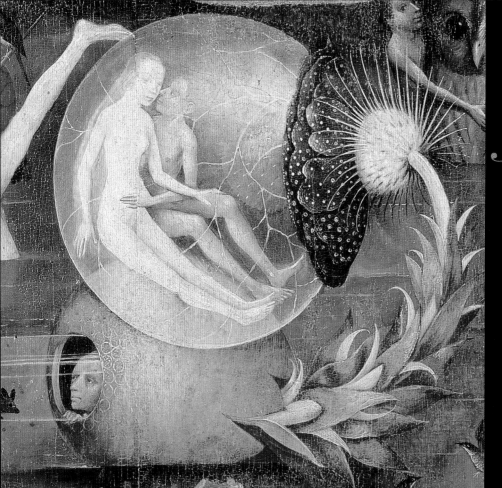

BOSCH

The Garden of Earthly Delights (Detail)

c. 1500

THIS is a detail from the central panel of the triptych *The Garden of Earthly Delights*— perhaps Bosch's most important work. It shows a vision of a quasi-paradise, which reflects the artist's penetrating conception of human desire. Lust is fulfilled, but a nightmarish undertone renders the garden ambivalent; hedonistic yet grotesque. The debt owed by Surrealism is clear, and was acknowledged.

HIERONYMUS BOSCH

(c. 1450–1516)

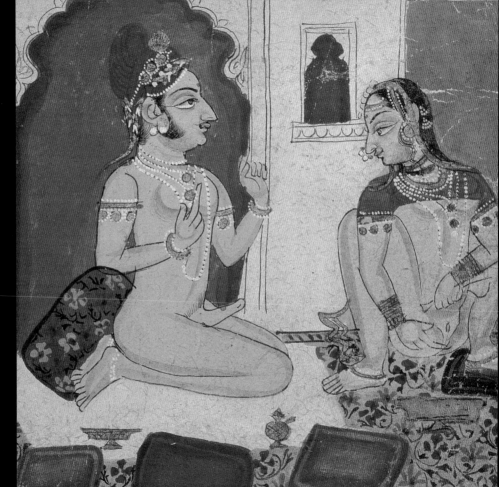

RAJPUT SCHOOL
A Prince and His
Lover (Detail)
1900

So far the foreplay is merely
verbal, but as his lover prepares
for what is to come,
the Prince is already in
a state of arousal. She
looks on with interest.

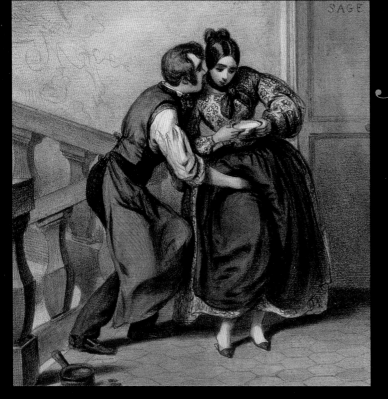

FRENCH

The Ambush (Detail)

19th Century

*T*WO servants meet on the landing and the man seizes his opportunity. The woman is handicapped by her fear of spilling the contents of the bowl. The title suggests that the encounter was carefully planned; and perhaps the man is not expecting too much resistance.

> **❝**
> Young I am, and yet unskilled
> How to make a lover yield.
> **❞**
>
> John Dryden (1631–1700)

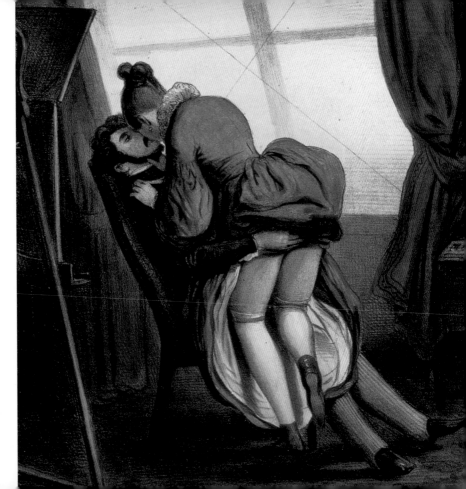

FRENCH

The Landscape Lesson (Detail)
19th Century

THE teacher is learning
something himself; the
innocent, studious artist is
surprised and engulfed by the
advances of the lady, but responds
with gusto. An interesting inversion
of the traditional relationship
between the dominant mentor
and the submissive pupil.

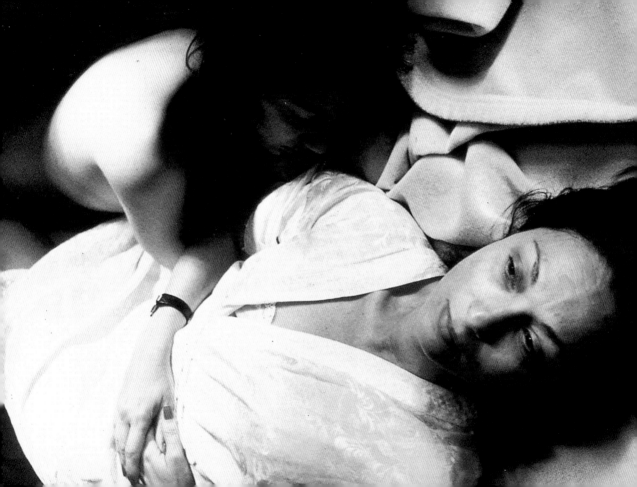

CARUCCI
Untitled
20th Century

*T*HE pressing advances of the naked figure are received ambivalently by the older woman, who seems to be deep in thought. A wry juxtaposition of the simple lust of youth and the complications of maturity.

ELINOR CARUCCI (b. 1971)

SPINKS
Untitled
20th Century

*T*HE sparse visual information here seems to make the image more interesting. The object of inspection—the male—remains a blur, while the woman who looks down toward his groin is more sharply defined and catches the viewer's attention.

TANSY SPINKS (CONTEMPORARY)

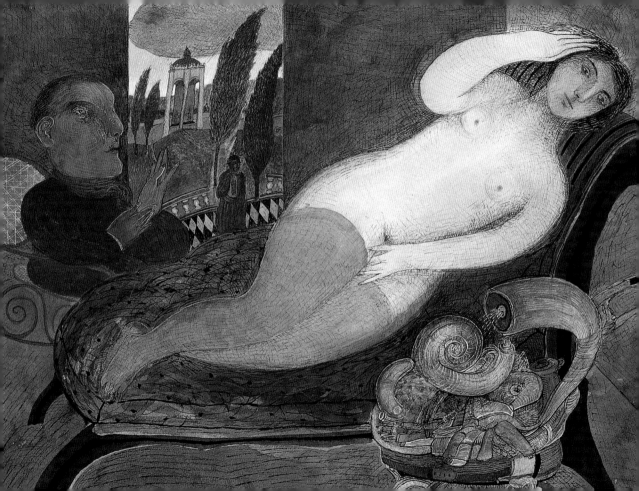

CIENFUEGOS
Woman and Man with the Flowered Robe
20th Century

*T*HE man's isolated position on the chair marks him as an observer for whom the woman on the chaise longue is performing. He sits fully clothed and complacently wide-eyed as she, naked, vulnerable, and compliant, caresses herself. There is another, distant, observer of the scene.

GONZALO CIENFUEGOS (b. 1949)

ROBOZ
Passion
20th Century

*T*HE calm before the storm. In the body language of the man's bowed head and the woman's stretching arm, the artist captures the overwhelming, pent-up passion that, through anticipation, makes the subsequent sexual act all the more pleasurable.

ZSUZSI ROBOZ (CONTEMPORARY)

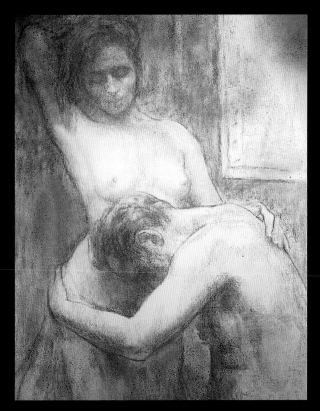

VERBEKE

Neptune, Thetis, and Cupid
20th Century

*T*HETIS is the most celebrated of the Nereides, the marine nymphs of the Mediterranean. Here, she cavorts with Neptune, god of the sea, while Cupid looks on, rather helpfully holding Neptune's trident for him while he is busy. Less obligingly, he is standing on a fish.

Thetis and Neptune's affair was quickly abandoned by the sea-god when it was prophesied that Thetis' son would be more illustrious than his father. Thetis married Peleus, bore Achilles, and the prophesy was fulfilled.

ROMMEN VERBEKE (1895–1962)

RODIN
Eternal Spring
1884

As the title suggests, these lovers represent the "eternal springtime"—that is, the procreative urge, or, more simply, lust. The male figure holds his companion with an arm and a kiss, and she arches her back to display neck and breasts. His knee creeps around toward her groin.

AUGUSTE RODIN (1840–1917)

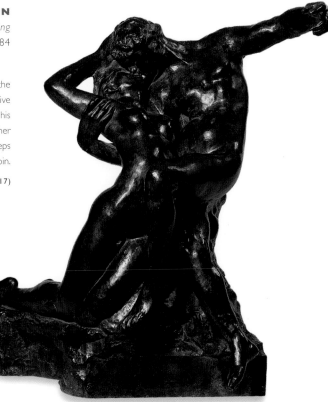

66

There was little she hadn't tried
and less she wouldn't.

99

Joseph Heller (b. 1923) *Catch-22*

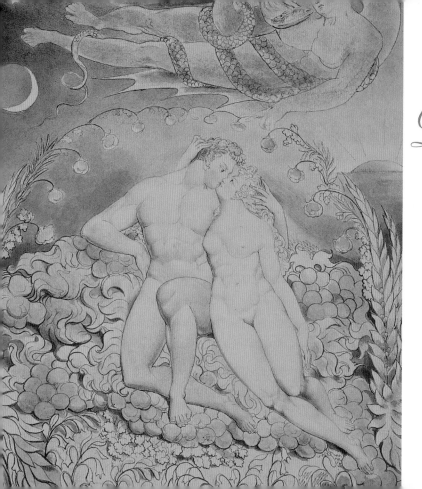

BLAKE

Satan Watching Adam and Eve
c.1807

DESPITE Blake's strong mystical philosophy, there is nothing elusive or enigmatic about his pictures; his spiritual visions are depicted with as much certainty and precision as those of a medieval artist.

WILLIAM BLAKE (1757–1827)

NISLE

Marie M.
c.1850

THIS is another of Julius Nisle's illustrations to an early edition of the memoirs of Casanova (1725–98). The foolish Marie has fallen victim to champagne, and is now in a suitable condition for Casanova's purposes.

JULIUS NISLE (ACTIVE MID-19TH CENTURY)

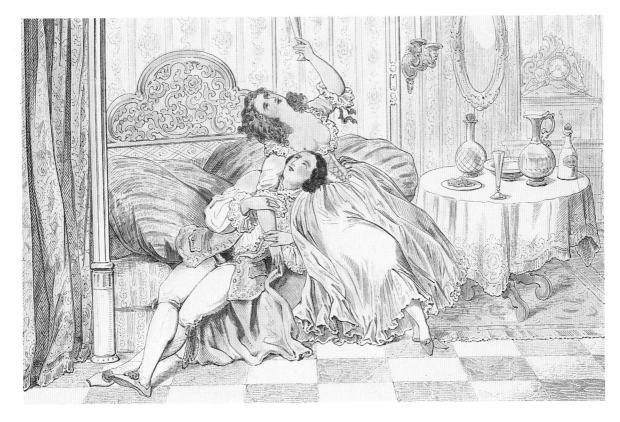

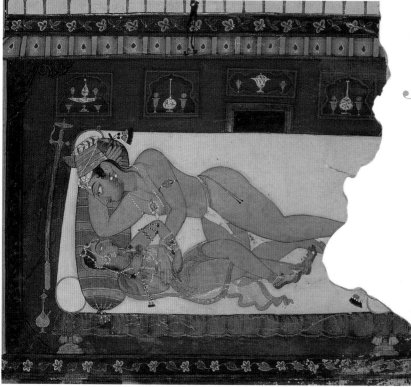

INDIAN

Lovers on a Couch
Late 18th/Early 19th Century

IN this stylized composition, the lovers' couch is shown from above to enable the audience to see what is going on, although the rest of the picture is shown in profile. The result is a curiously intimate image.

INDIAN

A Kiss at the Court (Detail)
Late 18th/Early 19th Century

THE detail and clarity of the bottom half of the picture contrast with the vague, flat expanse above. The cushions are scattered piecemeal over the floor, focusing our attention on the elegant lady and her lover.

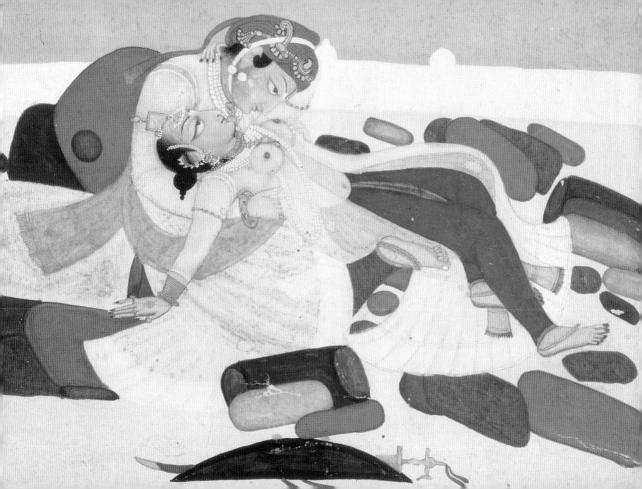

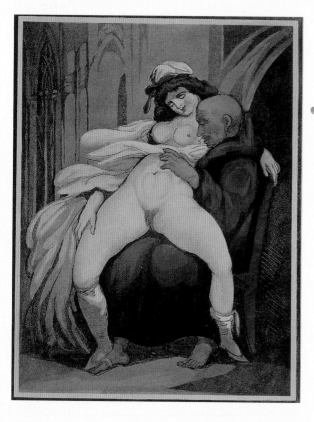

ROWLANDSON
The Clergyman Quenched
1808–17

IN the late eighteenth and early nineteenth centuries there was a great demand for political and social caricatures. Rowlandson's satirical prints and watercolors depict such characters as profligate squires, rapacious lawyers, drunken naval officers, immodest duchesses, and, as in this case, concupiscent clergymen.

THOMAS ROWLANDSON (1756–1827)

ROWLANDSON
Love in a Tub (A Cure for a Cold)
1802

THE age-old practice of lovers sharing a bath. The alternative title, *A Cure for a Cold*, reveals the excuse for their frolics. They are enjoying themselves considerably, apparently unconcerned by the arrival of the woman bringing gruel and a warming pan for their comfort.

THOMAS ROWLANDSON (1756–1827)

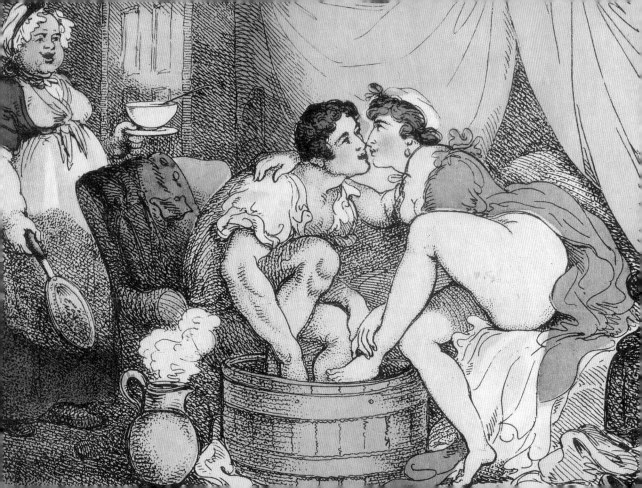

PAHARI SCHOOL

Krishna and Radha (Detail)

c. 1780

RISHNA decorates
Radha's naked
breast and, as she receives this
adornment, she stares into his eyes
with a look of mounting passion.
This picture is an illustration to *Gita
Govinda*, by the twelfth-century poet
Sri Jayadeva. This is the story of the
love of Radha and Krishna, whose
sexual union symbolizes the
culmination of the quest for
communion with God.

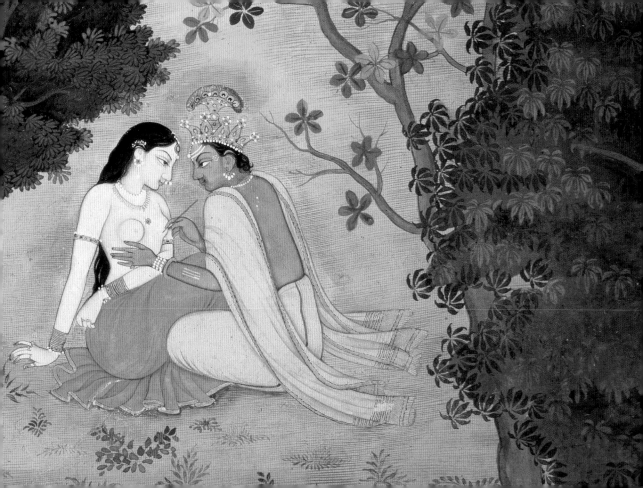

KOONS

Jeff and Ilona (Made in Heaven)
1990

A CLEAN, plastic rendering of the story of the Garden of Eden, which Koons turns into an expression of love by his commentary in the title. The cool, slick style is surprisingly erotic, perhaps because it complements the mock-pornographic pose and lingerie.

JEFF KOONS (b. 1955)

PICASSO
Man and Nude Woman
1970

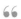N a confusing tangle of flesh, three hands caress the woman's body. A fourth— ambiguously identified as either her right hand or his left—grasps the base of an incontrovertibly phallic sword. The lovers' smiles are all the more suggestive for being understated.

PABLO PICASSO (1881–1973)

❝

I run my fingers down your dress
With brandy-certain aim
And you respond to my caress
And maybe feel the same.

❞

Sir John Betjeman (1906–84)
Late-Flowering Lust

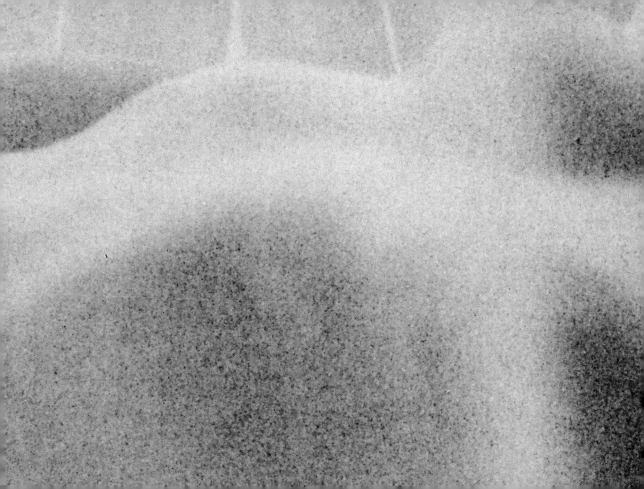

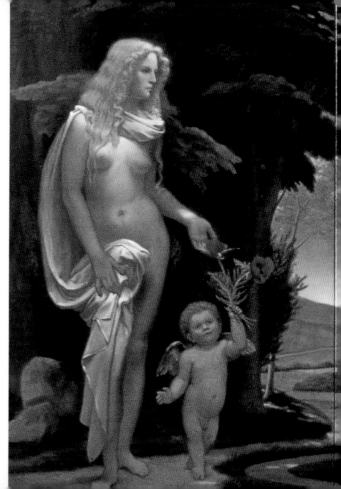

PREVIOUS PAGES
MANN
Untitled
20th Century

*A*N ethereal though impersonal picture; yet somehow the woman's anonymity actually heightens the erotic effect. The viewer sees only part of her body, but it is an intimate glimpse of a woman alone with her sexuality.

ROBERT MANN (b. 1960)

ERLEBACHER
Allegory of Love
1991

*W*HILE nineteenth-century artists often used classical or religious subjects as an excuse to produce erotic work, Erlebacher here uses familiar erotic imagery precisely in order to draw attention to the mythological tradition. This monumental triptych is at once a comment on, and a part of, the grand Western treatment of the erotic theme.

MARTHA MAYER ERLEBACHER (b. 1937)

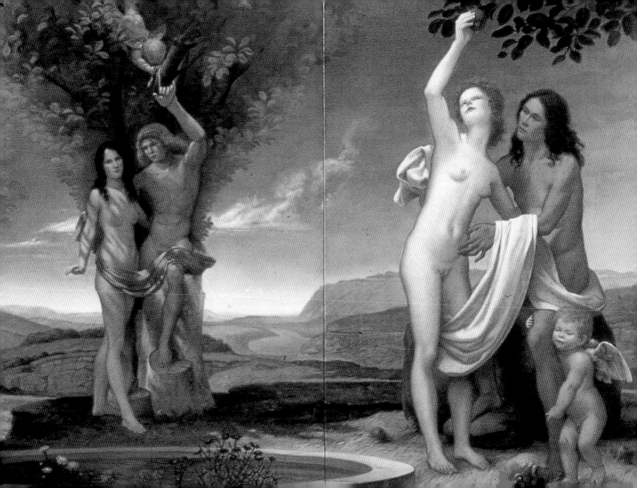

ERLEBACHER
Embrace
1995

A SOPHISTICATED portrayal of primitive passion. Two pale bodies, in a full embrace and at the pinnacle of prepenetration lust, stand isolated in the darkness on a rough, natural floor. The fact that there is no clue in the content to date the picture helps to suggest the timelessness of desire.

MARTHA MAYER ERLEBACHER (b. 1937)

THE PERFUMED GARDEN

Oh, you men who seek for the love and affection of women
and desire to retain them, see that you frolic before
copulation. Prepare her for the enjoyment and let nothing be
neglected to attain this end. Explore her with all possible
activity and, while so doing, let your mind be free from all
other thoughts. Do not let pleasure's propitious moment pass
by unheeded: it occurs when you see her eyes slightly moist
and her mouth partly open. Unite then, but never before.

Sheikh Nefzawi (16th Century)

CHAPTER SEVEN

THE MAIN EVENT

"It all comes to the same thing at the end."

ROBERT BROWNING (1812–89) *ANY WIFE TO ANY HUSBAND*

AMERICAN
Honeymoon Couple
1954

NO MATTER HOW FAR the preludes to the sexual act are biologically based, or to what extent the human animal may view them as pleasurable ends in themselves, ultimately these antics are merely the preparatory ritual for the act that propagates the species. The infinite variety of the preliminaries is delightfully intriguing, but in the end there is a man and a woman having sex.

In prehistoric art, or in that of Ancient Greece or Rome, the sexual act itself could be portrayed in a perfectly straightforward manner, uncomplicated by feelings of guilt. But, since the spread of Christianity, it is rarer to see such frankness in Western art. In the Middle Ages paintings and carvings could be used as a means of

ZICHY
A Deflowering
1911

presenting moral tales, reminding the illiterate populace of the consequences of sin. This provided an excellent opportunity both to depict the sinful acts themselves and to show a bit of sadism in the awful punishments to which they led.

By the Renaissance, classical myths or biblical stories were used to dissociate the scene from everyday experience, and to lend the work an intellectual rather than physical appeal. *Lot and His Daughters*, for instance, or *Jove and Olympia* provided useful subjects; and *Leda and the Swan* even allowed the execution to be quite explicit. Western painters have also used metaphor to deal with the forbidden details of the subject. In the eighteenth century this practice became so refined that a whole visual code developed,

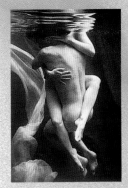

HOPE
First Light I
20th Century

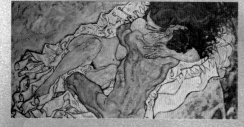

SCHIELE
The Embrace (Detail)
1917

enabling the sophisticated viewer to understand easily the real meaning of apparently innocent things: a violin case representing a vulva, for example, or an upset basket of fruit indicating lost innocence.

Although these subterfuges have been used for years to placate the prude and defy the censor, respected artists have often produced explicit erotic work. Unfortunately, this has frequently been destroyed by their heirs or hidden away in museums and art galleries, only to be seen by special arrangement, and then only by "serious scholars." The paintings of J. M. W. Turner (1775–1851), the photographs of Lewis Carroll (1832–98), and the prints of Thomas Rowlandson (1756–1827) have all suffered in this way.

In recent times it has once again started to become acceptable to depict the act of love without inhibition. In a way this is a pity: we have been robbed of our sense of sin—how much more exciting to know that we are tasting forbidden fruit!

In drawing and painting, and particularly in photography, explicit detail is seen to be the province either of pornography or of the sex-instruction manual. The erotic art of the Middle East, India, and China shows that work can be both beautiful and inspiring, but at the same time provide exact and detailed information on just what goes where, and how. Perhaps future art historians will look at those images we now regard as soft-core pornography and find them quaint, arousing, or even amusing just as we find the capering figures on a Greek vase.

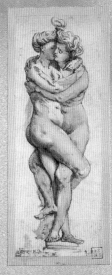

RUBENS
Embracing Couple
17th Century

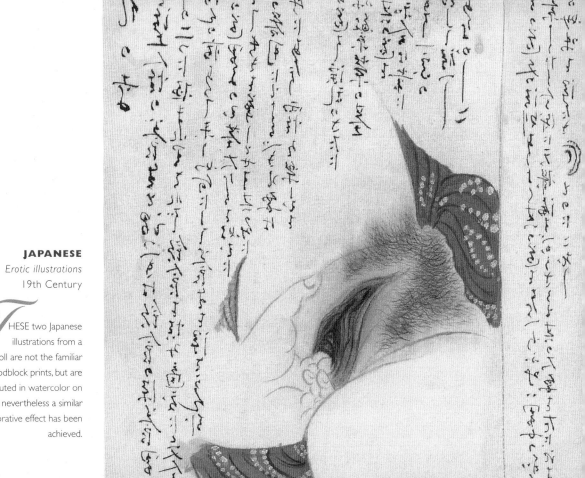

JAPANESE

Erotic illustrations

19th Century

THESE two Japanese illustrations from a scroll are not the familiar woodblock prints, but are executed in watercolor on silk; nevertheless a similar decorative effect has been achieved.

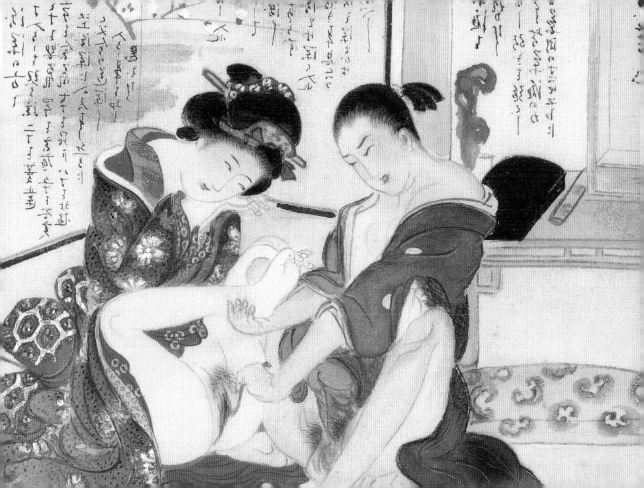

HOLDSWORTH
Lovers Series 7
1981

*T*HERE is a casual morning atmosphere as the couple make love seated in front of a window. Here the act of penetration appears to enhance an almost pantheistic enjoyment of the landscape outside, creating a mood of playfulness . . . with passion.

ANTHONY HOLDSWORTH (b. 1945)

HOPE
First Light 1
20th Century

*T*HIS portrayal of the sexual act recalls pregnancy and birth too; the lovers are suspended in a liquid as in the amniotic fluid of the womb. Hence, perhaps, the title.

CHRISTINA HOPE (CONTEMPORARY)

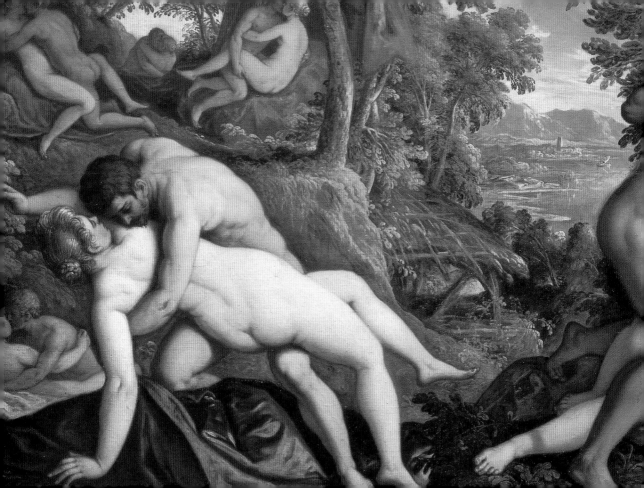

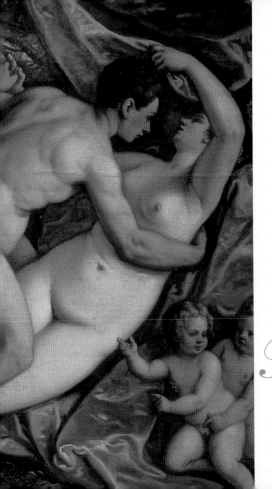

> "
> Methinks I lie all melting in her charms
> And fast locked up within her legs and arms;
> Bent are our minds, and all our thoughts on fire,
> Just labouring in the pangs of fierce desire,
> At once, like misers wallowing in their store,
> In full possession, yet desiring more.
> "

John Wilmot, Earl of Rochester (1647–80) *The Perfect Enjoyment*

FIAMMINGO

Lovers
1585–89

PAIRS of lovers cavort everywhere in a woodland setting. Even the cherubs in the corner, bizarrely, appear to be at it. The natural tone is somewhat let down by the fact that every couple has brought a luxurious blanket to lie on.

PAOLO FIAMMINGO (1540–96)

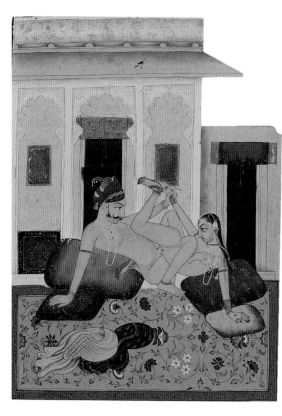

RAJPUT SCHOOL

Lovers (Detail)
18th Century

*T*HESE are royal lovers, making love on a terrace at night. They are employing the "moving forward" position, described in the *Kama Sutra*. Perhaps they are rather unadventurous because this seems to be a standard position where "the organs are brought together, properly and directly." Even so, they do appear to be enjoying themselves.

RAJPUT SCHOOL

Lovers
1790

*T*HIS is a complicated sexual posture of the sort to be encountered in the *Kama Sutra*. The *Kama Sutra* of Vatsyayana has been the standard Hindu work on love for many centuries. Apart from precise instructions on methods of copulation, it deals with the etiquette of sexual encounters, and also gives advice on such problems as how to seduce other men's wives.

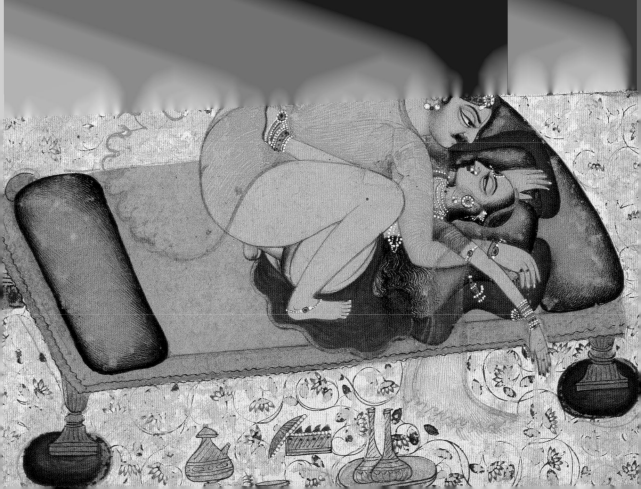

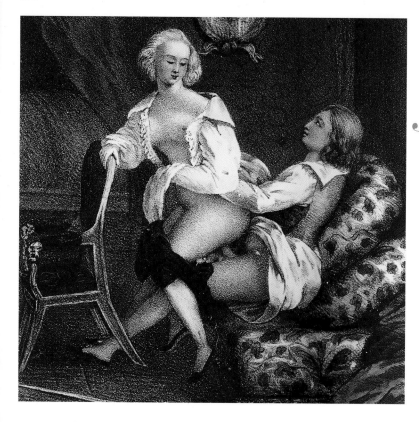

FRENCH

La Marquise de B . . . chez Faublas (Detail)
1840

FAUBLAS entertains an unnamed, presumably married, young noblewoman, who lowers herself onto him with considerable delicacy. The sword on the floor makes a clear enough symbolic contribution, but one that is hardly necessary.

66
Though his little was but small,

Yet she had his little all.

99

Nursery Rhyme

ENGLISH

Erotic Scene (Detail)

Late 18th Century

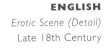 N erotic scene with an amusing twist:
a man barges in, pointing to his erect
penis as if to offer his services, much to the chagrin of
the impotent lover. It remains to be explained how
the intruder got to hear about the vacancy.

317

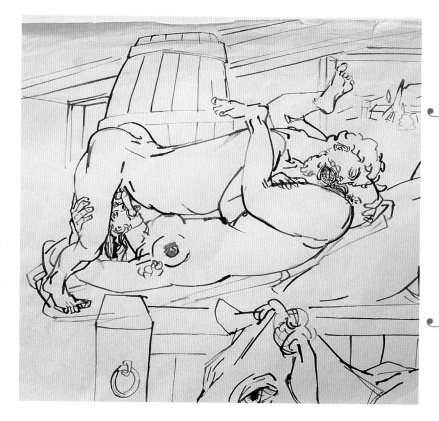

HOLDSWORTH

Lovers Series #11
1981

THE modern counterpart of the bawdy rural print. Exaggerated proportions provide a comic tone, accentuated by the cow's head poking into the bottom of the picture.

ANTHONY HOLDSWORTH (b. 1945)

EISEN

Couple Having Sexual Intercourse
19th Century

THE main physical act is emphasized here by isolating it from trivial surroundings. Only the screen behind the lovers, which gives them location, and the enveloping blanket, providing them with intimacy, are given either detail or color.

KEISAI EISEN (1790–1848)

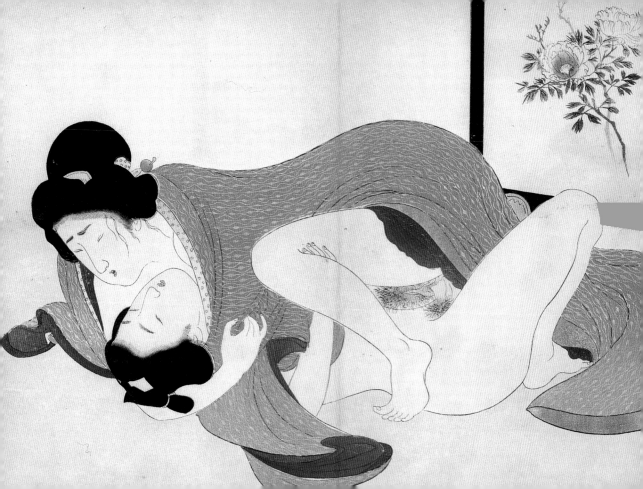

KLIMT

Lovers

1908

ALTHOUGH dating from Klimt's spectacular "golden period," this drawing is extremely sparse, using nothing but the barest outline of the couple. Nevertheless, it captures the moment perfectly.

GUSTAV KLIMT (1862–1918)

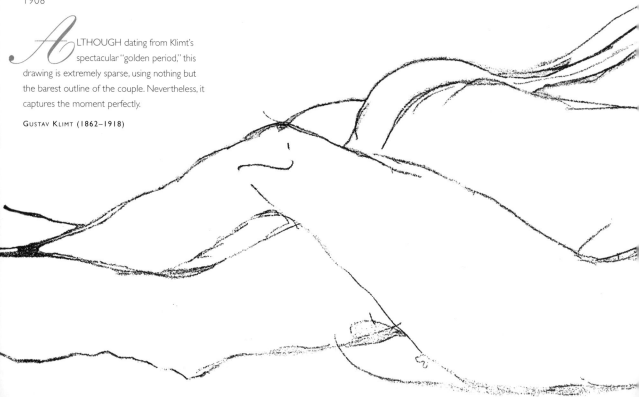

HOLDSWORTH

Lovers Series 15
1985

*T*HIS is a monotype, the simplest of all printing processes, so called because only one impression can be taken. Often, as here, the medium can be engagingly direct.

<small>ANTHONY HOLDSWORTH (b. 1945)</small>

CAMPOS

The Paws that Refreshes (with Apologies to Correggio)
1991

*I*N the original painting by Correggio (c.1494–1534, real name Antonio Aleggri da Correggio), Zeus the thunder-god ravishes Io while in the form of a rain cloud. Here, Campos identifies the source of Io's ecstacy as a cloud of tobacco smoke. The resulting painting is erotic, droll, and cautionary.

<small>PABLO CAMPOS (b. 1947)</small>

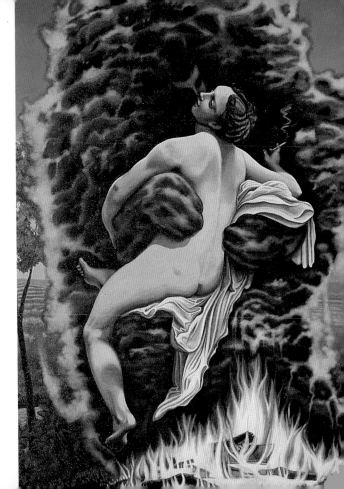

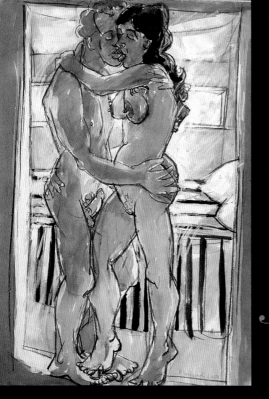

HOLDSWORTH

Lovers Series #8
1981

*H*OLDSWORTH creates strong
forms in charcoal and ink. The figures
are darker in tone than the bed in the background
which seems to be illuminated, suggesting that this
will be their inevitable destination.

ANTHONY HOLDSWORTH (b. 1945)

"
So the man tried various postures, and
then when he came to one called
Pounding on the Spot, he saw that the
woman's pleasure was intense.
"

Sheikh Nefzaris (16th Century)
The Perfumed Garden

HOLDSWORTH
Lovers Series #16
1985

A DELICATE balancing act and a complicated
feat of maneuvering, Holdsworth captures
the moment beautifully, in respect to both the difficulties of
their physical positions and urgency of their desire.

ANTHONY HOLDSWORTH (b. 1945)

325

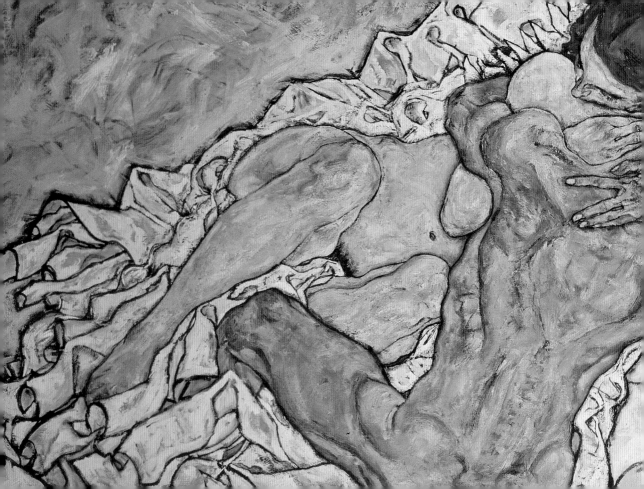

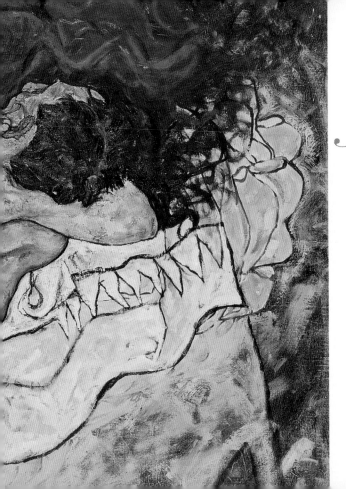

SCHIELE

The Embrace (Detail)
1917

*S*CHIELE was once a disciple of Klimt, but his style matured into a kind of erotic Expressionism. This picture, painted a year before his early death in 1918, shows all the characteristics that saw him both feted as a major artist, and imprisoned for indecency.

EGON SCHIELE (1890–1918)

66

It is not enough to possess her. I want her to abandon herself.

99

Pierre-Ambroise Choderlos de Laclos (1741–1803)
Les Liaison Dangereuses, Letter 110

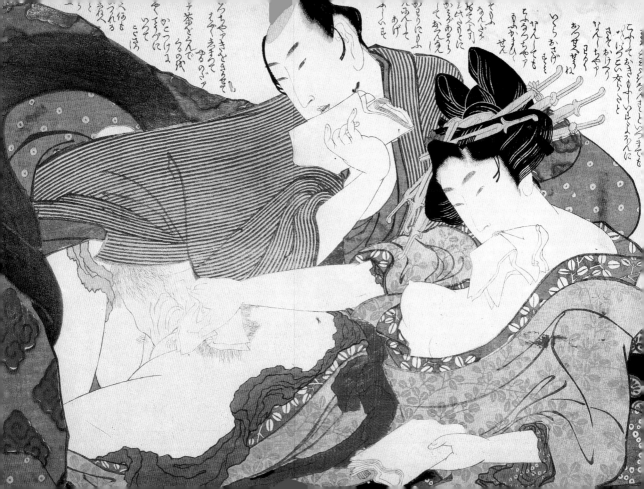

HOKUSAI

Lovers on Cushions
Early 19th Century

HOKUSAI is perhaps the best known Japanese artist in the West. He combined diverse traditional styles, often moving on to study under a new master after a quarrel with the old one. This exquisite and explicit print probably shows him at his best.

KATSUSHIKA HOKUSAI (1760–1849)

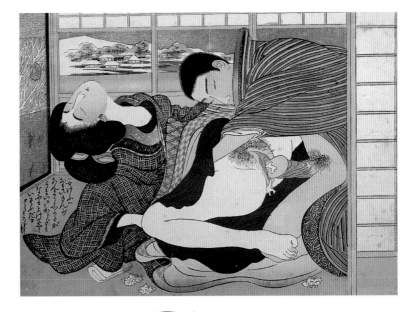

SHUNCHO

*Making Love
in Winter*
Late 18th Century

THE moment of climax is rarely depicted directly in any artistic canon. Here it is treated frankly, yet with a little humor; the flushed faces of the lovers is a clever, human touch.

KATSUKAWA SHUNCHO (ACTIVE 1770–1790)

RUBENS

Embracing Couple
17th Century

*T*HIS drawing of a pair of intertwined lovers demonstrates Rubens' magnificent draftsmanship. There are relatively few marks, with just a little white chalk to bring out the highlights, but we understand the weight and balance of their bodies, and their flesh is the flesh of real people and not the idealized smooth and faultless substance of many artists' work.

PETER PAUL RUBENS (1577–1640)

66

She was very salacious, and ... when the Stallions
were to leape the Mares she had a vidette to looke on them
and please herselfe with their Sport; and then she would act
the like sport herselfe with her stallions.

99

John Aubrey (1626–97) *Brief Lives*

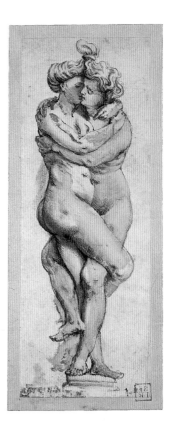

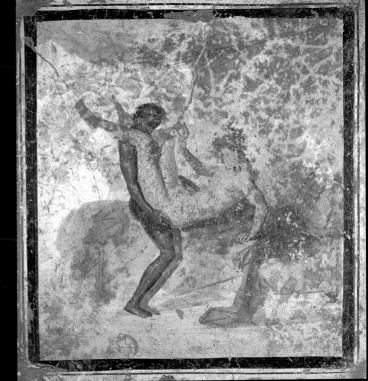

ROMAN
Erotic Scene
1st Century

THIS is an erotic mural from Pompeii. In 79 AD Vesuvius erupted and the city of Pompeii was completely engulfed by lava and volcanic ash. This had the effect of preserving the remains until they began to be excavated in the eighteenth century. Among the thousands of archaeological treasures that were revealed were a large number of erotic frescos, mosaics, sculptures, and objects.

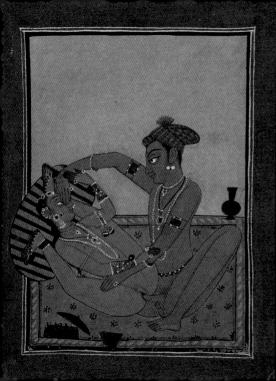

INDIAN

Lovers

18th Century

*T*HE woman lies on a cushion with her feet behind her shoulders, while the man squats on the rug and grasps her nose with his right hand (the thumb of which seems to be on the wrong side). This is a tricky posture that only the most expert of lovers should attempt—it is not even advocated in the *Kama Sutra*.

CHINESE

The Lying Horse

c. 1850

*T*HIS illustration shows a Mongol horseman and his concubine. Mongol warriors were inseparable from their horses, sometimes eating and sleeping in the saddle. Here, the horse cheerfully plays his part in the amorous affairs of his master.

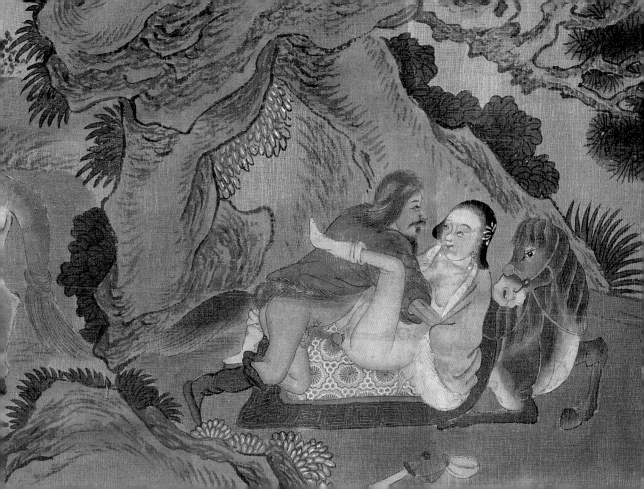

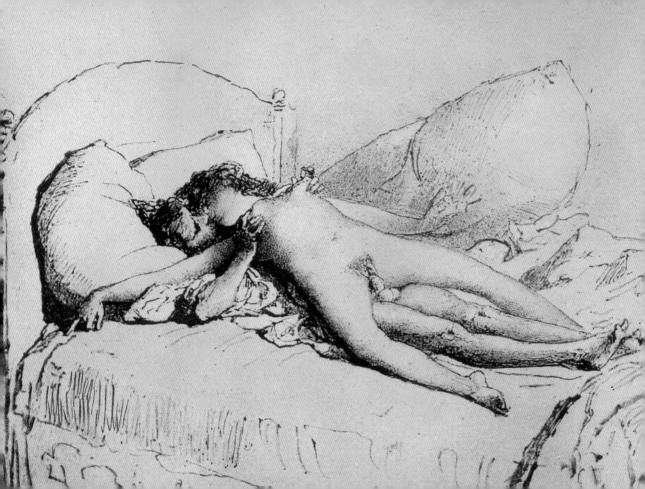



ZICHY

Couple Having Sex
1901

THIS is a plate from *Liebe* or *Love*, published in Leipzig in 1901. It is very unlikely indeed that anything like this could possibly have been published in Britain or North America in the first years of the twentieth century.

MIHALY VON ZICHY (1827–1906)

REUNIER

A Passionate Role
20th Century

THIS comes from *The Tower of Love*, published in the 1920s. It could still not have been published in Britain. At this time, even serious novelists, such as James Joyce or D. H. Lawrence, had to have some of their books published abroad in order to avoid prosecution for obscenity. These included *Ulysses* by Joyce, published in Paris in 1922, and *Lady Chatterley's Lover* by Lawrence, published in Florence in 1928.

REUNIER (ACTIVE DURING 1920s)

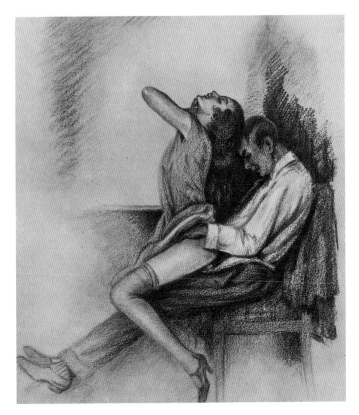

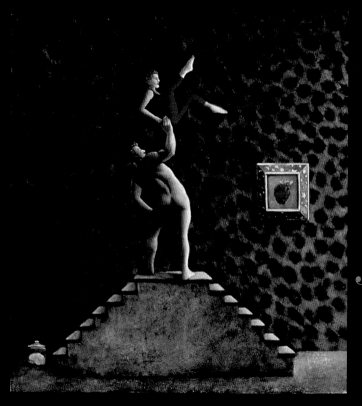

EVANS
Prince Charming
1997

A THOROUGHLY symbolic image of sex and love. The notion of masculine performance is paramount: Prince Charming demonstrates his physical prowess and his control over the elegant, passive female. Her heart is shown pierced, level with his navel; her brain remains grounded and unimpressed by his display.

CYNTHIA EVANS (b. 1951)

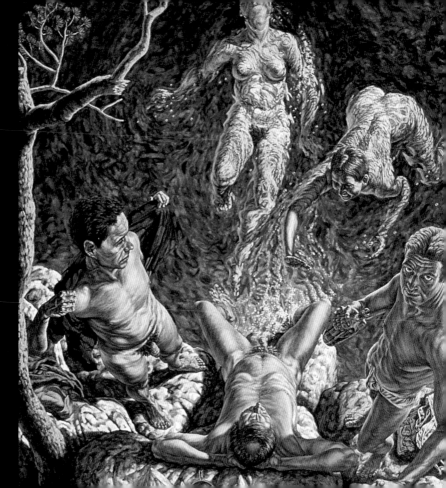

HESS

Edge of the Wilderness
1987

AWAY from the busy urban centers, a group goes skinny-dipping. They are free from social constraints, and show varying degrees of comfort with the situation. How far into the wilderness can they go, yet still be sure of finding their way back safely?

F. Scott Hess (b. 1955)

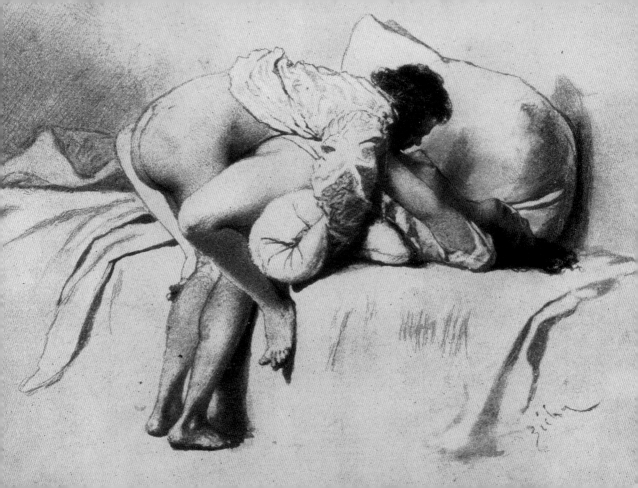

ZICHY

A Deflowering
1911

A VERY convincingly erotic drawing. The woman is losing her virginity; her toes curl up, she throws back her head, and she arches her back in an ecstatic spasm. Perhaps satiety will bring regret, but for now she is lost in physical pleasure.

MIHALY VON ZICHY (1827–1906)

ZICHY

Happy Memories
1911

THIS looks like an extremely demanding posture. They are both enjoying it enormously at the moment, but, for the man at least, severe back trouble may be what he has to remember it by.

MIHALY VON ZICHY (1827–1906)

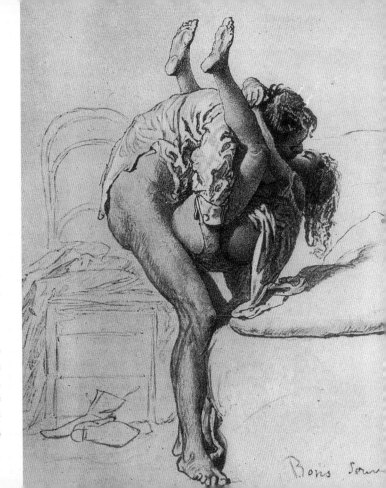

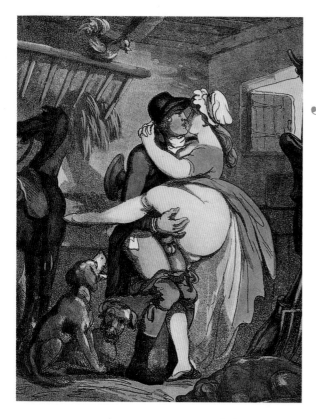

ROWLANDSON

The Farmer and the Milkmaid

1808–17

A FARMER takes advantage of a very buxom and accommodating young milkmaid. Most satirical prints of this period are simple line etchings, which were hand-colored by assistants working to the artist's directions. Some print-sellers, however, specialized in higher quality prints; and this example is an aquatint, a process that allows a full range of tones to be etched onto the plate itself.

THOMAS ROWLANDSON (1756–1827)

ROWLANDSON

The Country Squire New Mounted (Detail)

1808–17

A FAVORITE subject for caricature was the hypocrisy of respected members of the community, particularly when they were out of their normal milieu. Here, the squire has come up to London and has found himself a spirited new mount.

THOMAS ROWLANDSON (1756–1827)

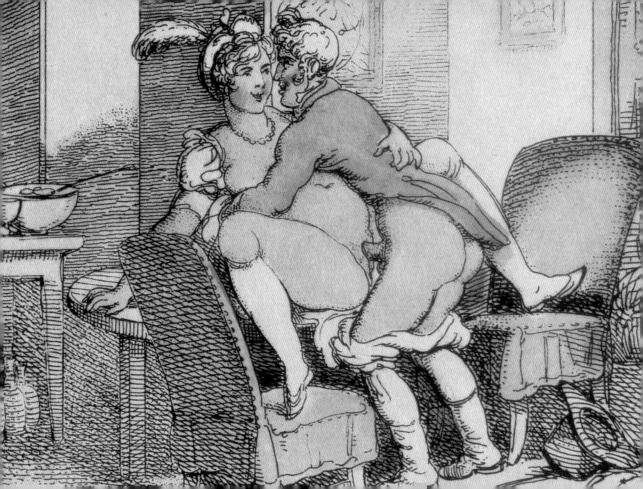

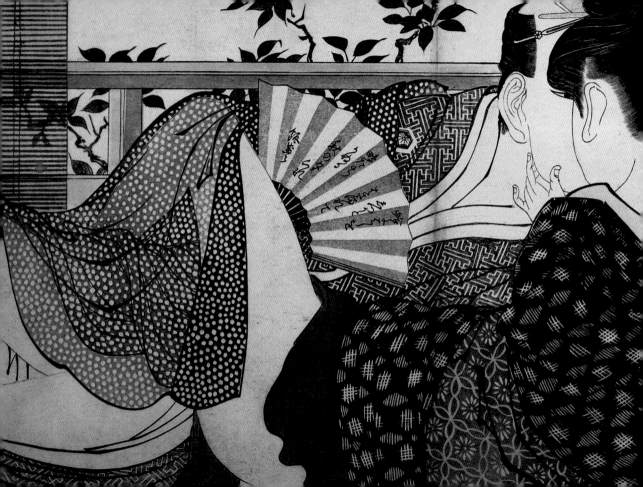

> 66
>
> Therefore, oh men, when you have brought woman to the
> favorable condition, introduce your member; then if you take
> care to move in the proper manner, she will experience a
> pleasure that will satisfy all her desires.
>
> 99

Sheikh Nefzawi (16th Century) *The Perfumed Garden*

UTAMARO

Lovers

c. 1788

*T*HIS woodblock print comes from *Uta-makura*,
or *The Poem of the Pillow*, which is one of the most
celebrated of Utamaro's many erotic books.

KITAGAWA UTAMARO (1753–1806)

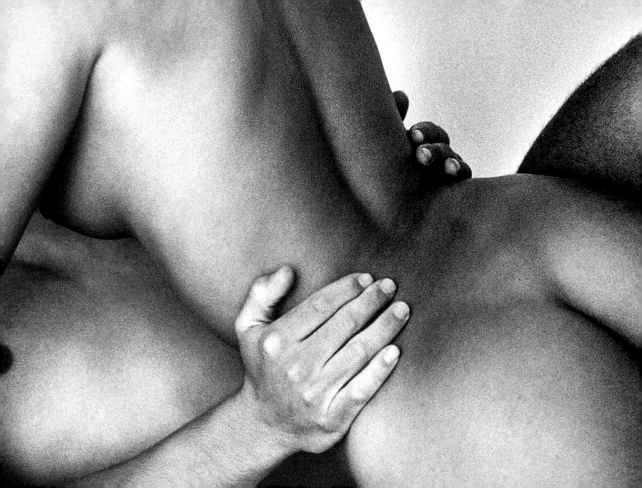

PARK
Untitled
20th Century

*H*E lies back, hands holding her waist but not controlling her, rather letting her do as she will. The camera is an intruder, but it is ignored, quite unable to penetrate their intimacy. The moment is between them alone.

CLARE PARK (CONTEMPORARY)

TENNESON
20th Century

*A*LL the rituals and responses of courtship have been completed. Their bodies clasp together and her legs wrap around his thighs. Nothing will divert them now.

JOYCE TENNESON (b. 1945)

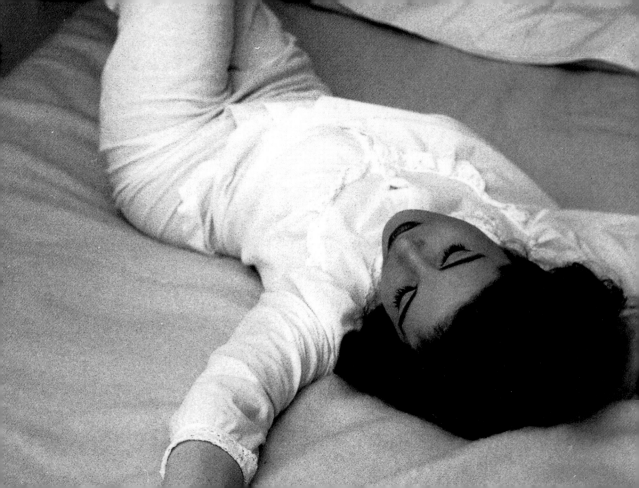

THE AFTERGLOW

"How lazy, a woman's first words after love-making; how husky and bare."

STANLEY KAUFFMANN (B. 1916) *THE PHILANDERER*

JACOBSEN
Relaxing
c. 1956

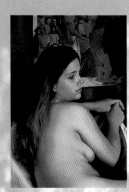

CORRY
Overture (Detail)
1994–96

WHEN ALL THE FLIRTING and fencing, sweating, sighing, and seduction have reached their goal, there are the rewards—first physical and then emotional. After the fever of desire and the climax of ecstasy come pleasant lethargy and languid feelings of well-being. John Cleland's *Fanny Hill* (published 1750) puts it rather well: "Giddy and intoxicated as I was with such satiating draughts of pleasure, I still lay on the couch, supinely stretched out, in a delicious languor, diffus'd over all my limbs . . ." The wild transports have been exhausted; as libido relaxes its wanton grip, the embraces become more affectionate and the caresses almost chaste. The lovers know they will soon be driven to repeat their lovemaking, but this time it will be long and slow and sensuous.

Artists have often recorded this happy state; usually in a fairly guarded way, but still we know perfectly well what has just happened—there are usually sufficient visual clues to indicate that this is not just another nude scene. Then there are those cheerfully frank smiles of satisfaction that make some eighteenth-century prints so endearing.

KAUFMANN
Perspective (Detail)
1997

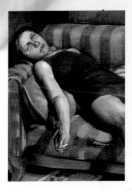

But the aftermath of love is not always so agreeable. Men know well that instant when urgency evaporates and returning consciousness drags them, unwilling, back to cold reality. And for women, too, climax can lead to anticlimax. Sometimes the reaction is merely prosaic; the need for a cigarette, or a sudden appetite for a large steak. Sometimes there is the vague depression of postcoital *tristesse*, or a sharper stab of conscience—a vision perhaps of a loved

one's trust betrayed. Sometimes the moment is spoiled by fear when the lust that made us so brave has subsided. There are those age-old fears—fear of discovery, fear of pregnancy; or that fear, ever-present in the 1950s: "Will he still respect me now, now he's got what he wanted?"

Whenever desire has been realized in that strange physical act, things are different. And if it is "The First Time," then things are changed forever: ruin or triumph, disappointment or transports of delight. It may be that a true pair-bond has been established: "I didn't know it could be like this! Now you are mine and I am yours." (This, in turn, provides another favorite theme in art: lovers separated.)

TOULOUSE-LAUTREC
The Bed (Detail)
1893

Or it may be that virtue and reputation have been surrendered: "What have I done?" being the immediate reaction. In the past the consequences for women could be very much more severe than they were for men. William Hogarth's (1697–1764) two paintings, *Before* (p.69) and *After* (pp.370–71), neatly illustrate the changing emotions and the changed circumstances brought about in so short a time. For the man the fun is over, leaving him disheveled and foolish, but for the woman all may well be lost forever.

Whatever follows lovemaking, whether it be a sweeter and more tender passion, or fear, guilt, and regret—and no matter if the further consequences be romance, tragedy, or farce—artists have found the whole business to be a rich source of material.

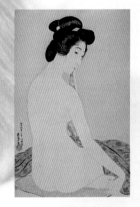

HASHIGUCHI
Woman After the Bath
1920

351

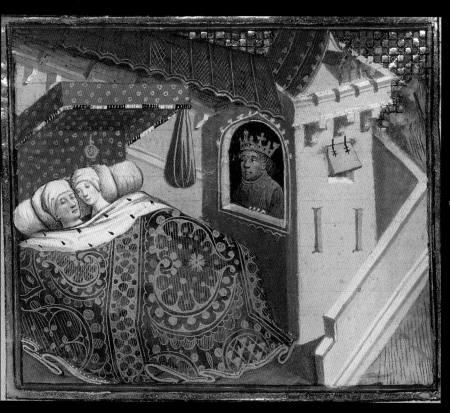

FRENCH

15th Century

*L*ANCELOT and Guinevere lie happily in bed together in a pleasant torpor after the exertions of sexual congress. King Arthur looks out at his adulterous wife and her lover with a glum but resigned expression on his face. Although Lancelot is always represented as the very model of chivalry, it was his disgraceful affair with Guinevere that led to war and the death of Arthur.

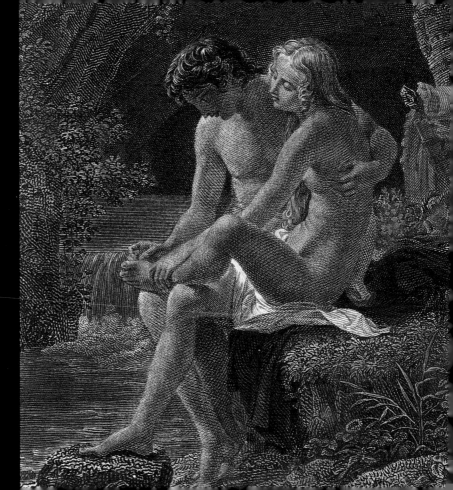

AFTER

HERSENT

Daphnis and Chloe (Detail)
1812

DAPHNIS tenderly removes a thorn from Chloe's foot. In Greek mythology, Daphnis was a Sicilian shepherd, the son of Hermes and a nymph. He was taught to play the pipes by Pan, and was regarded as the inventor of pastoral poetry. In a romance by Longus (third century) he loves the shepherdess, Chloe; but, in other versions, he was struck blind by a naiad to whom he had been unfaithful.

ENGRAVING BY JEAN PIERRE LARCHER
(b. 1795–DEATH DATE UNKNOWN)
AFTER A PAINTING BY LOUIS HERSENT
(1777–1860)

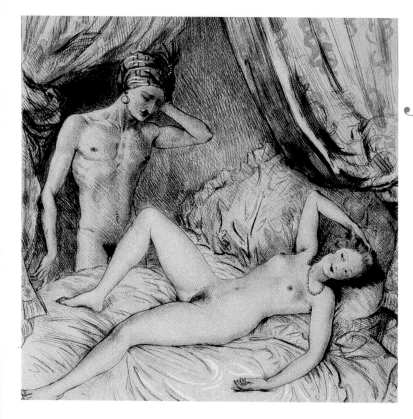

BÉCAT

Les Bijoux Indiscrets (Detail)
1939

THE man in this picture seems to be suffering from a touch of post-coital *tristesse*—or perhaps a bit of a headache? Not so the woman, she is still full of life, lying in a provocative pose and giving him a sidelong look. She is quite ready to resume their passionate labors.

PAUL-EMILE BÉCAT (ACTIVE MID-20TH CENTURY)

NISLE

Christine
c.1850

CASANOVA, the archetypal predatory lover, leaves his prey asleep and satisfied. He is discreet enough to be gone by morning, yet tender enough to cover her sleeping form, and give her one last, lingering look, before he goes.

JULIUS NISLE (ACTIVE MID-19TH CENTURY)

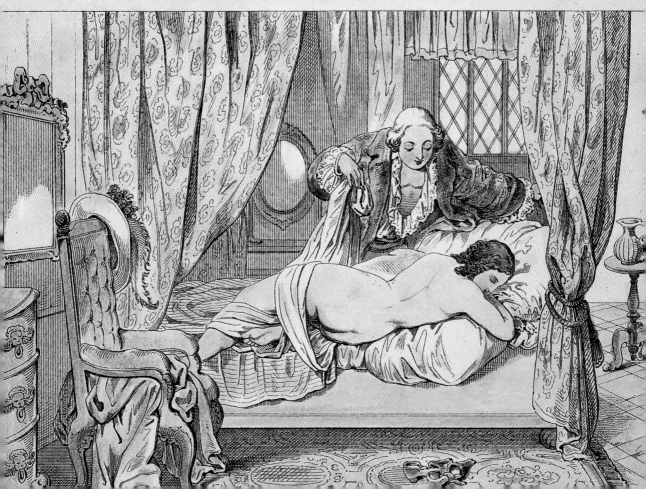

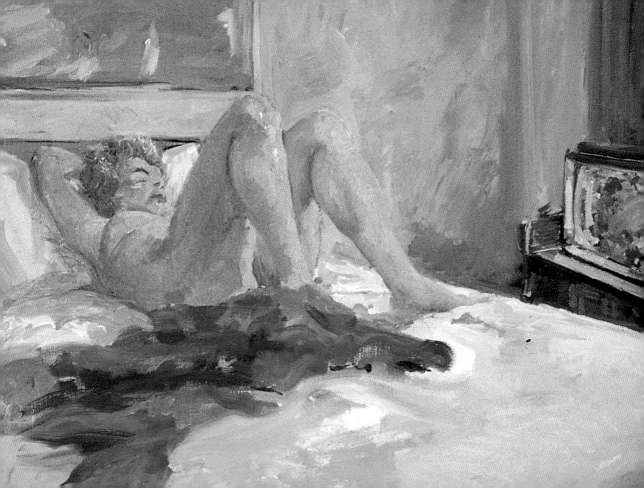

PREVIOUS PAGES

FISCHL
Motel
1984

A COUPLE
lie entwined
together, tired and
fulfilled, but still absorbed
in each other. In another
room, a woman lies
naked and lonely on the
bed; her only solace is the
television.

ERIC FISCHL (b. 1948)

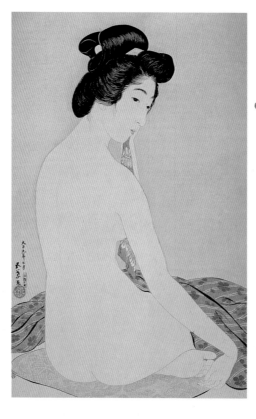

HASHIGUCHI
Woman After the Bath
1920

A VERY late color woodblock
print, simple in design and
perhaps influenced by the increasingly
well-known Western canon. Certainly
the anatomical precision is out of
keeping with earlier Japanese erotica.

GOYŌ HASHIGUCHI (1880–1921)

KUNIYOSHI
All Passion Spent
c.1855

K UNIYOSHI was a member of the
Utagawa school, which has a
poor reputation because of the large number of
mediocre prints it produced. But this example is
delightful; the man quietly pouring himself a cup
of tea while his lover sleeps.

UTAGAWA KUNIYOSHI (1797–1861)

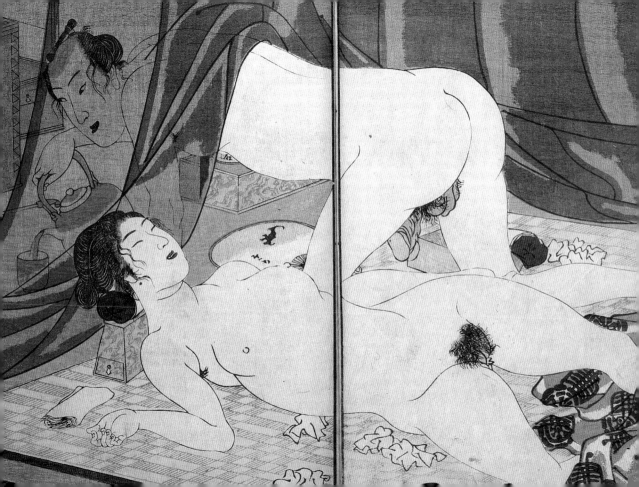

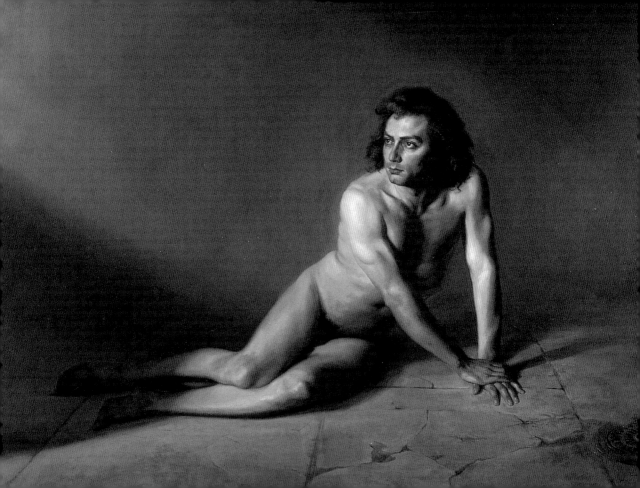

GRAVES
The Prisoner
1998

PERHAPS this prisoner allowed himself to be imprisoned by his own desires, and, now that his lust is quenched, he can look up to the light and to his escape.

C. DANIEL GRAVES (b. 1949)

YASKULKA
Opal Moon
1998

OPAL is said to bring bad luck, but it also symbolizes hope. Here, as the woman thoughtfully caresses her lover, there is an air of quiet strength of spirit in the face of adversity.

HAL YASKULKA (b. 1964)

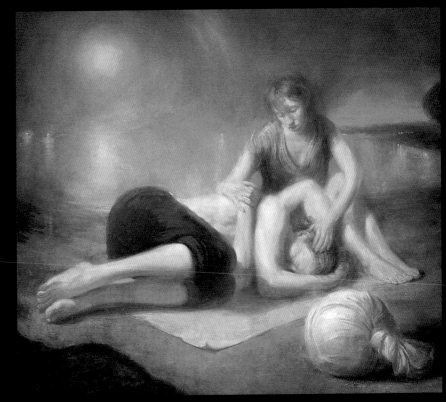

361

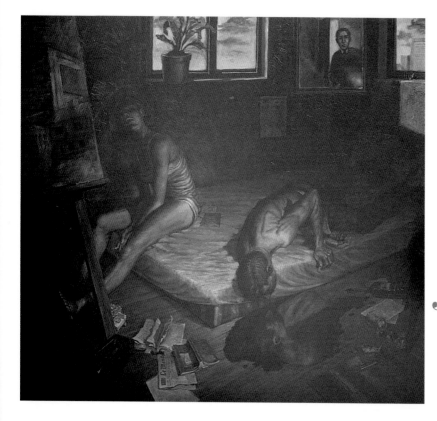

66

'Darling,' she whispered again, and her eyelids lowered and rose, 'you're terrific . . .' He shuddered secretly.

99

Stanley Kauffmann (b. 1916)
The Philanderer

KAUFMANN
In and Outside
1996

A COUPLE in a dirty artist's studio, after sex, are surrounded by a set of puzzles with no solution. The multiple, disparate images can only be reconciled if some are real and others artificial—but which are which?

RUPRECHT VON KAUFMANN (b. 1974)

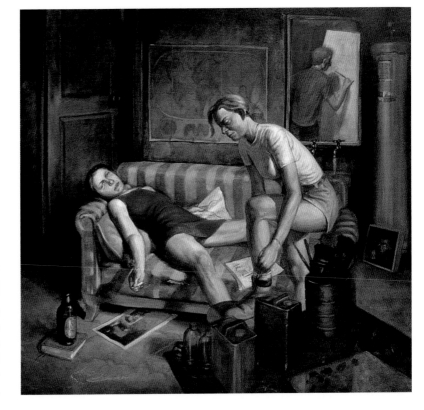

KAUFMANN

Perspective

1997

*A*GAIN, von Kaufmann gives us an ambiguous picture based on art, illusion, and reality. The artist in the mirror may be painting one or both of the women; he may even be von Kaufmann, painting himself. The wanton figure on the couch commands attention.

RUPRECHT VON KAUFMANN (b. 1974)

PATRICK
Levitation (Detail)
20th Century

A WOMAN rises over strange, gloomy waters. She seems to be in a dreamlike state, as though perhaps her desires have been satisfied. Yet this is not a pleasant, comfortable torpor—she appears to be haunted by dark and dreary visions.

IAN PATRICK (CONTEMPORARY)

VAN KATUIJK
Untitled
1995

T WO naked figures lie among nebulous draperies, presumably exhausted after sexual excesses. The textures and tones used contribute to its heavy air of lassitude.

JOKE VAN KATUIJK (CONTEMPORARY)

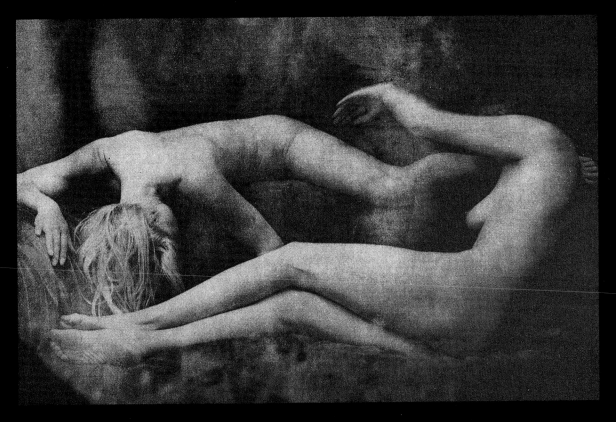

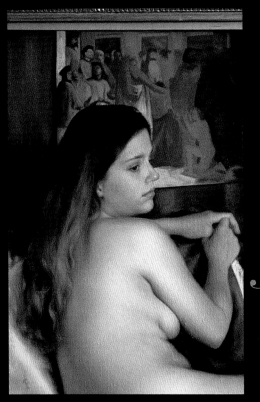

> ❝
> Do not drink rainwater immediately after coition as it tends to weaken the loins. It is advisable to rest after coition and not to indulge in violent exercise.
> ❞

Sheikh Nefzauri (16th Century)
The Perfumed Garden

CORRY
Overture (Detail)
1994–96

THIS young woman is awake, watchful, and thoughtful. An air of mistrust and doubt pervades the painting; it is surely no accident that the model's pose is unflattering. Quite another aspect to the postcoital experience.

KAMILLE CORRY
(b. 1966)

TOULOUSE-LAUTREC
Two Friends
1895

ONE of the women lies asleep while her friend looks around at the viewer with a rather self-satisfied, yet challenging, expression on her face, as though she is expecting censure for her recent activities.

HENRI DE TOULOUSE-LAUTREC
(1864–1901)

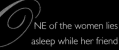

GREEK

Sleeping Hermaphrodite
2nd Century BC

ERMAPHRODITUS was the beautiful son of Hermes and Aphrodite. The nymph of the fountain of Salmacis fell in love with him, but he was unmoved by her advances. One day, when he was bathing naked in the fountain, she embraced him closely and prayed to the gods to be united with him forever. Her request was promptly granted, and their bodies became fused into a single body that exhibited the characteristics of each sex.

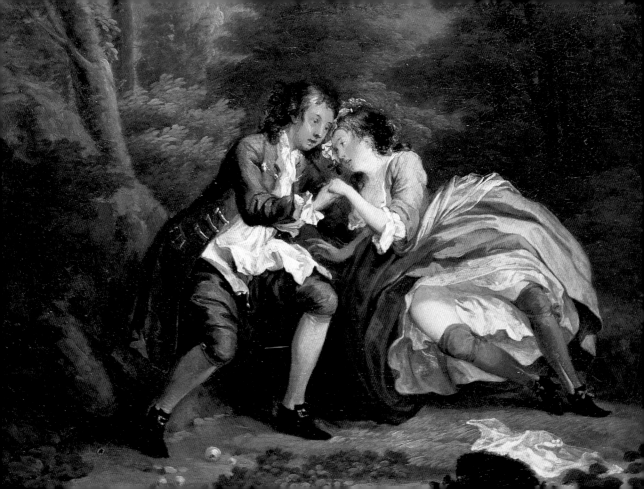

HOGARTH
After
c. 1730–31

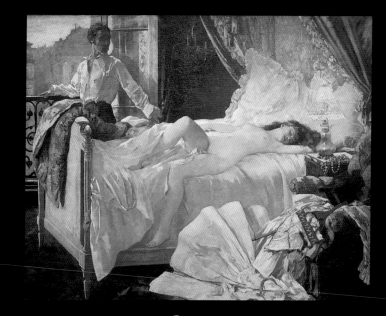

*N*OW that the blind, wild passion of lovemaking is over, the couple is left disheveled and bewildered. The woman's fruit has been spilled, symbolizing her lost virtue. They regret their folly, and she faces an awful, cold reality; but he continues to hold her hand in a tender gesture. This is the second of a pair entitled *Before* and *After*.

WILLIAM HOGARTH (1697–1764)

Behind the concrete bunkers
Two lovers unstick themselves.

Sylvia Plath (1932–63) *Berck-Plage*

GERVEX
Rolla
1878

A painting to accompany Alfred de Musset's (1810–1857) epic *Rolla*. Like the poem, the image is bitter-sweet—hedonistic and pathetic, tender yet pessimistic.

HENRI GERVEX (1852–1929)

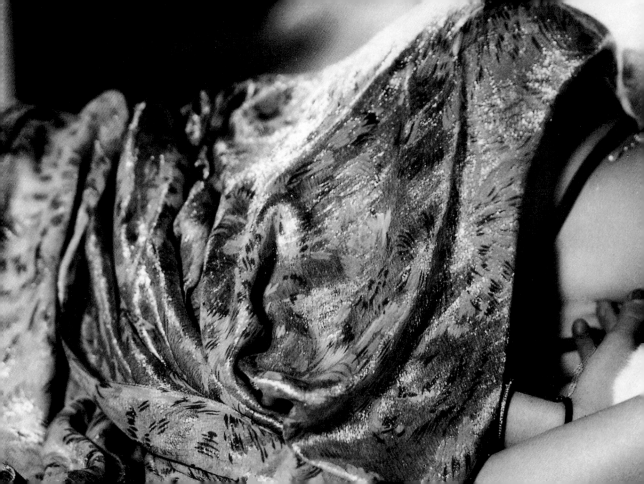

> 66
> Never were two more suited, each one's shame
> answered with, first, affection, then desire:
> now I lie sleepless dwelling on your shame,
> and shamelessly desiring your desire.
> 99

Robin Skelton (1925–1998) *You Were Ashamed*

SASHA

Sleepy Margot
1933

THIS photograph shows the British movie star Margot Grahame (1911–82), lying in her bed, in full makeup and wearing her jewelry. As she gazes into our eyes, she looks as though she is enjoying that sweet sadness that so often follows the voluptuous pleasures of the flesh.

SASHA (1892–1953)

HOWARD—V[?]
March 1842
N° 13

FROST

*Life Study of Female
Figure*
1842

HEN artists
are engaged
in life drawing and
painting, the degree of
concentration required
often means that the
sexual attractions of
the model are soon
forgotten. This picture,
however, is full of erotic
overtones—the
woman lies relaxed,
and yet it seems to be
a repose born of
sexual satisfaction.

WILLIAM EDWARD FROST
(1810–77)

GROSZ

Afterwards
c. 1939

HE woman in this pen-and-
watercolor drawing is treated
in an unusually sympathetic way
for Grosz. Much of his best-
known work is social and political
satire, in which he depicts
characters such as prostitutes
and profiteers as repulsively
ugly and deformed.

GEORGE GROSZ (1893–1959)

HESS

Dear Katie

1996

EMPTY oyster shells, dried slices of lemon, pieces of nutshell, and an upturned champagne bottle tell of consumed pleasure; similarly, the scribbled note and sheaf of money are the only remains of a lover.

F. Scott Hess (b. 1955)

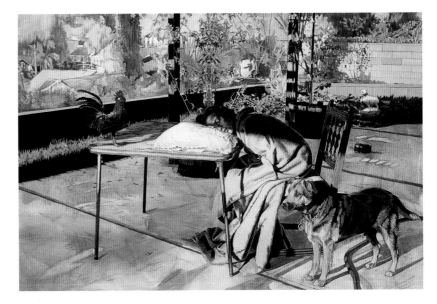

> 66
> Kissing don't last:
> cookery do!
> 99
>
> George Meredith (1828–1909)
> *The Ordeal of Richard Feverel*

WICKMAN

Passion Painting

1997

THE excellent evocation of morning sunlight makes this peculiar subject seem all the more strange. The fact that the woman is sleeping through the cockerel's call gives us a clue about last night; now, with the dawn comes another day.

Patty Wickman (b. 1959)

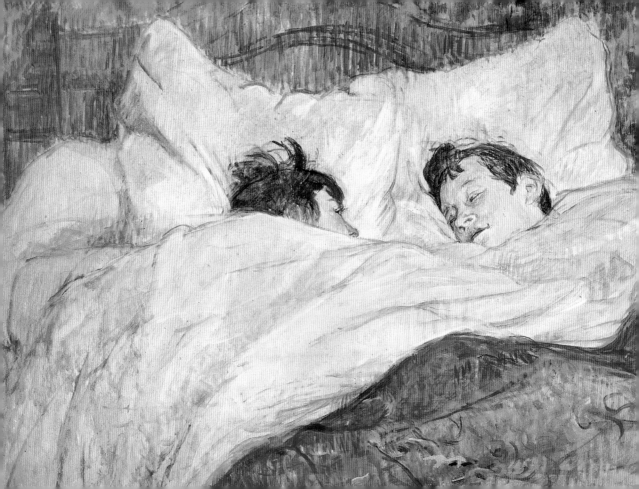

TOULOUSE-LAUTREC

The Bed

c. 1893

*T*HEY are no longer driven by the urgency of their passion, but affection remains. They continue to gaze at each other in a rather somnolent way, and yet there is a look in their eyes that suggests that sleep may be postponed.

HENRI DE TOULOUSE-LAUTREC
(1864–1901)

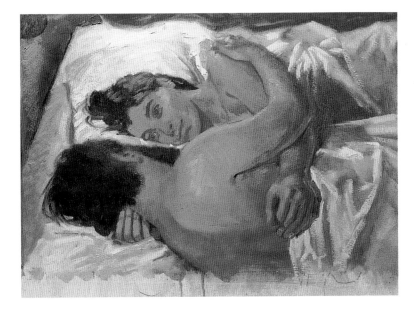

A little warmth, a little light
Of love's bestowing—and so,
good-night!

George du Maurier (1834–96) *Trilby*

CRETARA

Lovers

1996

A TOUCHING postcoital picture in soft, warm colors. The artist and his wife as models make this a powerful expression of Cretara's love; he affirms his affection in a way that both subordinates, and includes, physical lust.

DOMENIC CRETARA (b. 1946)

COURBET

The Sleepers (Detail)
1866

THIS is an overtly erotic picture; there is no attempt to disguise its true subject matter by using the pretext of a classical or biblical theme. Courbet insisted that those themes, favored by the Romantics, should be abandoned—painting should be concerned with things that could actually be observed. But he was also a man who enjoyed controversy and was probably well aware of the likely reaction to this painting.

GUSTAVE COURBET (1819–77)

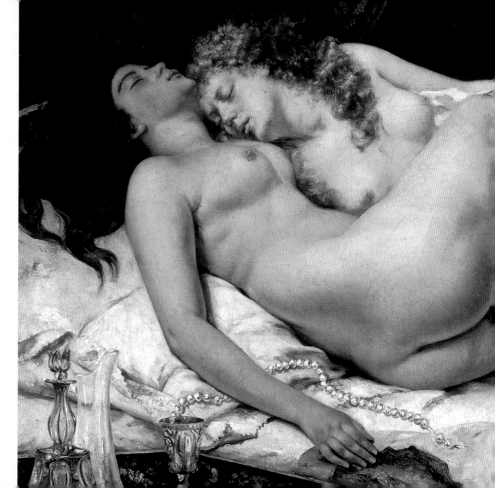

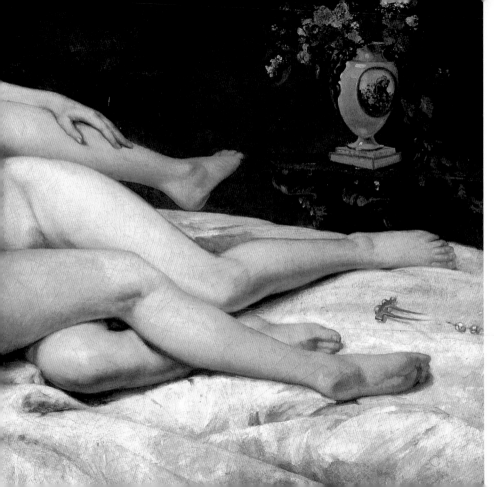

FOLLOWING PAGES

REITER

Sleeping Woman (Detail)
1849

A PLEASANT evocation of the long, still morning after a night of love. The lighting suggests a window off-picture, and hence a busy world outside. Inside, the air stagnates agreeably, but eventually the woman must accept that morning has come.

JOHANN BAPTIST REITER
(1813–90)

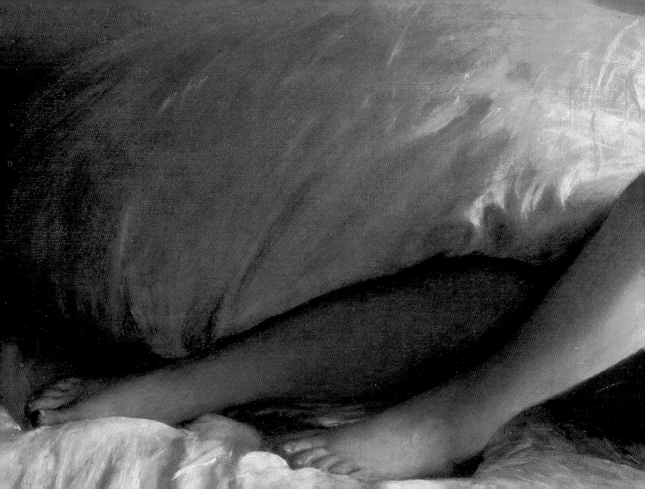

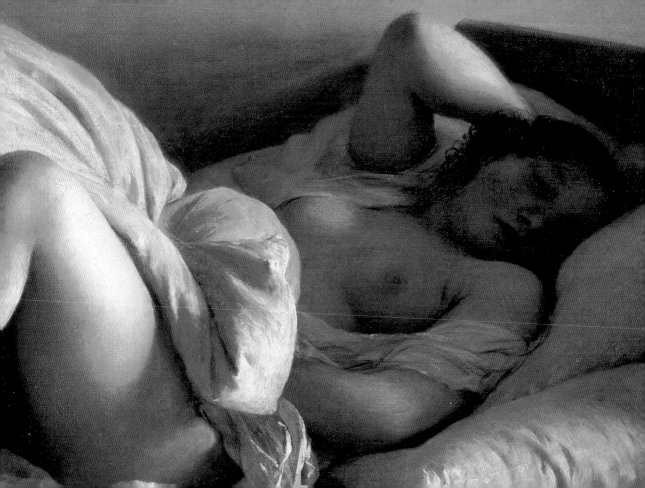

INDEX OF ARTISTS

REINHOLD BEGAS
1831–1911
German sculptor, most prolific and influential of a family of artists. Begas specialized in spectacular monumental sculpture, his greatest work being the Neptune fountain in Berlin (1891). He also completed several official commissions for Emperor William II.
Pages 208–9

SVEN RICHARD BERGH
1858–1919
Swedish painter and writer, known for his landscapes and portraits. Bergh absorbed diverse elements to produce his own, increasingly psychological, works. He attacked conservative opinions in the art world, and worked hard to improve the provision of art education and exhibition in Sweden.
Pages 46–47

TOM BIANCHI
b. 1949
American photographer. He trained as a lawyer and practiced law before becoming an artist. His early work was abstract painting, but he developed an interest in drawing the human figure and this led him to explore the possibilities of photography. He is now one of the leading photographers of the male nude in the United States.
Pages 188–89, 254–55, 256–57

WILLIAM BLAKE
1757–1827
English engraver, illustrator, poet, and mystic philosopher. He was largely ignored in his own lifetime but afterward recognized as an artist of the first rank. His best work combines his own text and illustrations in a single format; indeed he saw each of his works as an atomistic whole, inseparable from, and expressive of, his religious and philosophical beliefs.
Pages 264, 286

HIERONYMUS BOSCH
c. 1450–1516
Dutch painter, real name Jerome van Aken, but called Bosch after his birthplace of Hertogenbosch. He painted religious subjects, but set them in bizarre landscapes and fantastic architecture. His favorite themes depict the follies and weaknesses of humanity, and the horrific consequences of sin. His pictures are full of unearthly creatures, half-human and half-beast, as well as demons and hellish monsters who tempt and torture the human beings. His work had a strong influence on the Surrealists.
Page 276

FRANÇOIS BOUCHER
1703–70
French painter, widely considered to be the leading exponent of the Rococo style. He enjoyed fabulous success and executed portraits of two of Louis XV's mistresses, as well as mythological compositions and countless decorative commissions. His decorative predilections made him the target of critical attacks by Diderot and others.
Pages 222–23, 224–25, 226, 261, 272

YANNIS BOURNAIS
Contemporary
Photographer.
Page 22

JOHN BROWN
Contemporary
Photographer.
Pages 122–24

GEORGES JULES AUGUSTE CAIN
1856–1919
French painter, son of the Parisian animal sculptor, Auguste Nicolas Cain (1822–94).
Pages 84–85

PABLO CAMPOS
b. 1947
Chilean painter, now a US citizen. His work includes both abstract and figurative elements. Campos has worked extensively for clients in the movie industry, and has designed stage sets across the United States.
Pages 89, 90–91, 242–43, 323

ANTONIO CANOVA
1757–1822
Immensely successful Venetian sculptor. He executed works for the Duke of Wellington, Catherine the Great, Napoleon, and especially the papacy. In 1815 the Pope appointed him to recover looted works from Paris, and made him Marquis of Ischia in 1816. He was regarded as the foremost Neoclassical sculptor.
Pages 6, 164–65

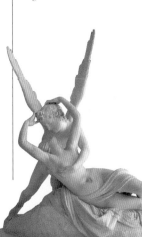

ELINOR CARUCCI

b. 1971

Born in Jerusalem, Carucci gained a degree in Fine Art in 1995 from the Bezalel Academy of Art and Design. Her interest in photography began as a child and she now aims to present images that reflect the reality beyond the artificiality of the posed portrait.
Pages 280–81

MARC CHAGALL

1887–1985

Painter and illustrator, born in Russia but worked mainly in France. He was a member of an influential circle of artists, including Guillaume Apollinaire (1880–1918), Robert Delaunay (1885–1941), Fernand Léger (1881–1955), and Amedeo Modigliani (1884–1920), who worked in Paris before the First World War. His work has a dreamlike, fantastic quality, and often draws on memories of his early years in Russia, showing scenes of Jewish life and its accompanying folklore.
Pages 159, 160–61, 194–95

MICHAEL CHILDERS

Contemporary

Born in North Carolina, Childers graduated from UCLA Film School, where he directed student films. He began his photography career in the 1960s. He is among the entertainment industry's most renowned photographers.
Pages 140–41, 262–63

WES CHRISTENSEN

b. 1949

American artist specializing in small-scale, realistic watercolors. Although his subjects are generally contemporary, they often make reference to mythology and to famous images from the artistic canon.
Pages 41, 232, 236–37

GONZALO CIENFUEGOS

b. 1949

Born in Santiago, Chile, Cienfuegos has exhibited extensively throughout South America and his paintings can be found in a number of public and private collections. Cienfuegos' art synthesizes aspects from every era of art history and often contains a sense of irony and mockery.
Pages 266, 282–83

LOUIS JOSEPH RAPHAEL COLLIN

1850–1916

Painter, notable for his pictures of young girls.
Pages 258–59

MIGUEL CONDÉ

b. 1939

American artist, now naturalized in Spain. His work has a surrealist strand but maintains a strong traditional base.
Pages 53, 232–33

KAMILLE CORRY

b. 1966

American painter who studied in Florence. Her paintings utilize traditional techniques; her Renaissance-style depiction of modern subjects is notable.
Pages 12, 20, 348, 366

GUSTAVE COURBET

1819–77

French painter, son of a wealthy farmer. His early work was in the Romantic tradition, but he later became the leader of the Realist school, claiming that painting should be concerned with things that could actually be seen. He had an obstinate personality, and became something of a revolutionary socialist, eventually being imprisoned for his part in the destruction of the Vendôme Column.
Pages 380–81

LUCAS CRANACH THE ELDER

1472–1553

German painter and printmaker, named after his birthplace, Kronach in Bavaria. He went to Wittenberg as court painter to Fréderick III, the elector of Saxony. Cranach was a shrewd businessman and became an extremely wealthy and respected citizen. His work includes religious and classical subjects, landscapes, hunting scenes, and portraits; but the most successful paintings in his lifetime were his erotic nudes, and his studio was kept busy producing replicas.
Pages 66, 76

WALTER CRANE

1845–1915

English painter, designer, and illustrator. He was an important member of the

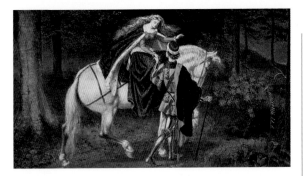

Arts and Crafts movement, and was influential in the development of Art Nouveau. Although he is best known for his book illustrations, he also produced designs for wallpapers, fabrics, and stained glass. He was a prominent educationalist, holding a number of teaching posts and becoming Principal of the Royal College of Art in 1898.
Pages 50–51

CRESILAS

fl. 440–430 BC

Greek sculptor, originally from Crete, but worked mainly in Athens. His most celebrated work is his portrait of the Athenian statesman Pericles (c. 490–429 BC), which demonstrates his unusual freedom of expression.
Pages 201, 253

DOMENIC CRETARA

b. 1946

American artist who continues the tradition of classical painting, often referencing Greek and Roman mythology, historical events, and famous painters, to make his contemporary narratives more universal.
Page 379

MAX DAUMICH

20th Century

Page 246

JACQUES-LOUIS DAVID

1748–1825

French painter who, ironically, trained first with Boucher (1703–70) before becoming as central a figure of Neoclassicism as the latter had been of the Rococo style. This reaction against the frivolity of the day was manifest also in his support for the Revolution, and later Napoleon. He died in exile following the fall of the Emperor.
Page 204

EDGAR DEGAS

1834–1917

French painter and sculptor, leading light of Impressionism. However, his upper middle- class roots made him something of an outsider, and he was at odds with other members of the Impressionist group because he was more concerned with faithful rendering of form than with light and color. His work was influenced by Japanese woodblock prints and by photography—some of his compositions have the spontaneity of a cropped image in a viewfinder.
Page 202, 217

CLAUSTRO DE SILOS

14th Century

Pages 92–93

EUGÈNE DELACROIX

1798–1863

Prolific French painter, regarded—against his will—as a Romantic. Certainly, his loose style constituted a reaction to the austere classicism of Jacques-Louis David (1748–1825), but in theme and method, however, he adhered to the Classical tradition. A preoccupation with color and his choice of lurid subject matter brought him vitriolic criticism, as well as devoted praise.
Page 204–5

SIR FRANK DICKSEE

1853–1928

English painter, who became President of the Royal Academy in 1924 and was knighted in 1925. He painted historical, literary, and mythological subjects, usually in a rather sentimental way.
Page 126

STEPHEN DOUGLAS

b. 1949

American artist known for his moody, life-sized allegorical figures and portraits, for which he has been commissioned by several well-known individuals. He teaches art in southern California.
Pages 235

WILLIAM DYCE

1806–64

Scottish painter and designer; he was born in Aberdeen but worked mainly in London. He was a versatile artist, producing portraits, landscapes, and historical and religious pictures. He painted frescoes in Buckingham Palace, Osborne House, and the House of Lords. In 1844 he became Professor of Fine Arts at King's College, London,

and he was elected a member of the Royal Academy of Arts in 1848.
Pages 146–47

KEISAI EISEN
1790–1848
Japanese writer and printmaker, notorious for his alcoholism and debauched lifestyle. A one-time brothel-keeper, he produced a great deal of homosexual pornography, but his prints of female figures represent his best work.
Pages 318–19

NELLY ERICHSEN
Active 1882–97
British painter. His favorite subject was the figure, which he often put into a domestic setting.
Page 116

MARTHA MAYER ERLEBACHER
b. 1937
American painter whose work tends to eschew realism in favor of a moody, emotionally-charged sensuality.
Pages 267, 298–99, 300

CYNTHIA EVANS
b. 1951
American painter whose work is often reminiscent of both the themes and techniques of Surrealism and Magical

Realism. She has worked in the United States and in Spain.
Pages 59, 336

PAOLO FIAMMINGO
1540–96
The name "Fiammingo," meaning "Fleming" in Italian, was adopted by a number of Flemish artists who worked in Italy during the sixteenth and seventeenth centuries.
Pages 312–13

JOHN FIRTH
Contemporary
Photographer who worked for Bernsen's International Press Service.
Pages 142–43

ERIC FISCHL
b. 1948
American painter. Member of the neo-figurative movement of the 1980s. His work hints at the insecurities that lurk behind the material success of contemporary suburban life.
Pages 356–58

WILLIAM HENRY FISK
1827–84
English painter who studied at the Royal Academy Schools. He became an anatomical draftsman at the Royal College of Surgeons, but continued to paint. His work was exhibited widely, and he was associated with the University College School in London for many years.
Pages 65, 74

PETER FLÖTNER
c. 1495–1546
German sculptor and engraver, working mainly in Nuremberg. Following his visits to Italy, he was influential in promoting the Renaissance style in northern Europe.
Pages 74–75

ELEANOR FORTESCUE-BRICKDALE
1871–1945
English painter, designer, and book illustrator. She studied at the Royal Academy Schools in London. Her paintings vary in style but often show the influence of the Pre-Raphaelites. During the early part of the twentieth century her illustrations for children's books, songbooks, and poetry became particularly fashionable.
Pages 130–31

JEAN-HONORÉ FRAGONARD
1732–1806
French painter, like Jacques-Louis David (1748–1825), a pupil of Boucher (1703–70); but while David reacted against Boucher's superficiality and taste for decoration, Fragonard embraced and developed it. In particular, he painted erotic scenes that, combining sexual honesty, restraint, and a wry element of tongue-in-cheek, possess a charm that Neoclassicism somehow lacks.
Pages 68, 162–63

WILLIAM EDWARD FROST
1810–77
Pages 374–75

HENRY FUSELI
1741–1825

Swiss-born painter, friend of William Blake (1757–1827), and, like Blake, concerned with fantasy, imagination, and dramatic intensity. He produced large numbers of works to illustrate Milton (1608–74) and Shakespeare (1564–1616); and his treatment, in many cases of sexual themes, influenced a number of twentieth-century artistic movements.
Page 268

DIDIER GAILLARD
b. 1953

During the 1970s, French photographer Gaillard studied drawing at the School of Fine Art in Paris. It was here that he took up photography and went on to develop the idea of nudes in motion. He uses a shutter speed of one fifteenth of a second, evoking a fleeting figure.
Pages 220–21, 234–35

KARL BEGAS VON GEMÄLDE
1794–1854
Pages 40–41

FRANÇOIS PASCAL SIMON GÉRARD
1770–1837

French painter, born in Rome and a favorite pupil of Jacques-Louis David (1748–1825). He became one of the most sought after society and court portraitists of the time. While his style certainly had its roots in David, he developed a less heroic, more graceful, manner.
Page 273

THÉODORE GÉRICAULT
1791–1824

A central figure of Romanticism, both in his life and his work. Killed in a riding accident in his early thirties, he had already shocked audiences with his gruesome and politically-motivated masterpiece, *The Raft of the Medusa*. He alienated many critics with his innovative approach.
Pages 170–71

JEAN-LÉON GÉRÔME
1824–1904

French painter and sculptor, steeped in the academic tradition. He used his considerable influence to oppose emerging modern trends such as Impressionism. Of his own work, notable for its technical virtuosity, his oriental scenes are the best known.
Page 57

HENRI GERVEX
1852–1929

French painter.
Page 371

GIULIO ROMANO
1492–1546

Italian painter and architect, Raphael's chief pupil, and the foremost figure of Mannerism. The movement is difficult to define, but it is typified by sophisticated, often superficial, stylistic effects. Giulio is the only artist mentioned in Shakespeare's works (1564–1616).
Pages 274–275

HENRI GILLARD GLINDONI
1852–1913

Painter and illustrator. His work dealt mostly with genre and historical subjects. His illustrations appeared in journals such as the *Illustrated London News*.
Pages 38–39

EMIL GUSTAV ADOLF GLOCKNER
1868–death date unknown

Landscape and portrait artist working in oils, distemper, and watercolor.
Pages 28–29

EVA GONZALÈS
1849–83

French painter, a disciple of Édouard Manet (1832–83). Her main subjects were portraits.
Page 45

C. DANIEL GRAVES
b. 1949

American artist, studied in the US and Florence, where he later formed the Florence Academy of Art. Graves has had exhibitions throughout Europe and the United States of his portraits and interior paintings.
Pages 24, 360–61

GEORGE GROSZ
1893–1959

Painter and caricaturist, born in Germany. He became a member of the Dada group in Berlin, and then a leading exponent of the Neue Sachlichkeit (New Objectivity),

producing antiwar illustrations and social satire, which depicted the middle classes as evil. He was prosecuted for obscenity and blasphemy, and moved to the United States, becoming naturalized in 1938. Shortly before his death, he returned to Berlin, despairing of his "American Dream."
Page 375

J. A. HAMPTON
20th Century
Photographer who worked for the Topical Press Agency.
Pages 62–63

GOYÔ HASHIGUCHI
1880–1921
Japanese print artist. His portraits combine the best of the Uikyo-e tradition together with a strong western-style realism.
Pages 351, 358

HEYWOOD HARDY
1842–1933
English painter. He specialized in scenes depicting hunting, coaching, racing, and other equestrian activities.
Pages 48–49

DIANNE HARRIS
Contemporary
Photographer living and working in Britain. A degree in Art and Design was followed by courses in Electronics and Engineering—all of which are reflected in her work. Harris is a part-time photographic tutor in London.
Page 9

FRANCESCO HAYEZ
1791–1882
Italian painter, working mainly in Milan. He was one of the first Italian artists to embrace Romanticism, painting historical, mythological, and religious subjects. He was also a popular portrait painter, having many influential Italians as his clients.
Pages 110, 130

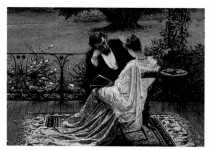

WILLIAM JOHN HENNESY
1839–1917
English painter. Although he worked in the United States for a time, he lived mainly in Britain and France. His work comprises figures and landscapes, often set in Normandy or the English county of Sussex.
Page 73

HERMANN-PAUL (HERMANN RENÉ GEORGES PAUL)
1864–1940
French illustrator and painter. He made his name through his drawings for a series of faintly radical periodicals. Later he illustrated books by, among others, Émile Zola, (1840–1902), Colette (1873–1954), and François Rabelais (1483–1553).
Page 94–95

LOUIS HERSENT
1777–1860
French painter who taught at the École des Beaux-Arts in Paris. He suffered from chronic ill-health, but still became extremely successful in fashionable society. His work often reflected support for the establishment and, indeed, for the restored monarchy.
Page 353

F. SCOTT HESS
b. 1955
American artist, studied in Vienna and later worked in Paris and Tehran. He has exhibited in the United States, Europe, and Asia, winning many prizes.
Pages 31, 77, 337, 376–77

TANIA HIRSCHBERG
Contemporary
Hirschberg studied photography at the London College of Printing in 1991 and went on to spend a year as an assistant to a fashion photographer in Paris. She has since concentrated on a series of self-portraits.
Pages 172–73, 186–87

WILLIAM HOGARTH
1697–1764
English painter and engraver. He spent some years of his childhood in the precincts of the Fleet Prison following his father's incarceration for

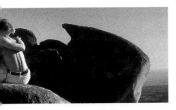

debt, which perhaps influenced the moral flavor of his satirical prints. The idea of a serious purpose for engravings was innovative; but Hogarth's importance in the development of the medium should not obscure his technical brilliance.
Page 69, 370–71

JOCELYN BAIN HOGG
Dates unknown
Pages 154–55

KATSUSHIKA HOKUSAI
1760–1849
Japanese artist, famous in the West—probably because his subject matter coincided with Western taste. He produced many landscapes, but also some fantastical scenes, portraits, and everyday genre scenes in the Ukiyo-e tradition. He was extremely prolific, and the quality of some of his work suffers as a result.
Pages 328–29

ANTHONY HOLDSWORTH
b.1945
British-born American artist. His practice of plein air painting is a paradoxical development of Impressionist techniques.
Pages 310–11, 318, 322–23, 324, 325

SIMON HOLLOSY
1857–1918
Page 8

CHRISTINA HOPE
Contemporary
American photographer focusing on the play of natural light and shadow, particularly under water. She exhibits regularly throughout the United States.
Page 311

JEAN-BAPTISTE HUET
1745–1811
French painter. He painted flowers and other botanical subjects, and genre scenes, often of a rustic nature.
Pages 168–69

PIERRE HONORÉ HUGREL
1827–death date unknown
Painter, pupil of the Swiss artist Charles Gleyre (1808–74). From 1850 he exhibited portraits, genre subjects, and pastoral scenes.
Page 206–7

ROGER HUTCHINGS
b. 1952
British photographer. He studied documentary photography at Newport College of Art in Wales with the *Magnum* photographer David Hurn. He has worked as a freelance photojournalist for the *Observer* since 1982, and in 1994 he won first prize in the "People in the News" category of the World Press Photo awards.
Pages 56–57

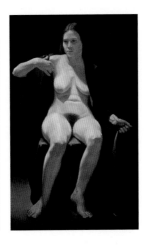

JEAN-AUGUSTE-DOMINIQUE INGRES
1780–1867
French painter and leading exponent of the Neoclassical style. Known for the sensuous beauty of his nudes and the meticulous detail of his portraits.
Page 2

HEYER JACOBSEN
Dates unknown
Photographer.
Pages 346–47

ANITA JANOSOVA
b. 1951
American artist, trained in Italy, who has adapted the Old Master narrative tradition to make her own, feminist, statements. She paints models as great female figures of mythology.
Page 243

J. R. V. JOHNSON OF OXFORD
20th Century
British photographer active in the mid-twentieth century
Page 152

JOKE VAN KATUIJK
Contemporary
After training at the Academy for Photography in Haarlem, The Netherlands, van Katuijk has

concentrated on images of nudes and portraits using the technique of photogravure—a labor intensive etching process that gives a softened image.
Pages 364–65

RUPRECHT VON KAUFMANN
b. 1974

German artist now resident in the United States. His large, allegorical oil paintings are especially interesting for their dramatic lighting effects.
Pages 349, 362, 363

E. F. KITCHEN
b. 1951

American photographer. She began her career in cinema as director and producer, and now works in California, mainly as a portraitist.
Pages 238–39

GUSTAV KLIMT
1862–1918

Austrian painter and draftsman whose increasingly avant-garde works fell out of official favor, leading to his and other artists' secession from the Association of Visual Artists. In his "golden period" he achieved new heights of decoration in the Art Nouveau style; but his human forms, mainly female, remained sensual.
Pages 125, 241, 320–21

JEFF KOONS
b. 1955

American artist fascinated by mass-produced commodities, advertising, pop culture, and kitsch. Koons' work has been subject to critical controversy, yet he always claims his art is free from irony or cynical manipulations. He wants it to appeal to a wide audience.
Page 294

UTAGAWA KUNIYOSHI
1797–1861

Japanese Ukiyo-e artist and member of the Utagawa School founded by Utagawa Toyoharu (1735–1814). Kuniyoshi specialized in landscapes, often populated with military figures. He illustrated an account of the 1855 Edo earthquake.
Pages 358–59

JOHANN KURTWEIL
Active mid-19th Century
Pages 128–29

BORIS MIHAJLOVIC KUSTODIEV
1878–1927

Russian painter and stage designer. When he was tempted away from the Astrakhan Theological School by the Russian Realists, the "Wanderers," Kustodiev too became a recorder of rural Russian life. His satirical treatment of the merchant classes anticipated his later

role as set designer for the Moscow Arts Theater.
Pages 246–47

EDMUND BLAIR LEIGHTON
1853–1922

English painter and illustrator. He was associated with the later, less intellectually pure, development of the Pre-Raphaelites; and his paintings often show the sentimental view of chivalry and medieval life.
Page 47

ANNE LEIGNIEL
Contemporary

French-born photographer, now living and working in New York. Working mainly with models, she aims to focus on the mystery of the body and sensuality of the skin.
Page 212

MAX LINGNER
1888–1959
Page 145

FRA FILIPPO LIPPI
c. 1406–69

Florentine Renaissance painter, brought up in a Carmelite friary. His most famous works are his paintings of the Virgin and Child and his frescoes in the Prato Cathedral. When he was imprisoned and tortured for fraud the Medici family came to his rescue. Sandro Botticelli (1444–1510) was one of his pupils
Pages 14, 33

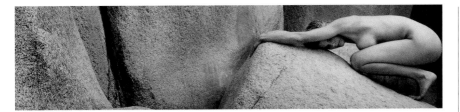

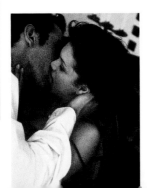

mythological subjects in a distinctively sensuous style. Moreau became a teacher at the École des Beaux-Arts in Paris in 1892; his students included Henri Matisse (1869–1954) and Georges Rouault (1871–1958).
Page 35

JIM MORPHESIS
b. 1948
American artist whose paintings of the human form often make reference to classical and mythological themes. His use of quotation from Greek and Roman poets, and the Bible, has brought him to the attention of the literary world.
Pages 240–41

JOHN NAVA
b. 1947
American artist whose work consists largely of realistic portraits, nudes, and still lifes. An excellent draftsman, he also produces set designs for theater and ballet.
Pages 138–39, 186

JULIUS NISLE
Active mid-19th Century
Pages 210–11, 286–87, 354–55

KIRA OD
b. 1960
American artist who spent ten years as a medical illustrator before turning to sculpture. Od's works often combine human and animal forms to suggest mythical figures.
Pages 64, 82, 254

ANDRÉ JACQUES-VICTOR ORSEL
1795–1850
French painter who studied the Christian art of ancient Rome, and became convinced of the importance and role of art in civilization. His paintings make overt and unashamed use of symbols and allegory, at the expense of form and, ultimately, artistic quality.
Page 162

ROBIN PALANKER
b. 1950
American artist. Her passion for ballet is evident in much of her work, especially in her perceptive treatment of human movement. She paints only with dry pigment.
Pages 43, 78–79, 111, 132–33, 166

CLARE PARK
Contemporary
British photographer who pursued a career as a ballet dancer with Ballet Rambert, but as a result of injury exacerbated by anorexia, she went on to use this background to reflect her views on the "distorted quest for ideal womanhood" at The Royal College of Art. It resulted in a black and white ongoing series of self protraits. Park has exhibited widely.
Pages 203, 251, 344–45

IAN PATRICK
Contemporary
American photographer living in Paris. After studying at Art Center College of Design in Los Angeles, he moved to New York where he did many album covers and portraits for magazines. Now in Paris, he works in fashion and advertising. His main interest is people—observing, perceiving, and interpreting their passage of time.
Page 364

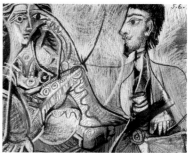

ALBERT JOSEPH PENOT
Active late 19th Century
Painter of interiors and genre scenes. He was a pupil of Gabriel Ferrier.
Page 214

PABLO PICASSO
1881–1973
Spanish painter, sculptor, and designer, widely considered the foremost artist of the 20th century. His output encompassed myriad styles and themes. With Georges Braque (1882–1963), he originated Cubism, and he was also involved in the beginnings of Surrealism. His "blue" and "pink" periods are especially notable, and his masterpiece is *Guernica*, inspired by the Spanish Civil War.
Pages 34–35, 144, 156, 160, 295

PRAXITELES

Mid-4th Century BC

One of the greatest of the Greek sculptors. His work is now known mainly through Roman copies and from descriptions by writers such as Pliny (23–79 AD). There is one extant work, however, that is thought to be by his own hand: the marble statue of *Hermes and the Infant Dionysus*, which was found at Olympia in 1877.
Page 221

GAETANO PREVIATI

1852–1920

Italian painter and writer. He was a leading exponent of Divisionism, a technique in painting in which individual hues and tones are left distinct from each other. Previati used the technique to great effect in his large, decorative canvasses. He wrote several theoretical works in which he advocated Divisionism.
Pages 192–93

MUHAMMAD QASIM

17th Century
Pages 98–99

GREGORY RADIONOV

b. 1971

Ukrainian artist whose work combines different styles and schools. He has exhibited in the Ukraine, Spain, Hungary, and the United States.
Pages 44, 237

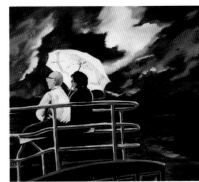

ARTHUR VON RAMBERG

1819–75

German painter, lithographer, and draftsman. He studied in Dresden and Munich, and at the University of Prague, and later taught at Weimar. His work mainly comprises historical and genre scenes.
Page 100

JOHANN BAPTIST REITER

1813–90
Pages 381–83

PIERRE-AUGUSTE RENOIR

1841–1919

French painter. He started as a painter of porcelain, before embracing Impressionism. His light-hearted subject matter made him one of the most popular of the Impressionists, and pictures of nudes and young girls were still prevalent even after he had moved on from Impressionism in the 1880s. Although, in his later years, he was crippled by arthritis, he continued to paint and to develop his style until his death.
Pages 67, 80

REUNIER

20th Century
Painter active in the 1920s.
Page 335

MIGUEL ANGEL REYES

b. 1964

Mexican-born American artist. He specializes in the male nude, and has exhibited in Mexico and Japan as well as throughout the United States.
Page 25

ZSUZSI ROBOZ

Contemporary
Page 283

AUGUSTE RODIN

1840–1917

French artist, hugely important in the development of sculpture. He freed the human form from its Neoclassicist, idealized treatment—to the extent that he was accused of casting one of his sculptures from a live model. His naturalistic approach was consciously Impressionistic, and opened up new possibilities for three-dimensional art.
Pages 124, 265, 285

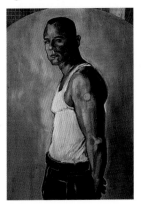

ANDRÉ ROUILLARD
b. 1931
French painter who specializes in acrylic paints to create subtle play of contrasts between the usual and unusual, natural and unatural. He includes elements of both Surrealism and Symbolism in his art. His work is exhibited regularly in France.
Pages 158, 194

THOMAS ROWLANDSON
1756–1827
English caricaturist, watercolorist, and illustrator. Studied painting in Paris and at the Royal Academy Schools in London. Gambling forced him to turn to caricature as a source of ready money. His abilities far exceeded those of most of his fellow caricaturists and his output was prolific. He depicted with sympathy and humor all the follies, pretensions, and bawdiness of a society in which he participated wholeheartedly.
Pages 290–91, 340–41

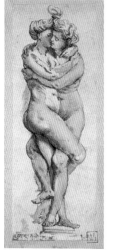

STEPHANIE RUSHTON
b. 1964
Page 7

DEBORAH SAMUEL
b. 1956
Canadian-born photographer who trained at the Limerick College of Art and Design, in Ireland, and then at Sheridan College, in Oakville, Canada. Now living in the US, she has completed many award winning

PETER PAUL RUBENS
1577–1640
Flemish painter and diplomat, in which role he helped to secure a peace settlement between England and Spain, and was knighted by Charles I. As an artist, he was enormously popular throughout Europe, and enjoyed much royal patronage. His output was immense— not only of painting, but of decorative design, book illustration, and work in other media.
Pages 228, 307, 330

album covers and works on magazine, fashion, and film commissions.
Pages 112, 140

SASHA (ALEX STEWART)
1892–1953
Born in Edinburgh, Scotland, Sasha became a professional photographer in 1914, and established his own studio in London. His work centered on theater and society portraits and in the 1930s he worked with British film companies, taking portraits of such stars as Vivien Leigh (1913–67) and Fred Astaire (1899–1987).
Pages 372–73

EGON SCHIELE
1890–1918
Austrian painter and draftsman. His early work was influenced by Gustav Klimt (1862–1918). His later work is Expressionist in style, showing a mastery of dynamic line, particularly in his erotic drawings of nudes. He was imprisoned for indecency in 1912, and a number of his drawings were burned.
Pages 306, 326–27

AUGUSTE SERRURE
1825–1903
Genre painter, born in Anvers in what is now Belgium.
Pages 180–81

KATSUKAWA SHUNCHO
Active 1770–1790
Relatively undistinguished Japanese artist who was perhaps unfortunate to be working during the golden age of Ukiyo-e. His illustrations made to celebrate the Chrysanthemum Festival are notable.
Page 329

YUSHIDO SHUNSHO
1726–92
Japanese artist who specialized in actor-prints, but who, unlike his predecessors, portrayed his subjects as actors rather than in character.
Pages 270–71

HENRYK SIEMIRADZKI
1843–1902
Polish painter. Taught in the academic tradition, he had a large and varied output of landscapes, genre scenes, portraits, religious paintings, and scenes from Classical antiquity.
Pages 113, 118–19

HUNT SLONEM
b. 1951
American artist whose large-scale paintings of tropical birds and other exotica are on display in many public places. Mysterious male figures are another component of his work.
Pages 58, 114, 170

TANSY SPINKS

Contemporary

Photographer.

Page 281

JAN HAVICKSZ STEEN

1626–79

Dutch artist, best known for his amusing genre scenes, but also a prolific painter of portraits, still lifes, and religious and mythological subjects. He was born in Leiden, the son of a brewer; and he himself worked as a brewer and an innkeeper, giving him a useful insight into the tavern life which he so often depicted.

Page 248

THÉOPHILE-ALEXANDRE STEINLEN

1859–1923

Swiss painter and illustrator, born in Lausanne. He worked mainly in Paris

as a poster artist and a contributor to illustrated journals.

Page 129

BRIAN DAVIS STEVENS

Contemporary

Stevens aims to work simply, preferring to use natural light wherever possible. He utilizes many different darkroom techniques and processes to produce the desired effect of timeless prints.

Pages 22–23

FRANK STONE

1800–59

English painter and illustrator. He was a close friend of Charles Dickens (1812–70), assisting with Dickens's theatrical works, and illustrating *The Haunted Man*. Stone mainly produced scenes of courtship and flirtation, enjoying considerable contemporary success.

Pages 100–1

DAVID STORK

Contemporary

American photographer well known for his in-depth documentations into political and historical regimes, including Ceausescu's Romania and Castro's Cuba and insights into life in Los Angeles and Las Vegas.

Pages 104–5

JOYCE TENNESON

b. 1945

American photographer. Her nude and semi-nude figures, often with diaphanous white coverings, have a sensual and spiritual quality, which is communicated as much by body language as by facial expression. She also works as a fashion and editorial photographer.

Pages 244–45, 250–51, 345

TINTORETTO (JACOPO ROBUSTI)

1518–94

Venetian painter, the son of a dyer (*tintore*), hence his nickname. One of the most successful and prolific Venetian artists of his time, but unpopular among his contemporaries because of his unscrupulous methods of securing commissions. His most celebrated work is the large series of paintings depicting scenes from the lives of Christ and the Virgin, in the Scuola di San Rocco in Venice.

Page 225

HENRI DE TOULOUSE-LAUTREC

1864–1901

French painter and printmaker, born into a wealthy, aristocratic family. He lived and worked in Paris, and his paintings and posters

of scenes in music halls, circuses, cafés, and brothels helped to make the Montmatre area of the city famous. His dissipated lifestyle led to his early death at the age of thirty-six.

Pages 81, 137, 350, 366–67, 378–79

KITAGAWA UTAMARO

1753–1806

Japanese printmaker and illustrator in the Ukiyo-e style. Erotic scenes were prominent among a wide range of subjects, all treated with the same masterly use of space and color. Utamaro's own life was rather dissolute, tending to mirror the more scandalous instances of his art.

Pages 19, 342–43

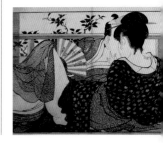

ADRIENNE VENINGER
b. 1958

Photographer born in Slovakia but now living in Canada. She has exhibited regularly in the United States, Britain, Japan, and her home countries of Slovakia and Canada.
Page 213

ROMMEN VERBEKE
1895–1962

Belgian painter. Much of his work is concerned with the sea, either as straightforward seascapes or with other marine-related subject matter.
Page 284

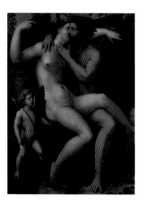

VERONESE (PAOLO CALIARI)
1528–88

Italian Renaissance painter, nicknamed "Veronese" because he was born in Verona, though he is considered to be a member of the Venetian school. His *Last Supper* got him into trouble with the Inquisition because of what were considered to be irreverent details, such as a dwarf, a jester, and a parrot. He escaped by changing the title of the picture to *The Feast in the House of Levi*.
Pages 230–31

ÉDOUARD VUILLARD
1868–1940

French painter and printmaker. His earlier work was influenced by the Impressionists, by the fashionable Japanese prints, and particularly by Paul Gauguin (1848–1903). Later, his work became more naturalistic, and with Pierre Bonnard (1867–1947) he became the chief exponent of Intimisme, a style of painting that depicted intimate domestic scenes.
Page 216

JOHN WILLIAM WATERHOUSE
1849–1917

English painter. He depicted mainly Greek and Roman scenes, and literary subjects. He had a fanciful, romantic approach to his work, which made him popular in his day.
Page 146

PATTY WICKMAN
b. 1959

American artist specializing in large-scale narrative paintings focusing on spiritual issues and interpersonal relationships. She is an Associate

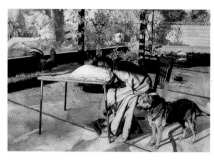

Professor of Art at the University of California, Los Angeles, and has exhibited extensively throughout the US and in the Netherlands.
Page 377

LANA WONG
Contemporary
Photographer.
Pages 60–61

HAL YASKULKA
b. 1964

American artist, trained in both New York and Los Angeles and working in the style of the Old Masters to produce portraits and landscapes. He has also painted murals for hotels, public spaces, and for an impressive array of record labels.
Page 361

HANS ZATZKA
1859–1945

Austrian painter who studied at the Academy in Vienna from 1877 to 1882. As well as his paintings, he decorated numerous churches in Vienna, Mayerling, Innsbruck, and Olmülz.
Pages 126–27

MIHALY VON ZICHY
1827–1906

Hungarian artist.
Pages 268–69, 304, 334–35, 338–39

● PICTURE CREDITS

A K G, London pp 32, 34, 36, 40, 54, 70, 72, 75, 88, 95, 100, 120, 129, 137, 144, 160, 168, 176, 182, 183, 185, 198/199, 210, 216, 246, 287, 294, 295, 316, 322, 355, 367, 375 / Galerie Belvedere/Eric Lessing 125 / Berlin, National Gallery 39, 208 / Bibliothèque Nationale 184, 352 / Musée Bonnat 2 / British Museum 231 / Musée D'Orsay 80 / Archiv für Kunst & Geschichte, Berlin 215, 218, 353 / Collection R. Lebel 35 / Eric Lessing 252, 273, 320/321, 331, 371 380/381 / Louvre 163 / Louvre/Eric Lessing 6, 164, 221, 368/369 / Naples National Museum of Archaeology 83, 260 / Nottingham City Museum & Art Gallery 268 / Prado, Madrid 276 / Jochen Remmer 253 / Musées Royaux des Beaux Arts 161 / Rodin Museum/Eric Lessing 124 / Wallace Collection 68 / Peter Willi/Musée des Beaux Arts, Lyons 230, 258/259;

BRIDGEMAN ART LIBRARY
pp 134, 277 / Musée des Beaux Arts, Lyon, France 162 / Musée des Beaux-Arts, Rouen, France 206/207 / Berko Fine Paintings, Knokke-Zoute 180/181 / Blackburn Museum and Art Gallery, Lancashire 42 / Bristol City Museum & Art Gallery 126 / British Library, London 19, 71 / British Museum, London 328 / Budapest Museum of Fine Arts 330 /

Simon Carter Gallery, Woodbridge 115 / Casa Buonarroti, Florence 229 / Cason Del Buen Retiro, Madrid 16/17 / Chester Beatty Library & Gallery of Oriental Art 358 / Christie's, London 48/49 / Cider House Galleries, Surrey 128 / Cooley Gallery, Connecticut 73 / Museo Episcopal de Vic, Osana, Catalonia 93 / Galerie L'Ergastere, Paris 94 / Fitzwilliam Museum, Cambridge 69, 150, 370 / Giraudon 378 / Goteborgs Konstmuseum, Sweden 46 / Gavin Graham Gallery 214 / Guildhall Art Gallery, London 106/107 / Haags Gemeentenmuseum, Netherlands 248 / Hessisches Landesmuseum 146 / National Museum of India, New Delhi 92 / Archiv für Kunst & Geschichte, Berlin 249 / Kunsthistorisches Museum, Vienna 228, 312/313 / Louvre, Paris 99, 204, 205, 222/223, 224 / Magyar Nemzeti Galeria, Budapest 8 / Josef Mensing Gallery, Germany 127 / Metropolitan Museum of Art, New York 33 / Roy Miles Gallery, London 28/29, 74, 116 / Nardoni Galerie, Prague 81 / National Gallery of Scotland 147 / Noortman, London Ltd 45 / Osterreichisches Galerie, Vienna 326/327, 382/383 / Philips, The International Fine Art Auctioneers 84 / Prado, Madrid 209, 225 / Private Collection 21, 117,

241, 270/271, 288, 289, 292/293, 314, 315, 329, 332, 333, 359 / Pushkin Museum, Moscow 272 / Stapleton Collection, UK 151, 169, 227, 269, 275, 278 279, 290, 291, 308/309, 317, 319, 334, 335, 338, 339, 340, 341 / Victoria & Albert Museum, London 52, 98, 174/175, 342/343, 374 / Whitford & Hughes, London 96/97, 131 / Christopher Wood Gallery, London 50/51 / York City Art Gallery 101;

COUTURIER GALLERY, Los Angeles / Michael Childers pp 141, 262/263 / Ian Patrick 364 / David Stork 104;

EDIMEDIA pp 30, 38, 47, 85, 118, 148, 149, 171, 191, 211, 219, 226, 261, 284, 285, 354 /AKG Berlin 76, 119, 145 / Musée D'Orsay 80;

MARY EVANS pp 193;

HULTON GETTY pp 10, 56, 57, 62/63, 142/143, 152, 190, 196/197, 302/303, 346/347, 372/373;

LIZARDI/HARP GALLERY, Los Angeles / Brian Apthorp pp 18, 136, 178, 179 / Tom Bianchi 188, 189, 255, 256/257 / Pablo Campos 89, 90/91, 242, 323 / Wes Christensen 41, 232, 236 / Miguel

Conde 53, 233 / Kamille Corry 20, 366/ Domenic Cretara 379 / Stephen Douglas 235 / Martha Mayer Erlebacher 298/299, 300 / Cynthia Evans 59, 336 / Eric Fischl 356/357 / C. Daniel Graves 24, 360 / Scott Hess 31, 77, 337, 376 / Anthony Holdsworth 274, 310, 318, 324, 325 / Ruprecht von Kaufmann 362, 363 / E. F. Kitchen 238 / Anita Janosova 243 / Richard Lopez 102, 103 / Jim Morphesis 240 / John Nava 138/139, 186 / Kira Od 82, 254 / Robin Palanker 43, 78/79, 132/133 166 / Gregory Radionov 44, 237 / Miguel Angel Reyes 25 / Hunt Slonem 58, 114, 170 / Patty Wickman 377 / Hal Yaskulka 361;

DAVID MESSUM FINE ART / Zsuzsi Roboz p 283;

THE SPECIAL PHOTOGRAPHERS GALLERY / Yannis Bournias pp 22 / Elinor Carucci 280 / Didier Gaillard 220, 234 / Diane Harris 9 / Tania Hirschberg 172, 187 / Jocelyn Bain Hogg 154/155 / Joke van Katwyk 365 / Anne Leigniel 212 / Robert Mann 296/297 / Clare Park 251, 344 / Deborah Samuel 140 / Tansy Spinks 281 / Brian David Stevens 23 / Joyce Tenneson 244/245, 250, 345 / Adrienne Veninger 213 / Land Wong 60/61;

SEX

SEX

SEX

SEX

SEX

SEX

TONY STONE IMAGES / Bill Aron pp 153 / John Brown 122/123 / Kevin Lynch 26/27 / Stefan May 173 / Stephanie Rushton 7 / Jerome Tisne cover, 4/5;

SUPERSTOCK pp 86, 87, 108/109, 130, 167 / Camera di Commercio, Milan/Fratelli Alinari 192 / Musée D'Orsay, Paris/Giraudon, Paris 217 / Heidelberg University Library, Germany/Explorer, Paris 177 / Christina Hope 311 / The Huntington Library, Art Collections & Botanical Gardens, San Marino 286 / Kactus Foto, Santiago, Chile 282 / Andre Rouillard 194 / Tretiakov Gallery, Moscow 247;

© ADAGP, Paris, and DACS, London 1999 pp 161, 191, 216 / © DACS, 1999 pp 375
© DACS 1999 / Succession Picasso pp 34, 144, 160, 295

ACKNOWLEDGEMENTS
For quotations from the following: 'As I Walked Out One Evening' by W.H. Auden, from *Collected Poems*, by kind permission of Faber and Faber; *My Uncle Silas* by H.E. Bates, published by Jonathan Cape, by kind permission of Random House Ltd; 'Indoor Games Near Newbury' and 'Late-Flowering Lust' by John Betjeman, from *Collected Poems*, by kind permission of John Murray (Publishers Ltd); 'The Agony and the Ecstasy of Divine Discontent' from *Love Poems of Rumi*, translated by Deepak Chopra and Fereydoun Ria, published by Ebury Press, by kind permission of Random House Ltd; *Meet My Maker the Mad Molecule* by J.P. Donleavy, published by the Bodley Head, by kind permission of Random House Ltd; *For Whom the Bell Tolls* by Ernest Hemingway, published by Jonathan Cape, by kind permission of Random House Ltd; 'New Numbers' by Christopher Logue, from *Selected Poems*, by kind permission of Faber and Faber; *Of Love and Other Demons* by Gabriel Garcia Marquez, published by Jonathan Cape, by kind permission of Random House Ltd; 'Berck Plage' by Sylvia Plath, from *Collected Poems*, by kind permission of Faber and Faber; *The Graduate* by Charles Webb, by kind permission of Constable Publishers.

Every effort has been made to trace all copyright holders and obtain permissions. The editor and publishers sincerely apologize for any inadvertent errors or omissions and will be happy to correct them in future editions.